Christo

The Reichstag
and
Urban
Projects

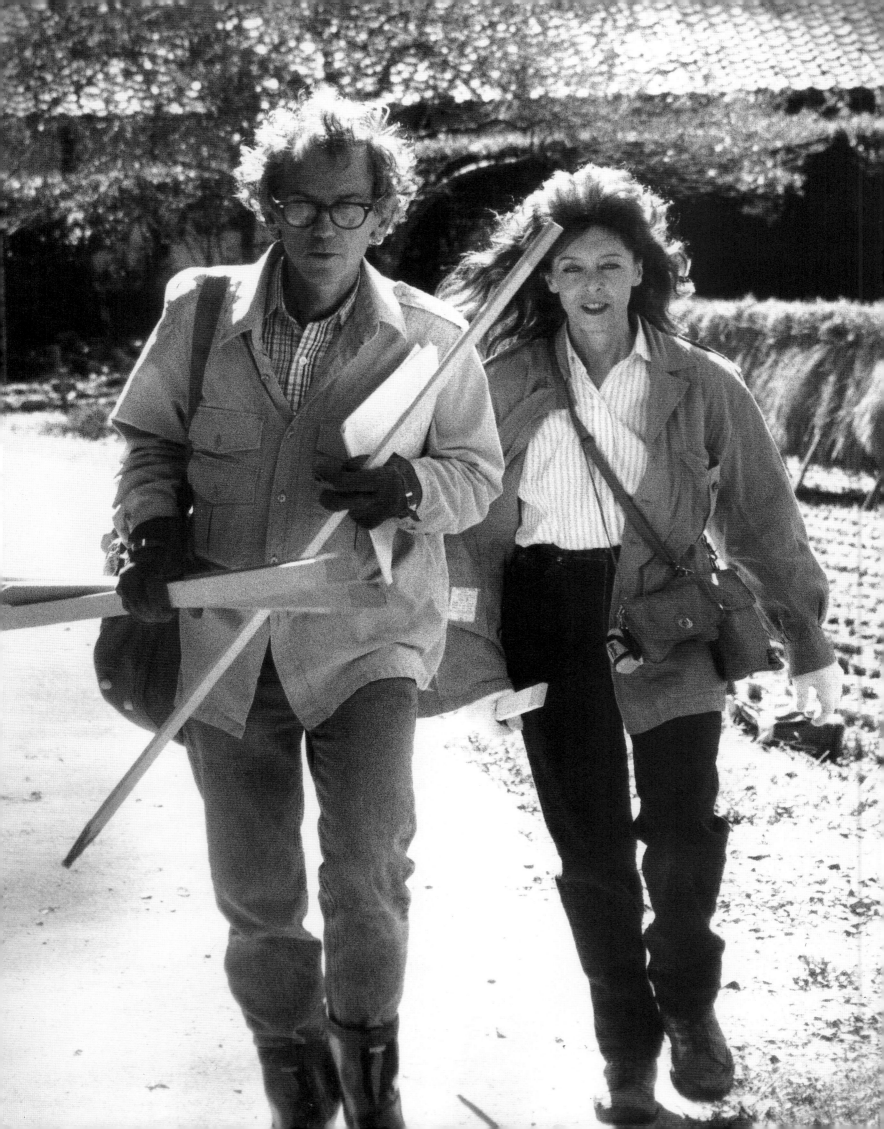

The Reichstag and Urban Projects

Christo, 1935 —
"

Edited by
Jacob Baal-Teshuva

Photography by
Wolfgang Volz

With contributions by
Tilmann Buddensieg, Michael S. Cullen
Wieland Schmied, Rita Süssmuth, Masahiko Yanagi,
and a poem by Cyril Christo

Prestel

Munich — New York

First published in German on the occasion of the exhibition
"Der Reichstag und urbane Projekte" at the KunstHausWien
from June 9 to July 26, 1993.

Front cover: *The Wrapped Reichstag*, cat. 25
Back cover: *Ten Urban Projects*, details of cats. 27-99
Frontispiece: Christo and Jeanne-Claude Christo marking the route for
The Umbrellas, Japan-USA. Ibaraki, October 1988
Photograph: Wolfgang Volz

Contributions by Rita Süssmuth and Tilmann Buddensieg translated from
the German by Canan Yetman
Poem on p. 19 translated by Michael Robertson
Copy edited by Michael Robertson

Prestel-Verlag
16 West 22nd Street
Eleventh floor
New York, NY 10010, USA
Tel. (212) 627 8199; Fax (212) 627 9866
and
Mandlstrasse 26, 80802 Munich, Germany
Tel. (89) 38 17 09-0; Fax (89) 38 17 09-35

Distributed in continental Europe by Prestel-Verlag
Verlegerdienst München GmbH & Co. KG,
Gutenbergstrasse 1, 82205 Gilching, Germany
Tel. (81 05) 38 81 17; Fax (81 05) 38 81 00

Distributed in the USA and Canada on behalf of Prestel by te
Neues Publishing Company, 16 West 22nd Street, New York, NY 10010, USA
Tel. (212) 627 9090; Fax (212) 627 9511

Distributed in Japan on behalf of Prestel by YOHAN Western Publications
Distribution Agency, 14-9 Okubo 3-chome, Shinjuku-ku, Tokyo 169, Japan
Tel. (3) 32 08 01 81; Fax (3) 32 09 02 88

Distributed in the United Kingdom, Ireland, and all remaining countries on
behalf of Prestel by Thames & Hudson Limited, 30-34 Bloomsbury Street,
London WC1B 3 QP, England
Tel. (71) 6 36 54 88; Fax (71) 6 36 16 95

Reproductions by Brend'Amour, Simhart GmbH + Co. KG, Munich
Typeset by Max Vornehm GmbH, Munich
Printed by Aumüller Druck KG, Regensburg
Bound by Ludwig Auer GmbH, Donauwörth

Printed in Germany

ISBN 3–7913-1323-1 (English edition)
ISBN 3-7913-1307-X (German edition)

Contents

Foreword

Christo started working on the *Wrapped Reichstag, Project for Berlin* in 1971, when Germany was still divided, with the Berlin Wall separating East and West. At that time, the problems with the project were greater, and much more complex. Permission for it had to be granted by all four powers — the United States, France, Britain, and especially the Soviet Union, which controlled East Germany with an iron fist.

Christo has worked on this project longer than on any other of his many temporary works of art, and is continuing to devote all his energies to removing every barrier to the realization of it — the wrapping of the Reichstag, a building that has remained a symbol of democracy.

The realization of the *Wrapped Reichstag,* financed by Christo and Jeanne-Claude Christo, will represent the fruition of years of teamwork and effort on both sides of the Atlantic.

"Christo's art is the creation of beautiful, temporary objects on a vast scale for specific outdoor sites. It is in the populist nature of his thinking that he believes people should have intense and memorable experiences of art outside museums," as the art historian Albert Elsen put it in the catalogue for an exhibition in the Art Gallery of New South Wales, Sydney, in 1990. For anyone who has seen one of Christo's projects realized, the excitement, the drama, the magical enthrallment, and the sheer visual beauty are unforgettable. How could I forget the unfurling of Christo's 25-mile *Running Fence,* early in the morning on the shore of the Pacific Ocean in Sonoma and Marin Counties, near San Francisco, in 1976, while the sun was rising and the rainbow of majestic colors was changing and reflecting on the white fabric of *Running Fence.*

The experience of seeing eleven islands in Biscayne Bay, Miami, being surrounded with pink, woven, floating fabric by thousands of enthusiastic young men and women and later flying over the islands by helicopter, is another sight one will never forget.

Christo succeeded in producing the same excitement, and a sense of fulfillment and majestic beauty, when, after considerable opposition and years of negotiations, the Pont-Neuf, the oldest bridge in Paris, was wrapped in a fabric that was silky in appearance and a golden sandstone in color. To see thousands of people walking on the wrapped bridge, going about their daily life, was an unusual sight.

In his book on Christo (New York: Harry N. Abrams, Inc., 1970), David Bourdon writes: "With ordinary fabric and cord, Christo has wrapped an imposing bundle of work and secured for himself a prominent position in mid-century art. He has packaged everything from tin cans to entire buildings. In his mile-long stretch of wrapped coastline in Australia, he has provided one of the eeriest visual spectacles of our time. It has been an extraordinary and fascinating career, especially for a Bulgarian refugee who, within the space of a few years, has become an international art celebrity. In all his packages, he transforms familiar objects into ambivalent presences, sometimes rendering them unrecognizable and often raising doubts about their past, present, and future identity and function. In his more epic endeavors, he questions the relationship of art to both the urban and natural environments. In a materialistic age, his art is a profound comment on the chronic expectations and frustrations aroused by the increasing number of consumer products that surround us in every aspect of daily life, which are 'enhanced' through packaging. No other artist so fully illuminates the twentieth century's preoccupation with packaging."

Special thanks are due to Wolfgang Volz for his magnificent photographs and his help with this project. I should like to thank my wife Aviva for her invaluable advice. Many thanks are also due to Josy Kraft, curator of the Christo and Jeanne-Claude Collection.

Special thanks go to Christo and Jeanne-Claude for their long friendship, cooperation, patience, and many hours of work, advice, and help in producing the book and the exhibition.

To all of those involved, my heartfelt thanks and appreciation.

Jacob Baal-Teshuva

Wrapped Reichstag, Project for Berlin

The Reichstag

In 1971, when Christo started working on the *Wrapped Reichstag* project, there was little hope that the parliament of Germany would ever again house the national legislature. Today, more than ever, the Reichstag demonstrates the encounter between the East and the West, the past and the future.

The Reichstag stands in an open, almost metaphysical area that brings to mind its turbulent history since its inauguration in 1894. In 1933 it was burned, in 1945 it was almost completely destroyed, and in the 1960s it was restored. The Reichstag has continually undergone changes and perturbations, but has always remained a symbol of democracy.

For a period of two weeks, the richness of thousands of square meters of silvery fabric, together with the ropes securing it, will create a sumptuous flow of vertical folds highlighting the features and proportions of the imposing structure, revealing the essence of the building's architecture.

Throughout the history of art, the use of fabric has fascinated artists. From the most ancient times to the present, fabric, forming folds, pleats and draperies, has been a significant part of paintings, frescoes, reliefs, and sculptures made of wood, stone, and bronze. In the Judeo-Christian tradition, for example, in weddings and other ritual celebrations, veiling has a sacred or joyful message. The use of fabric on the Reichstag follows this classical tradition.

A high-strength synthetic woven fabric, meeting the prescribed standards for fire retardation, and Dacron rope will be used to wrap the Reichstag. Each facade will be covered by five tailor-made fabric panels. The fabric and ropes will be attached to expanding columns that permit installation and removal without altering the building. All vulnerable statues and ornaments will be protected by specially fabricated cage-like structures.

The work will be completed in three phases. The first phase includes all off-site work, such as cutting and sewing the fabric panels and constructing the cages and attachment columns. In the second phase, the attachment columns and protective cages will be installed, and the folded fabric panels will be moved and positioned on the roof terrace. With these low-visibility preparations completed, the final phase can be undertaken, in which the fabric is unfurled from above and secured over some three to four days. After removal, all the materials used will be recycled.

The temporary work of art *Wrapped Reichstag* will be entirely financed by the artist, as he has done for all his projects, through the sale of his preparatory studies; drawings, collages, scale models, early works, and original lithographs. The artist does not accept sponsorship.

For more than twenty years Christo has exhibited and lectured about the Reichstag in museums, universities, and galleries all over the world.

The *Wrapped Reichstag* project represents not only many years of effort in the artist's life, but also years of teamwork. It has involved politicians and businessmen, artists and individuals from every social background, and people from East and West. The communal energy is an important part of the dialogue that has become vital for the *Reichstag* project.

Fabric, like clothing or skin, is fragile. Christo's project will have the unique quality of impermanence. The physical reality of the *Wrapped Reichstag* will be a dramatic experience of great visual beauty.

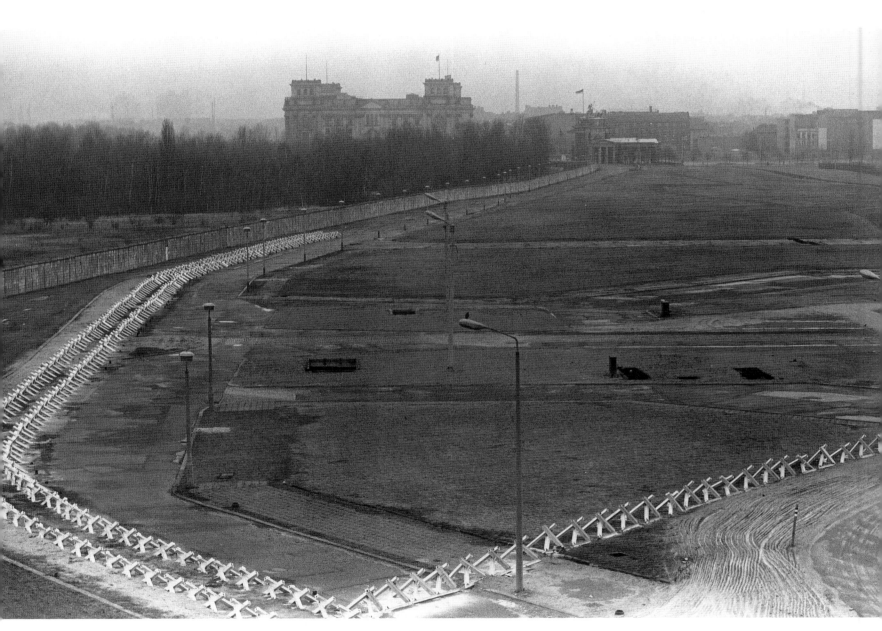

Reichstag, Brandenburg Gate, and Berlin Wall viewed from the former Haus Vaterland building, 1977. Photograph by Wolfgang Volz

Christo's personality and development must be appreciated before one can enter into a discussion of the validity of his project to wrap the Reichstag. Only then can one confine oneself to the project itself. For me there is no question of his seriousness and the objective chance to realize this project. To characterize and understand the work, eight aspects seem to be absolutely essential.

The Philosophical Aspect

The ancient Greeks said that wonder was the beginning of all philosophy. A sense of wonder at trivialities and what is habitual and seemingly self-evident triggers off prolonged thinking about what seems obvious. Christo's art is always directed toward this philosophical dimension, to further meditation on what is familiar and habitual and aims to bring to our notice things which are near at hand and well-known, and which we easily overlook for just this reason. Christo achieves this sensibility by either veiling or unveiling. He deprives us of familiar objects by wrapping them, and thus making them strange and mysterious; he makes us curious. Rediscovering them from their wrappings, we see them with a new awareness, new eyes.

The Aesthetic Aspect

The state of a wrapped object not only has the negative aspect that the object is withdrawn, estranged from us; it also contains its own formal qualities. The wrapped object—tree, house, tower, whatever, can also be beautiful in its wrapping, can be an aesthetic object. We discover its special outline, form, and volume. The wrapping reflects light, sun, clouds, gleams in many colors, plays an unusual, fascinating game, raises expectations about the wrapped object.

The Technical Aspect

Christo has great experience in realizing utopian projects; he is fascinated by the magnitude of the task. This fires his imagination and also makes his helpers enthusiastic. Christo has a host of helpers who have learned from past projects: engineers, techni-

cal personnel, experienced and skilled workmen, and helpers who are already familiar with Christo's work and who can advise him on the choice of materials, fixing, strengthening, etc. The role of the artist lies in the concept and idea for the project, which should at the same time be non-utilitarian, but also sensible. The technical details are given over to professionals – Christo only supervises the various phases of the realization.

The Social Aspect

Christo's art seeks the public. It is not feasible without publicity or the participation of the public. It requires active, not only passive, public participation. It is constructed in such a way as to give rise to lasting reflections on it. The process which leads to the realization of a work by Christo is part of the work of art itself and is the social dimension of the work. The public, regularly confronted with Christo's plans and ideas at hearings, seems to be included, with all its reactions, within Christo's work. It is important for Christo that the public is not only represented through the technicians, workmen, professionals, and students who take part in the project, but also through the general public, which is represented by its members of parliament, politicians, press, and television. Public and official opinions and statements about any of Christo's projects are for him an integral part of his work. Especially in the case of the *Wrapped Reichstag* project, public opinion – if possible in all districts of Berlin, but also in other German towns – should be prepared and made familiar with Christo's project through lectures, discussions, films, etc. The artist himself would be available to the public for questions.

The Financial Aspect

The following fact is decisive. The project will not cost the German taxpayer one penny. Christo is not interested in subsidies. He finances his own projects – not through a personal fortune (which he does not possess), but through his work. With a project in mind, he sells high-quality collages and drawings to collectors, galleries, and museums. He uses the revenue from these sales to realize his project. In this way, his work is self-sufficient.

The Urban Aspect

Christo's biggest projects have been based on landscape – accentuating, strengthening, or changing the definite impression of a landscpae (a rocky coastal strip, a valley in Colorado), they become part of this landscape. Now Christo is returning to the urban space with which he began. However, this is a much bigger project than the previous wrappings of houses or monuments. The *Wrapped Reichstag* is going to draw attention to the isolated urban situation of this building on the fringe of the vital life-stream of West Berlin, and perhaps it may provoke later architectural and planning ideas.

The Historical Aspect

The Reichstag is part of German history, and in a certain sense its symbol. Do we still possess the Reichstag? Or have we only retained the empty shell, which is filled with the glories and miseries of the past and its controversies and conflicts? Why is the Reichstag so precious to us as a national monument, on the one hand, and on the other so irrevocably burdened with painful memories? Is it only because the building was left without a vital function, a few yards away from the Wall which separates a city, a country and a people without mercy? Or is it because this empty Reichstag is itself a symbol of the partition, the tragic development of German history – and guilt? When Christo wraps the Reichstag – for however short a time – he will be putting a finger into a deep wound. This, however, is his intention. Christo is not looking for thoughtless acclaim from gallery visitors. His art leads him into confrontation with the present day – into discussions about ecology (as with the *Running Fence* project in California), and now (1977) he is drawing attention to German partition. We should accept this.

The Political Aspect

From the historical aspect, the political one follows. This is, it seems to me, the decisive one. How will the people – and here, the people become the public – react? Will they realize that the example of the wrapping – and therefore the emphasis on a historical building – not only touches a chapter of our history, but touches present-day Germany, our everyday life, in which we live quite comfortably and without too much thought? Are people aware that Christo is only veiling something which we have missed for a long time and which we only possess as an empty shell? Are they going to react with sensitivity, humor, courage, ingenuity, and spontaneity, the qualities which are specially attributed to the people of Berlin? Are thoughts being activated or only emotions provoked? Here lies the risk in this artistic experiment, but at the same time its importance and its chance.

Summing up, I would like to say that we should have the dar-

ing to carry out the project *Wrapped Reichstag*. But it should not be done without being explained to people sufficiently in advance. This seems to me imperative. Against the background of the intense media interest that can be expected, the problematic nature of the project should be discussed in all its aspects and dimensions. Only when there is a general understanding of the project – not of course an undivided consensus, which can never be obtained for any artistic work, and which perhaps is not even desirable – should it be implemented. For the *Running Fence* project in California, Christo progressed in just this manner. In contrast to California, this project rests not only on the numbers attending meetings, but on a qualitative weighing up of the arguments and a critical examination of the hoped-for result.

Only when the expected (and welcome) controversial debates have arrived at the crucial points, can the realization of the project be most effective. The project will not only make us conscious of our situation at this point in time, historically and politically, but also of our existence between the past and the future.

This essay was originally published in the exhibiton catalogue *Christo: Project for Wrapped Reichstag, Berlin* (London: Annely Juda Fine Art), 1977. The translation has been corrected.

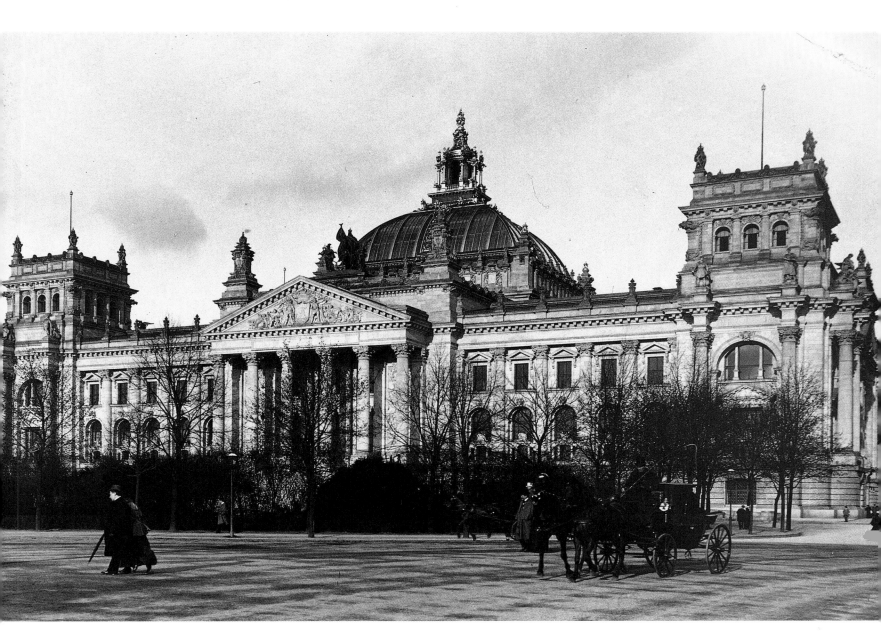

Reichstag, 1896. Architect: J. Paul Wallot, constructed 1884 – 94. Photograph from Landesbildstelle, Berlin

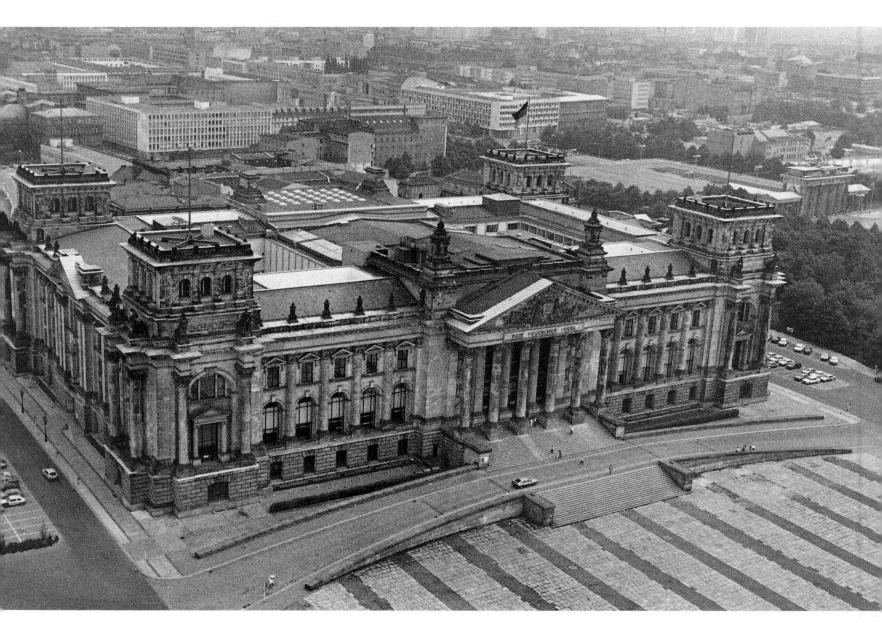

Reichstag, view of the west facade. In the background, Brandenburg Gate and East Berlin, 1986. Photograph by Michael S. Cullen

Tilmann Buddensieg **The Reichstag and Artists**

My dear Scheerbart! I think the Reichstag building is just a bit too square. Otherwise it is good.
Yours, Otto Erich [Hartleben]
Berlin, 11 December 1894

In the summer of 1977, several representatives of the [German] government publicly voiced their opinions on the question of art. At the 25th exhibition of the Künstlerbund, the federal president [Walter Scheel] described art as an area of freedom in which government should not meddle. Earlier, the president of the Bundestag [Karl Carstens] stated his position on Christo's project to temporarily wrap the Reichstag in Berlin, marking out the limits to artistic license that even our government, despite its institutional liberalism, considers to be necessary. He said that these limits lie where "a large proportion of our fellow citizens" have no sympathy for an artistic project that would temporarily transform an object of "special historical significance" to such an extent that it would spark controversy.

In other words, the freedom of art is seen as less sacrosanct when an artist such as Christo sees the hallowed preserve of national symbolism as his artistic domain. If so, then the view of Walter Wallmann [then Christian-Democratic mayor of Frankfurt] that politicans should "ensure freedom for art and artists and make no judgments over what should be considered valuable or worthless art" falls by the wayside. Wallmann feels that art is often "provocation, offense, protest against convention."

If this statement is applied to the Christo project, then the project can be seen as a form of provocation that abandons the safety net of artistic freedom without disqualifying itself as an artistic event. After thoroughly studying Christo's project, Carstens saw it as just such an overstepping of the boundaries, but nonetheless conceded that it had a "significant artistic effect" – thus avoiding a simple form of defense: that Christo was a charlatan, a "jester and a waster of time" (as Rudolph Borchardt put it).

This controversy over a planned artistic project leads to the realization that the artistic freedom for art and artists demanded by Walter Scheel and Walter Wallmann functions as a democratic maxim only as long as artists are prepared to content themselves with "free self-realization." Since Christo appeared on the scene, we must deal with the emergence of a "political art" of a different kind than the one the chancellor [Willy Brandt] described at the Bonn Sommerfest. It is an art that lays bare the very German taboo of political and national symbolism.

The differing viewpoints held by the coalition government and the oppostion in this discussion are united by expressions of mutual tolerance. Willy Brandt understands those who are concerned, Dietrich Stobbe [then mayor of Berlin] respects Karl Carsten's decision, and all three are convinced of the "significant artistic effect" of the wrapping of the Reichstag. Thus, whether or not Christo's intention represents "valuable or worthless art" is not the issue. The issue is the assessment of the political implications of the artistic effect produced: assessing how the majority of the population will react to the provocative project – a majority that could very quickly become a majority of voters.

This is an understandable concern for elected representatives of the people, particularly since what is at stake is not an inappropriate application of majority resolutions to the artistic value of the Reichstag project, but only the question of the majority's view of the political implications of the project. Carstens feels that a controversy over "the Reichstag building, with its unique historical significance and its quality of symbolism for the continuing unity of the German nation," would be "detrimental" at present. Brandt, on the other hand, sees the project as being "helpful" in recalling the "symbolic value" of the controversial building, and Stobbe also hopes for a more "positive provocation" and "liberating discussion." Both Social Democrats feel that "an objective and well-prepared discussion" could make the project "understandable to a public that will certainly be hesitant."

This discussion has created a remarkable situation. Christo's project calls for politicians to canvas for its public acceptance, not to finance it – which in any case he has not requested – or else to take responsibility for rejecting it. This would expose the limitations on artistic freedom mentioned above. This time there would be no grounds for joining Helmut Schmidt in lamenting that "art and politics" have "far too little in common." From the very beginning, Christo has sought out a "community experience" and "tremendous political implications," not in order to ridicule these with ropes and strips of cloth, but to enable the people themselves to understand this temporary artistic act as a stimulus for thought. It is an invitation to dance with the obscure concepts

Reichstag, view of the east facade, 1983
Photograph from Landesbildstelle, Berlin

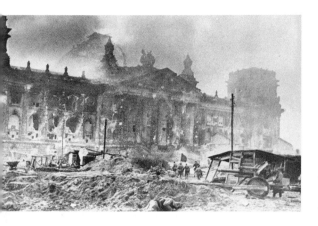

The battle for the Reichstag, 1945
Photograph by Ivan Shagin
Courtesy of E. P. Dutton, New York

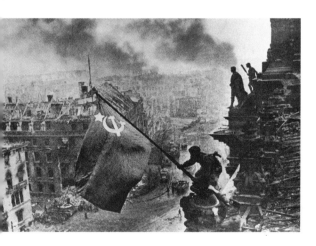

Reichstag, 1945.
A victorious Soviet soldier
raises the Red Flag
Photograph by Yevgenii Chaldei
Courtesy of E. P. Dutton, New York

concepts and static expectations of national symbolism, historical tradition, and political reality. The Reichstag is in desperate need of such public interest. In its short existence, there has never been a time when it was not the subject of "detrimental discussions." Before we all embrace a "smiling Wilhelminianism" [Julius Posener] and while everyone anxiously follows the meticulous restoration of even the smallest ornament on the Berlin cathedral, it is worth making one observation. The author is

unaware of any precedent in architectural history in which there has been a comparable antithesis between the historical significance of a building and the negative image of its appearance. This judgment is shared on all sides, even among those with irreconcilable political convictions. The early monarchistic opponents of parliamentarism denounced the building, just as the Weimar Republicans and the National Socialists did. Finally, even those federal politicians who unenthusiastically supported the rebuilding of the Reichstag left no doubt that their conservationist attitude stemmed from purely political-historical motivations, to a certain extent despite the building's "beautifully horrid" shape.

Of course, no one doubts that it is possible to have uplifting services in ugly churches, and good schools, efficient hospitals, or a fast fire department in unattractive buildings. In those cases, however, comparison with something better has always been possible, and an ideal unity between form and function has been achieved hundreds of times both in earlier periods and today. But there is only one German Reichstag, and almost all comparisons with foreign parliament buildings have been to its disadvantage.

The inadequacy of the building, a typical German conflict between emotional validity, visible form and historical significance, may explain the attacks on it that used the exterior as an excuse to denounce what went on inside. The great Weimar architect Hugo Häring referred to the "building of a political community as a formal theme of the utmost significance." This idea has not lost any of its relevance, and no one can estimate what consequences, in the sense of rejected identification or even simply sympathy, the aesthetic condemnation of Paul Wallot's building must have had.

It has, after all, always been a delicate matter of a cultural criticism unique to Germany—from Langbehn to Moeller van den Bruck to Sedlmayr and Marcuse—to take "cultural despair" [Fritz Stern] over the artistic manifestations of the zeitgeist and apply it to the national and political situation. Was it not more than a mere case of artistic misfortune that the Germans had their unpopular Reichstag, while the Americans had their capitol, the British their houses of parliament, and even the Austrians a parliament that was incorporated into the capital city with dignity? Even the Hungarian "imitation" of the British model unforgettably shapes Budapest's skyline, while the Reichstag could only be crowded forcibly onto the same postcard with the Brandenburger Tor and the pine trees of the Tiergarten. One need only compare the political impact of the proximity of the Swedish Parliament to the royal palace to fully understand the extent of the hostility and fear that led to the distancing of the Reichstag away from the historic city to a site closer to the regular location of circus tents, prisons, invalid homes, and parade grounds, and apparently provoked the Kaiser's decision not to have a dome that would be too prominent in comparison with the palace. This is why it was "no coincidence that by virtue of its

town-planning placement, the Reichstag was pushed aside and taken out of the context of the building complexes representing the national power of the time" [Ludwig Hilberseimer]. It is also why 99 percent of the Reichstag is now [1977] in West Berlin, although unfortunately completely on the outskirts.

In 1927–30, in a memorable competition, several of the Weimar Republic's leading architects attempted to give expression to the new constitutional situation that had arisen in 1919 through far-reaching architectural and town planning measures. Their intention was to reduce the Reichstag's isolation by transforming the Königsplatz [King's Square] into the Platz der Republik as a "documentation of the new German goals." Despite the distant respect toward Wallot's building this showed, the Reichstag remained the "epitome of everything that had been overcome, and Peter Behrens was able to present a suggestion that would erase all shapes and forms from its exterior" [Fritz Schumacher]. Bruno Taut suggested – with measures more permanent than those of Christo – "making the Reichstag invisible from the outside" and wrapping it in modern functional architecture. Karl Wach wanted to "put the building inside a large box, so that the face of the old building can still gnash its teeth" [Kiessling]. This design reminded Hilberseimer of a "toy building-brick type of architecture in which there had not been enough bricks to make a whole building."

Can anyone seriously believe that the short but tremendous aesthetic pleasure created by Christo's wrapping of the Reichstag, which even skeptics agree would be produced, could in any way add to the insidious damage that has been continuously inflicted on the German parliamentary system by allowing it to operate in an absolutely hideous and odious location? "If it is possible to hate a building, then I have learned to hate this building more and more... I am convinced that the irritability of the representatives, unfortunately apparent in so many discussions, is a direct result of the artificiality of the Reichstag building" [Gustav Radbruch, minister of justice, 1920–24].

Is it not worth the effort, by way of a short-lived variation, to transform this "artificiality" into the beauty of canvas flowing in the Berlin air? Would this enveloping transformation not fulfill man's basic need to examine the "truth" that may remain in the dwindling significance of the aged facades of his world? And would such a temporary wrapping not be more humane than the only other means of getting rid of unpopular, awkward buildings that have lost their function – that is, demolishing them? One can only recall with disbelief the pleas of art writers, architecture critics, architects, and members of the Werkbund, among others, and the broad consensus for tearing down the Reichstag in the 1950s. In the current desolateness of its reconstructed state, there are still many who remember the flashes from the explosive charges that were required to demolish the damaged dome of the plenary hall.

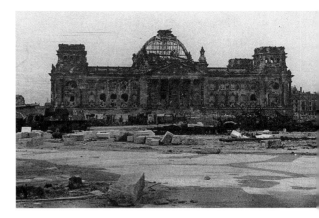

The ruins of the Reichstag,
with the dome burned out, 1946.
Platz der Republik in the foreground
Photograph from Landesbildstelle,
Berlin

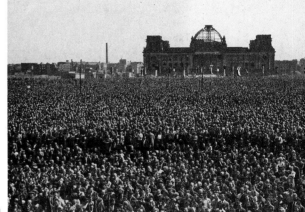

Freedom demonstration on the
Platz der Republik in front of
the Reichstag, May 1st, 1950
Photograph from Landesbildstelle, Berlin

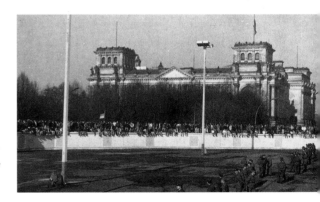

The Reichstag after the fall of
the Berlin Wall, November 10th, 1989,
seen from the east
Photograph by Dietmar Katz

Those who still oppose this project, despite a "well-prepared discussion" [Stobbe] concerning wrappers and wrapping, as well as those publicizing the event, could join with the wrappers in delight when seeing the ropes loosened and the wrapping fall once again. After such a Christo "fermata" in the history of the Reichstag, everyone would have their Reichstag back again, and many might even learn for the first time that they do have it and what it means.

Those critics for whom Wallot's Reichstag still represents the expression of "Wilhelminian bragging" should remember the testimony of Cornelius Gurlitts, a contemporary, who, as one of the most influential art historians of his time and a friend of Wallot's, had first-hand knowledge of contemporary discussions about the Reichstag. In 1929 he wrote, "There was also a view that the building should be simpler. Wilhelm II wanted to give the 'talking-shop' more of the look of an administrative building . . . others demanded that the 'people's house' should reflect the character of the newly achieved prominence of the Empire and pay homage to Bismarck's creation. I remember clearly the anguish Wallot felt over this conflict of fundamental ideas. In the end it was the left-wing parties who were victorious. Representatives Eugen Richter, a Democrat, and August Bebel, a Socialist, approached Wallot with a request for an opulent design and supported the full use of his talents. It was with Wilhelm II that Wallot fell from grace.

Thus, the issue with the Reichstag building is not one of 'Wilhelminianism,' it is the expression of the people's voice at that time and the artistic representation of what was then considered modern." The kaiser wanted for the representatives of the German people what we have now finally achieved in Bonn – office buildings. East Berlin's "Palast der Republik" corresponds more to Bebel's wish for a "display of splendor" and can rival the Reichstag building with regard to its use of expensive materials, the total area of its cycles of paintings, and the eclecticism of its architecture.

Once the grandeur of the Reichstag was no longer subject to the imperial requirement for dynastic glorification, the splendor of Bebel and Richter's "people's house" must have seemed useful as a painful provocation to the kaiser. Wilhelm had felt the Reichstag was unnecessary anyway, since he believed the will of the people and the emperor's exercise of power were one and the same, and didn't need to be legitimized by a "talking-shop." The building could therefore stand as a monument to a parliamentary system that had been wrested from the monarchy unwillingly, as well as a symbol of a view of the empire from which the monarchy had distanced itself (Wilhelm: "the pinnacle of tastelessness").

We must finally learn to understand once again how a younger generation of architects, resisting Historicism and advancing towards Modernism, were capable of calling Wallot's Reichstag a "creative building" that signified the dawn of a "new era in German architecture" and liberated it from the shackles of imitative styles as Hermann Muthesius described it in 1902. Fritz Schumacher said, "The building cannot be excluded from consideration in the progressive stream of our architecture" because "we can all be thankful to it for a piece of redeeming impetus." The architect Max Berg, who designed the Jahrhunderthalle in Breslau in 1930, described the Reichstag as "the only artistic

accomplishment of any quality in the decorative and grandiose style that typified the Wilhelminian period."

What was it that constituted this "accomplishment of quality"? Perhaps it was what might be called the synthetic style characteristic of the Reichstag's architecture. Wallot believed that none of the earlier styles was suitable for the parliament of the German Empire. Classical architecture was too Prussian, late Romantic too imperial, Gothic was too southern European and Catholic, neo-Gothic too northern German and Protestant, Renaissance was too bourgeois, and Baroque too courtly. He rejected the option of using a style that was local to one of the German states and the provincial popularity, and chose instead a local and somewhat timeless, free-floating "Reichsstil" (imperial style). This decision was so consistently implemented that a true analytical interpretation of his architectural language has not yet been achieved. For a Historicist building to be surrounded by such unusual circumstances is one of its positive qualities. Russell Hitchcock was therefore capable of seeing Vanbrugh's Blenheim Castle as a "model," "more than Bernini or Schlüter." This originality of style synthesis clearly distinguished Wallot from the Wilhelminian court architects, whose often eccentric genealogy reminted the art of the height of the Holy Roman Empire into a legitimization of the Hohenzollern dynasty. Thus, by way of Theodoric the Ostrogoth, the kaiser could exploit even the mosaics of Ravenna for the neo-Romanesque Kaiser-Wilhelm-Gedächtnis-Church and, during the Messina earthquake catastrophe, ponder his Sicilian ancestry.

Wallot's synthetic Reichsstil could be interpreted as a visible analogy to Bismarck's political unification of the German tribes, even if Wallot himself never appears to have commented on it. It is extremely significant for Wallot's architectural language that he did not limit himself to an architectural "unification" of the German regional styles, but expressed the idea of a German *Kulturnation* (cultural nation) in more universal terms. He therefore chose an architectural style consisting of basic elements from antiquity, the Renaissance, and the Baroque. In the distinct elements of antiquity and the Italian Renaissance, he brought to the forefront a common root of German culture, harmonizing it with the more Germanic elements of Schlüter's Baroque style. "Few buildings will, as this one shall, convey to a later era knowledge of a strange nation whose Germanic essence was poured into the molds of Roman law and classical education" [Kurt Diestel, 1907].

The limitations of Wallot's achievement soon became evident. The "intellectual and educational elitism" which, in 1916, Max Scheler saw as the "strong point and embodiment of German democracy" even had an impact on a building such as the Reichstag, inside and out. It was denied the "positive consequences" of German art, because the architectural "formula for the re-establishment of the German empire contained the wrong

preposition – the 're' split off the best part of its energies and left them in the past" [Müller-Wulckow, 1919]. The productive powers of the new Reich were pushing toward a new architectural language that was embodied in the new AEG buildings on Huttenstrasse and Brunnenstrasse. Even at the beginning of the twentieth century it was trying to rid itself of unpopular buildings by using "merciful covering" and "a kind of concealment art." At the Centennial Exhibition in 1906, Peter Behrens veiled the rooms of the Nationalgalerie with "provisional linen walls" to "mercifully conceal. . .what the Nationalgalerie had been and hopefully will never be again. This will inaugurate a new branch of artistic creation, a sort of art of concealment, one that a later generation, at least in Berlin, will probably find very useful. Too pious to let go of buildings such as Raschdorff's cathedral and a series of monuments that happily sprouted from the ground in the Tiergarten, one will instead envelop them in a shell of valuable artwork" (*Zeitschrift für Bildende Kunst,* 1906). A discussion of the Reichstag's interior decor should be preceded by a quote from Nietzsche: "How close the most noble is to what is most common." A painting such as the one in the conference hall of the Bundesrat, with the fantastic theme "Kaiser Wilhelm I rides from an oak tree across a cornfield, toward a laurel tree," could not have been expected of Liebermann, and even Thoma, Böcklin or Klinger would only have accepted such a commission on the condition of being able to have complete artistic license with it. The artistic boundaries were so tightly drawn for Wallot that after intense parliamentary debates even a ceiling painting by Stuck and the ballot urns by Hildebrandt were rejected. The publication of these debates in *Pan* in 1899 symbolized the wider breach between the artists of the German avant-garde and state-commissioned work, and between the avant-garde and the artists of the academy and court who were engaged en masse at the Reichstag. This rejection is uncompromisingly expressed in Frank Wedekind's "Politisches Lied" (Political Song), published in *Simplizissmus* in 1898:

The windows in this house are small;
They might be in a prison wall . . .

Over the ages I've seen with my eyes
many a parliament building arise.
Why is it, then, that the Berliners' dome
Looks like the candy-box lid at home?

It's trying to cower beneath the pile;
That's why they created the Reichstag style.

Here's why the Reichstag needs a lid:
So the brave lads sitting there do what they're bid
Sitting as bowed as they possibly can . . .
Goodnight, goodnight, good nightwatchman.

Since then, the state has attempted only once to bridge the gap caused by this breach. In 1912, Legation Councillor Edmund Schüler, together with State Secretary of Foreign Affairs von Kiderlen-Wächter and the architect Peter Behrens, disregarding the possible controversy, declared the Imperial German embassy in St. Petersburg to be the document to "genuine" German artists, namely those of the Secession and the Werkbund. The attempted reconciliation was short-lived, however, and accompanied by continued suspicions, the final one being "pre-fascism." The efforts of the avant-garde to identify with contemporary political forces also failed on an international scale, as is evident in the Palais des Nations in Geneva, the Peace Palace in The Hague and the Palace of the Soviets in Moscow. There, those searching history for easy assurances reaped the benefits.

The freedom of art in the twentieth century included the Reichstag, until now, only in the imaginary veilings by Bruno Taut, the exposures by John Heartfield and Kurt Tucholsky, and the suggestions for architectural alterations described above. Consequently, the Reichstag has become a monument whose message has been negated or forgotten. It has not been able to assert its true function as the location and symbol of a German parliament. Christo and others can reduce the Reichstag's disastrous artistic deficit and, by risking an offensive artistic art, return their voice to these maligned stones.

This article first appeared in the exhibition catalogue *Christo: Project for Wrapped Reichstag, Berlin,* Annely Juda Fine Art, London, 1977.

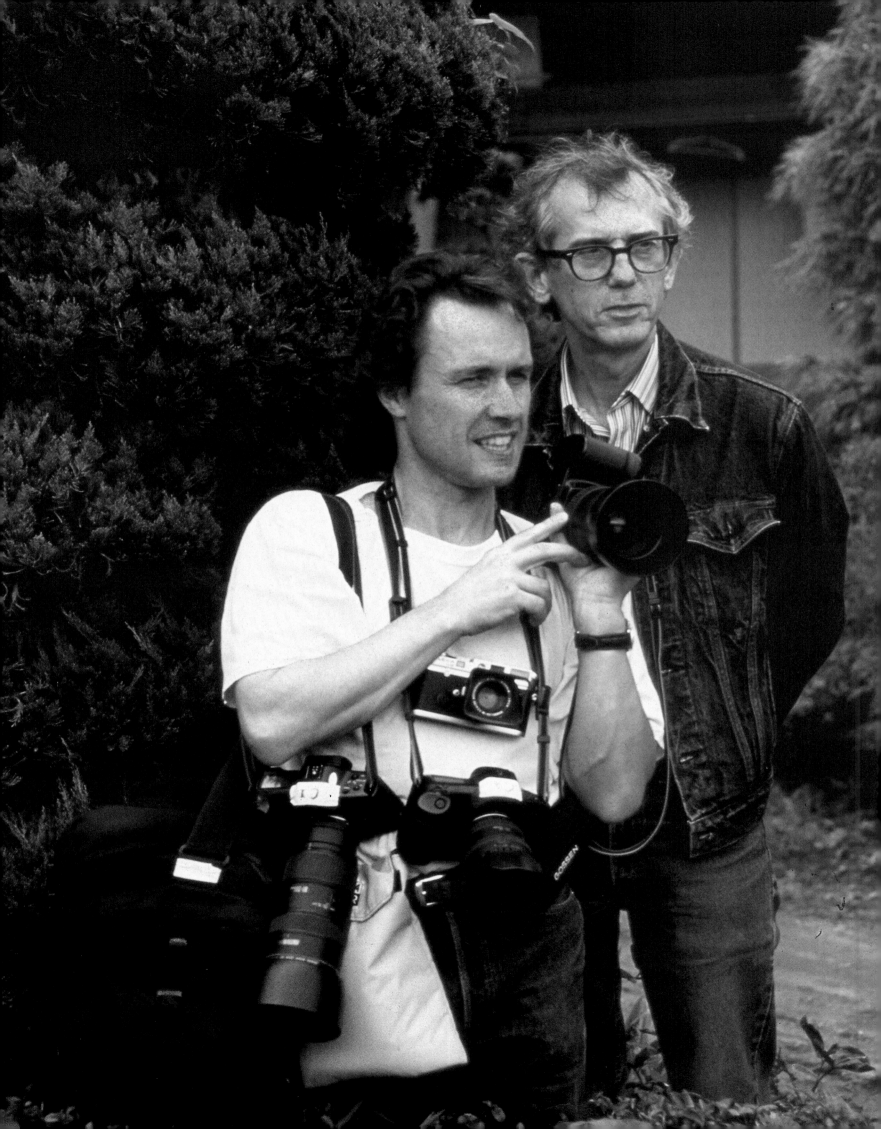

Masahiko Yanagi **Interview with Christo**

This interview was conducted in 1986 in connection with the exhibition "Wrapped Reichstag, Project for Berlin" at the Satani Gallery in Tokyo, and was published in the exhibition catalogue. (It is reprinted here by kind permission of the author.) Although the political conditions associated with the project have changed in the meantime, the interview is a significant document providing evidence not only of the artist's working methods, but also of the complex problems he was confronted with in attempting to implement the *Reichstag* project. Further developments since 1986 are detailed in Michael Cullen's "Chronology of the Reichstag Project," pp. 31–39 below.

Christo with his exclusive photographer Wolfgang Volz, who is also coordinator of the *Reichstag* project
Photograph by Sylvia Volz

You finally realized *The Pont Neuf Wrapped, Paris, 1975–85,* after ten years of preparation. Do you consider your work of art to be solely the object, in this case the wrapped bridge, or the entire process, including the ten years of preparation, with the object – the wrapped bridge – as its climax? Which is your art?

They are mixed together. You cannot have ten years of preparation if you don't have the final object. If it was only the proposition to wrap the bridge, without really wrapping it, there would not have been ten years of preparation. The people who were refusing the project and the people who were helping, they had to really truly believe that finally we would wrap the Pont-Neuf, the real thing. Now, when I say that it all is the work of art, it is basically that I see my projects as having two major periods or steps. One I like to think of as the software period, and the other as the hardware period. The software period is when the project is in my drawings, propositions, scale models, legal applications, and technical data. That software period is the more invisible, because there are only projections of how the bridge will look. This is different from an architect or a bridge builder, for example, who can refer to previous skyscrapers or bridges, and they can make their work look about the same. But because we had never wrapped a bridge, this proposition was unique, even for us. Although we make careful studies and scale models, we never really project how the work will actually look. In this software period, the work of art accumulates many things. Really, how the bridge would look at the end was not defined in 1975, when I had the idea. Formally, the crystal-clear vision of how the wrapping would look was not shown in the first drawings, which were clumsy and simple, while the final realization was the refined idea after ten years of work. What I would like to point out is that the creative act of making the final object is neither an isolated situation nor an abstract phenomenon. The realized work of art, *The Pont Neuf Wrapped,* is the accumulation of the anticipation and the expectation of a variety of forces: formal, visual, symbolic, political, social, and historical. This is why when we arrive at the hardware period – the second part – the physical making of the work is probably the most enjoyable and rewarding, because it is the crowning of many years of expectation. The hardware period is very much like a mirror, showing what we have worked at; and

more than that, the final object is really the ending of that dynamic idea about the work. This is why I see the entirety of these ten years as a creative period. The object is really the purpose of all that energy and effort, because if it were only an intellectual exercise, there would never be the resistance, the yes-and-no and give-and-take situations throughout these ten years. There's so much projection and imagination that certainly when we start to move onto the site for the physical work, it is very satisfying.

When you started the *Pont Neuf* project, did you ever expect that it would take a decade to realize? In general, how sure are you of realizing a project?

I never know in advance, but I do always propose work that has a chance to be realized. I do not propose utopian projects for which I am sure I will never get permission, or which are physically impossible. This is why the projects may look very difficult, sometimes even absurd, but they are not really. They are feasible, but stand at the limit between the possible and the impossible. We expect to encounter fearful problems and the chance that we will fail. All that gives excitement and energy to the project, because of the doubts. It is really like an expedition, going through the enormous amount of references and new elements. Each project has its own history, which is impossible to know in advance. The same thing with the *Wrapped Reichstag* project. During the fourteen-year history of this project, its many dimensions and levels have been revealed. This is why I don't like to accept only one interpretation. When we start a project, some wise people try to teach me their own interpretation. But these various reasons are only little facets of the magnitude of the site, the space, the street, the building's meaning. In a way, now is probably the most refreshing time with the new *Project for Japan and USA* [*The Umbrellas*], because this is the most fresh and sincere period, when everybody knows better than everybody else. The project is just a year old now, and after many years it will be curious to see all this in retrospect. Certainly I try to listen to everybody's advice, to avoid unnecessary aggravation, frustration, and problems; unfortunately, we never discover right away the roads and the manner in which we can get the permits. Probably the most important thing when we start a project is to keep the naive, almost childlike desire to do the object, and not to be changed at any moment or blocked by mature and serious thinking, because that will only damage the enthusiasm and our vision of the work. This is why, if you ask me whether we would really do the project, even foreseeing all the difficulties . . . I could not answer you.

In the past, you have abandoned several projects. And in the case of *Wrapped Monument to Cristóbal Colón, Project for Barcelona,* you abandoned it even after getting permission.

This is the only project I've abandoned after getting permission. Other projects I abandoned because I did not get the permit, or I lost interest, such as the 1968 *Wrapped Trees, Project for the Champs Elysées, Paris* or the 1967 *Wrapped Building, Project for Allied Chemical Tower, Number One Times Square, New York.* I do projects only if they are inspiring for me. I am excited about *The Umbrellas, Project for Japan and USA,* and I'm excited about the *Reichstag* project, but at some moment things might shift. For example, in 1981, I was very depressed after the refusal of the *Reichstag* project. We were having terrible problems with *The Gates, Project for Central Park,* and I was just advancing with the *Surrounded Islands, Biscayne Bay, Greater Miami, Florida, 1980–83.* I was ready to abandon the *Reichstag* project, but many people, including the former chancellor, Willy Brandt, told me that dropping the project was no longer only my personal decision, and that I should consider the many people who were helping make the project happen. It was very gratifying to see that, even though I was fed up and depressed, there were so many people with me, and that there was still a slim chance of getting permission.

Have you ever considered resuming an abandoned project if, over time, the circumstances have changed?

No, but it could happen, it is not impossible. Some old idea could become inspiring again, but for the moment it has not happened. Many people forget that I work for a long time on these projects. Last year a number of writers were saying, "Now Christo is working in the city," forgetting completely that the *Pont Neuf* project was first planned ten years before. And probably when we do the *Reichstag* project, many won't realize that it took over fourteen years. If an idea was valid to me in 1960, it might still be valid today. I truly don't know.

I would like to ask you about the *Wrapped Reichstag, Project for Berlin.* The suggestion to wrap this historic building came from Mr. Michael Cullen in 1971. What was your first reaction toward that proposal?

First, I had a special interest in Germany, because I had my first one-man exhibition in Cologne in 1961, and since 1958, I have had a great number of collectors, museum people, critics, and friends in Germany who are interested in my work. So there was a natural relationship with the German art scene and German culture in general. Also, in 1968 I did a large project in Germany, the *5,600 Cubicmeter Package, documenta 4, Kassel, Germany, 1967–68,* which was the first technically complicated work, and one of my first large, structural projects, involving a great number of permits and, of course, the fabulous help of German factory engineers. The first inspiration about Berlin was actually related to something I did in Paris. In June 1961, I had an exhibition in Cologne. During that same summer of 1961, the Iron Curtain, the Berlin Wall, was installed. I was still a stateless refugee, without a passport or nationality, and I was dead scared. When I came back to Paris, I

did my poetical interpretation of the Berlin Wall: the *Iron Curtain Wall of Oil Barrels, 1961–62,* a temporary wall of 240 oil barrels closing the Rue Visconti. In a way, I had a lot of links with Berlin, even though I didn't go to Berlin until 1976. In 1971, I was in Colorado working on the *Valley Curtain, Rifle, Colorado, 1970–72,* and Michael Cullen sent me a postcard proposing the project in Berlin. I remember that I was very interested right away. We met Michael for the first time in Zurich in the fall of 1971. Being out in nature working in the mountains of Colorado, I had a very great sense of urgency to do an urban project. In 1970, I did two projects in Milan: the Vittorio Emanuele and Leonardo da Vinci wrapped monuments. It is a constant interest of mine to use a focal point in a city and temporarily transform it in my way. The idea to go to Berlin and to work on the *Reichstag* project was so much more inspirational because of my links with Eastern Europe, and I was in some way expecting that finally I would do a project that could be visible from both East and West Berlin. This is why we were so keen right away on the *Wrapped Reichstag,* because that building is the only structure which is under the jurisdiction of the four Allied forces: the British, Soviet, American, and French military forces, plus the two Germanys, East and West. The building is of paramount importance to the German nation and to European history, and it is dramatically related to what Germany is today. The building is physically on the edge of Tiergarten park, and by being remote from the center of West Berlin, it projects itself on the two Berlins: on one side, you have East Berlin, completely restored with communist, Stalinist architecture, with its faceless facades and empty avenues, and in West Berlin you have the very flamboyant, Western architecture, skyscrapers of steel, glass, neon lights, and so much life. The Reichstag is a significant building, and visually the wrapping can be rewarding. Another aspect of the project is all the interrelations I would trigger. I would provoke direct discussions by getting the permits from both sides: from East Germany and the Soviets, and from West Germany and the three Allied forces. I don't know if you remember what was happening in the early 1970s. It was the time of detente, the end of the Brandt administration (Willy Brandt was very much the starting force of East–West relations), West Germany's involvement with East Germany was getting better, and that was a good indication that we could succeed in getting the permits. But we really didn't begin to work seriously on the *Reichstag* project until 1975.

You have just mentioned that you were interested in the city of Berlin because of its political implications. Before the Reichstag *project, had you thought of any other project for Berlin?*

Yes! You will be very surprised that one of the first *Running Fence* ideas was to have a *Running Fence* just along the Wall, and there are some drawings from between 1970 and 1972 of a fabric fence in West Berlin, running for 25 miles hiding the Wall . . . that was my first project for Berlin. I abandoned it because it wasn't really

doing anything to engage the East Germans on the other side of the Wall, because basically it was almost the same as building a fence, which was a repeat of the Wall, but entirely in West Berlin.

Long before you started the Reichstag *project, as early as 1961 when you created the manifesto "Wrapped Public Buildings," you proposed wrapping parliament buildings, along with museums and concert halls. Were you interested in parliament buildings as symbols of politics and political systems?*

I mentioned a parliament building basically because it is the most public building. A concert hall can belong to the concert society, and a museum to the museum society, but a parliament building belongs to the nation. It is the optimum, because it represents the truly public structure.

Still, can you say that this proposal is the origin of the Reichstag *project?*

Certainly, the *Reichstag* project is the final stage of those propositions. In 1961, when I did the *Project for a Wrapped Public Building* photomontage, the idea was to do something that would relate to many people. Unfortunately it was impossible to do it — I was too young and didn't know many people. It was natural that the first public building I wrapped was the Kunsthalle in Bern, because only art lovers or art professionals could understand my proposition and give me the go-ahead to wrap the museum. If you go through the history of my work, the only two large buildings that I wrapped were the Kunsthalle in Bern and the Museum of Contemporary Art in Chicago. The Reichstag will be the third building in this long line of proposals. The *Reichstag* project is much more than simply the wrapping of a public parliament, because it has many apparent problems; it is not the same thing as if we went to wrap the Capitol in Washington or the Palais Bourbon in Paris.

The Reichstag *project takes place in the midst of a large city. Are there any basic differences between urban projects and rural projects such as* The Mastaba of Abu Dhabi, Project for the United Arab Emirates, *the* Running Fence, Sonoma and Marin Counties, California, 1972–76, *and* The Umbrellas?

There are important differences. The space of the Reichstag is a very organized physical area. The avenues of East Berlin, the boulevards around the Tiergarten, the big open lawn in front of the building, the Wall along the east facade, the Spree River, all that is very confined and organzied, as with the Pont-Neuf. There is much more geometry and a formal character, which is different from projects like *The Umbrellas* or the *Running Fence,* which have a much more organic quality . . . rolling hills, etc. Even though it is not urban, *The Mastaba* is related, however, to the landmark dimension, and therefore can in some way be associated with the *Reichstag* project. It is one huge entity, functioning not as an object but as a focal point. *The Umbrellas,* the *Surrounded Islands* and the *Running Fence* use much more of the linear dimension, or length, which is immediately involved with space, distance, time . . . spending minutes, hours walking and driving. In that way, the space which is manipulated in that area can be either rural or

suburban space. It is less rigid, more accidental and varied. There is another important part of The Umbrellas project which can in some way be compared to the Running Fence. It is a module which is repeated several times. The Umbrellas has the physical dimension of the promenade . . . to see the project you can drive or you can walk: access to the project is by going through or around the objects, while with the Reichstag it is one single physical presence. It is almost magnetic, metaphysical – each of the four walls is very different, but still there are these four walls. With The Umbrellas we have an inner space; you go underneath, in the shadow of the umbrellas, and we have the structural transparency of the fabric creating a roof. That is a different special physical use and experience from those of the Wrapped Reichstag. The very essence is about architecture: inside the wrapped structure, there is architecture. It is strongly linked to urbanism and to the perspective of the city: streets, avenues, openings.

What is the Reichstag building used for now?

The building was in ruins until the 1960s. It was restored – most of the furniture is by Mies van der Rohe – and designed to be a large congress hall. Of course that made the Soviets very nervous. Their worry is that West German parliamentary activities might take place in the Reichstag and would begin the unification of Germany. This is why the Soviets insist that the building should not have a political use, but only be available for cultural gatherings and nonofficial meetings of the visiting German federal government. When Berlin was divided in 1945, extensive regulations were written, the size of a telephone book: how things should be done in the city, and how the people should move in Berlin, and how the Soviets can go to West Berlin . . . you can see Soviet officers in cars circulating in West Berlin, the same way the American army circulates in East Berlin. Often the German chancellor or president takes foreign visitors to show them Berlin. When Chancellor Schmidt wanted to take the Italian prime minister too near to the Reichstag, a Soviet jeep blocked the cortege because the Soviets felt that the chancellor approaching the Reichstag with officials would be too closely related to the idea of pre-war Germany. It is a delicate balance, always dependent on international relations – if the international political situation is less tense it will be less difficult to get permission. Right now in the building, there is a restaurant and a permanent exhibition on the history of Germany since the Napoleonic period, with photographs, documents and realistic, three-dimensional installations showing the destruction during the war, etc. There are hardly special events, nor is the building used much for other purposes.

To realize this project, from whom do you have to obtain permission? Who has the right to make the final decision?

It is very intricate. Twenty-eight meters of the east facade of the Reichstag are in the Soviet air-rights sector, but the upkeep of the building is done by the West German government. It is almost like an extension of the Bonn parliament in Berlin. This is why all the money for the expenses of the Reichstag is given by Bonn, not by the city of Berlin. Juridically the person responsible, the landlord for the Reichstag, is the president of the Bundestag in Bonn, the parliament of the German Federal Republic, who in the American sense would be something like the vice-president or the Speaker of the House. He is the second person in the political structure in West Germany. First there is the president of Germany, then the president of the Bundestag, and third the chancellor. The president of the Bundestag is the only one who can give the final permission because the Reichstag is mostly in West Berlin. That is the so-called "official way," but because the Reichstag is located in the British military sector, the West German government is obliged to ask the point of view of the British who automatically pull together the French and the Americans to discuss the okay or refusal. Being also in divided Berlin, the British, Americans, and French are obliged to inform, or discuss the east facade of the building with, the Soviet army headquarters in East Berlin, and of course, the Soviets will be obliged on their part to discuss the matter with the East German government, whose capital is East Berlin. Now this is how the thing is done.

In order to obtain permission, you've been talking to many politicians of foreign governments. Do you ever receive any assistance from the United States government in negotiating with foreign governments?

Certainly. For the project in Berlin, we tried at a difficult moment to get some help from Washington. This was our naive idea which did not work very well. In the summer of 1977, we had the first official refusal for the Reichstag project, and I was terribly disappointed. The Running Fence was completed, Carter had been elected, and at an exhibition which I had in Washington at the Corcoran Gallery, I asked Mrs. Mondale, who is a friend of the arts, if Vice-President Mondale could provide help for the project. But, ultimately we discovered many months later that it did not help anything. Then we understood that Germany is a financial giant, but is often called a political midget; Germany is not officially recognized as a world power, like England or France, in political negotiations. By being so powerful economically, Germany has an incredible influence over Eastern European countries and the Soviet Union, because it is the biggest funnel of hard currency to the Soviet bloc. West Germany uses Polish, Hungarian or Czechoslovakian workers in the same way America uses Hong Kong, South Korea, and Thailand: for cheap labor. All that makes the leverage of the West German industrialists extremely important. Instead of going to Washington for help, it is much better to have the support of West German financiers, businessmen, and industrialists, because of their strong influence on the East bloc. This is why in 1978 we created the Kuratorium für Christos Projekt Reichstag (Board for Christo's Reichstag project) in Hamburg,

made up of thirteen leading West German citizens from all kinds of fields, lawyers, businessmen, scientists, industrialists, and bankers, to help us translate my idea to Bonn and to the Soviet bloc. *They* are really doing our work to bring about the understanding that will lead to getting the permit. Also, in the mid-1970s, when things were going badly, just before the refusal, we tried to go to the chief of the American mission in Berlin, who is a civilian, and to the French and the British, to ask them to give some opinion or make some statement to influence or encourage the West German government to give permission. Unfortunately, the Americans, the British, and the French refused to make any statement. They said that they would await the decision in Bonn, and after that they would give their opinion in a statement. We learned later that the Allied forces would go along with anything the West German government said. That was our problem, not having understood that to build favorable support we should have worked with these people simultaneously, before approaching negotiations. Really, that was the biggest mistake.

Although the Reichstag is physically located in Berlin, permission can come only from Bonn. Does this mean that people in Berlin have very little influence on the decision to allow the project?

The city of Berlin is not only a city, it is also a state. The German Federal Republic is a federation of states, such as the state of Bavaria. The mayor of Berlin is like a governor, with his own ministers. It creates a very unusual situation because Berlin, as a city-state, has direct power, just like all the different federal states represented in Bonn. It is also obvious that, since Berlin is the former capital of Germany, the lordship or mayoralty of Berlin is often a stepping-stone to the chancellery; the mayor is always aspiring to become chancellor or president. Therefore the mayor's attitude towards my proposition is very important. We knew that from the beginning, even before we ever went to Bonn, and we tried to have the mayors of Berlin, all five in succession, on our side. We are unusually optimistic now because since February of 1986, for the first time, we have the majority of the senators in favor of the project (the mayor of Berlin has several senators, for industry, finance, arts, building, police, etc.). We never before had so great a majority and the support of the mayor himself. This is why we are very confident that the decision of the Berlin Senate to support the project will have an impact on Bonn. In that way we can make Bonn think much more seriously about our proposition. Also, I should mention that right now there is a group of German people, most of them without connections to us, who are organizing a committee in Berlin: *Berliner für den Reichstag.* They are collecting signatures, they have tables in the airport, the banks and in the streets, and they hope to collect half a million signatures in Berlin by the end of the year. They are young people and students and business people, all kinds. This is part of the push that the people who are for the project would like to make just before the final decision.

As with all your other large-scale projects, there must have been a lot of antagonism and objections toward your proposal. Could you give some examples? I am especially curious about the Soviet Union's response.

When the project became known in the mid-1970s, there was a lot of writing, even an editorial in *Pravda* against the project. Of course, the Soviets said that the *Reichstag* project was an American decadent stupidity and a frivolous imperialist intervention in Berlin, and it would be better if the Americans would spend money for the workers or the poor, etc. Of course, they didn't see that the project had any importance for art. Their criticism of the *Reichstag* project was used mostly for internal propaganda. Even though one of our Kuratorium members spoke with the Soviet ambassador a few month ago, I think the Soviets will still criticize the project, though more likely they will ignore it. Permission-wise, they really don't care. This is not the only time. Soviet television was saying about *The Pont Neuf Wrapped* that I was not an artist. They called me an American businessman who was wrapping the Pont Neuf to make millions of dollars selling T-shirts and post-cards, which I never do. This is the current Soviet opinion about all of my projects; it was the same about the *Running Fence* and the *Valley Curtain.* It is quite curious to see that, when the project was refused in 1977 by the conservative president of the German Parliament, Dr. Karl Carstens, his objection was exactly the same as that of one of the liberal writers, Günter Grass. Oddly enough, they managed to agree on the *Reichstag* project. *Their* main objection was, "Our duty is to keep *all* Germans united, and if there is a political division between East and West, at least we should keep a German cultural unity." They believe, as many Germans do, that people in East Germany have no knowledge of contemporary art and that they would not be able to understand my interpretation of the former parliament of Germany. This is not true because West Berlin television programs are seen in East Berlin, television waves cannot be stopped, and the East Berliners are aware of everything in the free world. In addition, many West German art historians go to lectures in Leipzig and Dresden. In December 1985, when we were in West Berlin, we had a very ferocious meeting with some newspaper editors and political writers who still say that the wrapping of the Reichstag will hurt the feelings of the Germans. And there is no way to change their minds, except by our proving that a majority of Germans would like to see the building wrapped.

In addition to its political implications, are you interested in the architecture of the Reichstag?

I will wrap any building that is *there.* The building is not extremely interesting in itself. It is a typical Victorian structure, built by a prominent but not great architect, Wallot . . . It is a strange and awkward building. It runs 445 feet on the east and west facades, and for that length it is extremely narrow, only 317 feet. It has four towers and an enormous amount of reliefs and statues. By cutting the facade in many horizontal levels, all its 140 feet in height is

completely lost, and it appears squashed. When the building is wrapped, you will see much more of the structure's height. Bismarck laid the cornerstone, and actually the Reichstag started to function in the late nineteenth century, but neither the Kaiser nor Bismarck were ever interested in the building. The Reichstag was used as a truly democratic parliament only during the Weimar republic.

Could you continue with the history of the Reichstag?

Before the end of the war, the center of the city of Berlin, with the ministries, the universities, the theaters, and the Bauakademie [Architecture Academy] was in what is today East Berlin. The east facade of the Reichstag looks to what is now East Berlin. All members of the parliament, ministers, and civil servants would enter the building at the south facade – from the direction of the Brandenburg Gate – while the west facade, facing the Tiergarten, was only used for ceremonial purposes. Because Bismarck decided to make it an imperial capital, Berlin was one of the best planned nineteenth-century cities, with fabulously long avenues such as the Unter den Linden, with the Brandenburg Gate just 500 feet from the Reichstag. The Reichstag is completely linked to this idea of the German empire. A famous German poet said, "The inside was built with such dark furniture and wooden walls that I'm not surprised that German politics is so dark; there's no light in the building." Philipp Scheidemann, the first minister president, proclaimed the Weimar Republic from the window of the Reichstag. That was the start of one of the most dramatic moments in German history, because it was followed by the arrival of the National Socialist Party and Hitler. The infamous fire in the Reichstag, instigated by Hitler in 1933, which destroyed the dome, was the signal for the Nazis to start to persecute the progressive elements and the Jews, and organize the trial in Leipzig. In that trial, the accused were a Dutchman and, curiously enough, a Bulgarian named Dimitroff. After the fire, the Third Reich parliament met in the Kroll Opera House across the large lawn . . . Then in 1945 the Reichstag was terribly damaged in the Battle of Berlin. The Soviet general made it a point to take the Reichstag. The building was not a valuable strategic point during the battle; only symbolically was it important. There was a Nazi commando which was defending the building and apparently hundreds of Soviet soldiers died during the fighting which proceeded step by step, and floor by floor, inside the building until finally the Reichstag was taken over. There are actually two famous photographs: one showing a *Katyusha* missile launcher with one of the bombs inscribed by the hand of a Russian soldier with the words "To the Reichstag," and the second one of a Soviet soldier at the top of the Reichstag hoisting the Soviet flag. The Reichstag remained in ruins until the 1960s, and finally the West German government made an agreement with communist

Germany to restore the building, which they did at a great cost. But they did not rebuild the dome.

Had you known about the Reichstag before you started this project?

I knew a little bit about the Reichstag because of the Bulgarian, Dimitroff, who became the first president of Bulgaria after the Second World War. But I was not really familiar with the building itself until I started to work on the project.

In what season do you want to wrap the Reichstag?

When we do a project, not only the *Reichstag* project, we try to do it during the most pleasant period of the year. It would be very sad and confusing if we were to do the wrapping during the cold, windy and miserable winter. The ideal is to have it in good weather, starting from the late spring to early fall. For the moment, we have had a talk with the mayor of Berlin, Mr. Eberhard Diepgen, and we hope the date is going to be sometime in late June or early July 1988. The summer in Berlin is very active. Berlin is like an island, and the Berliners cannot go to the countryside because the city is surrounded by East Germany. Most of the Berliners use the parks and the open public spaces during the summer. Ideally, to do it when the Berliners are outdoors would also involve the East Berliners who can also see the building. Also, for technical reasons, since much of the work will be fabricated off site, and the roof of the building will become our working platform, we need to have good weather.

How long will the Reichstag be wrapped?

Like *The Pont Neuf Wrapped,* the *Running Fence,* and *Surrounded Islands,* we would like to have it wrapped for two weeks.

Do you think that if you kept it wrapped for a longer time more people would be able to experience it?

My creative process ends when the work is completed. Probably, it can stay longer, but it is too expensive. I cannot be involved with the housekeeping of the project for more than two weeks. It could easily stay a month or two, but it becomes extremely expensive for us and we can plan our projects and our costs up to a point, after that it is pointless.

When the building is wrapped, what is going to happen inside?

We don't want to stop the use of the building. The West German government will be involved with the wrapping of the building, and probably won't use the building for anything except the current exhibition and the restaurant.

I believe the wrapping of this large building will be an enormous undertaking. How much are you usually involved with the technical design of the actual wrapping?

Very much. In some way, all the time, because nobody knows how to wrap a building, even I don't know. Curiously enough, with the *Reichstag* project we have advanced very far in the technical procedure, because in 1984–85 there was a chance that we could do the *Reichstag* project before the *Pont Neuf* project. Our American engineers often went to Berlin. We spent many days there doing technical studies. I have made several scale models, including an engineering scale model. Then there was another confusing political failure. However, much of the general idea of how it is to be wrapped is already quite clear. When we do an urban project, we need to create a working area. In this case, it could have been on the side of the building, but not the east facade, because it would require putting cranes in Soviet territory, which is impossible. For the east facade, we will be obliged to work from the roof, which is why we have decided to do all the work from the top. Because the roof is a fragile area, with glass and asphalt, we need to build a second roof on top of the roof of the Reichstag, almost like a scaffolding covered with wood. The fabric will be hoisted to the roof, folded in protective cocoons, and we will have our workers up there. That is the rationale of why we decided to have the fabric on the top of the building and by simple gravity let the material down with less interference from the public traffic around the building. We will use a number of methods which worked well with the *Pont Neuf* project; we will install cables under the fabric and also at the bottom. This was not sure in 1984–85 when the engineer designed that system, since we had not yet tested it in the *Pont Neuf* project, but with the wrapping of the bridge in Paris we saw that the cable system supporting the fabric from underneath was clever and ingenius in that it was not more expensive, but was quite fast and easy to install, very light and also appropriate to secure my ropes. With the Pont-Neuf street lights, we had to cage them at the top under the fabric; those lamps were relatively small, but with the Reichstag we will need to build enormous cages for all these huge, sculpted stone soldiers and urns to protect them. Formally, I would like to transform the shape of the building, which is extremely broken visually, and I would like the building to have a more general and simplified shape. All that will take some time to prepare. That will be done in a factory in advance, and then brought to the Reichstag.

What kind of material are you going to use, and what color will it be?

Different from the rather light woven nylon used for *The Pont Neuf Wrapped,* the fabric for the *Wrapped Reichstag* will be a much thicker fabric, coated with PVC, a heavy material. Coating the fabric will make it very much like the material I used for the project in Kassel, the *5,600 Cubicmeter Package,* making the folds much

stiffer and angular, very much like a Gothic sculpture — with more broken shapes, not rounded. The fabric will be extremely structural and less refined than in *The Pont Neuf Wrapped.* It will be in a silver metallic color, like the frosted metal of automobiles. The fabric I used for the latest scale model is not exact, but already gives some idea of the material, because it is not white. For the early collages and the first scale model I simply used white cloth. The metallic-colored material will magnify the contrasts between the highlights and the shadows. In that way, it will be very strong visually, because the sky of Berlin is always cold blue or gray. I think it will be very beautiful with Berlin's metallic sky.

Listening to your detailed explanation about the actual wrapping, and having looked at beautiful photographs of your previous projects, it is evident that you pay a lot of attention to how the actual wrapped object will look. How important is the visual or aesthetic aspect of your project?

Very important. It is everything, that's how important it is. After the *Pont Neuf* project, many people were surprised to see how the work was different from what they had envisioned, because they had assumed I would wrap the Pont-Neuf in the ugliest way. We were curious to see that many people were not aware that the fabric would be visually gratifying, very beautiful and intensely strong. I am conscious of how much excess fabric is required for the folds to be distributed harmoniously, of how the energy of the folds and the gravity of the fabric will be translated. All those details are a very important part of the way I plan my project. Often people are astonished when they finally see my realized work of art, because they haven't taken a careful look at the drawings, or may have never looked at the drawings at all. They've only heard that Christo is going to wrap a bridge, or make a fence. Certainly with the *Reichstag* project, I want very much to go beyond the early scale model propositon and drawings by using a much richer and fuller material. But I am not yet sure how I want the sections of fabric to be sewn (there will be special sections for the facade and for the towers), or how the fabric will be distributed around the sculptures and walls. It is not yet clear, this is why we need one-and-a-half years of lead time to go into production with the real materials. A lot of details have to be taken care of so that the completed project can be visually rewarding.

Since you did *The Pont Neuf Wrapped* last fall, the *Reichstag* project is the only wrapping proposal in progress. Does this mean that you are losing interest in wrapping?

Formally, the *Reichstag* project is related to my ideas of the 1960s. I cannot say whether I will or will not wrap anything else in the future. Probably the wrappings represent one of the most significant periods of my work. The wrapping project which was broadest in scope, scale, and the elements was the *Wrapped Coast, Little Bay, One Million Square Feet, Australia, 1969.* An additional aspect of the *Reichstag* project is in its being a public building, a part of architecture, not civil engineering, as in the case of

The Pont Neuf Wrapped. Therefore, the *Reichstag* project has an enormous significance for me, with the scope of what we discussed before, my early 1960s propositions for *Wrapped Public Buildings.* Certainly the *Reichstag* project is the culmination of that idea. I cannot say that I will never again cover something with fabric, but for the last fifteen years, the projects which we realized, from the *Valley Curtain* to the *Running Fence* and the *Surrounded Islands,* and hopefully now *The Umbrellas, Project for Japan and USA,* are formally very different and go beyond wrapping or covering.

What do you usually do with the fabric after a project?

It is not only the fabric, it is the cables, the steel . . . We donate it so that it is recycled for all kinds of purposes. In California, we distributed the materials to the ranchers, and in Colorado to the highway department. The fabric for the *Pont Neuf* project is still in Basel, Switzerland, but we are going to give it to the charitable organization *Action Internationale contre la faim* for refugees in Pakistan and Bangladesh. In this case, we can give the fabric but we cannot pay for transportation, and for the moment I think the relief fund is having problems finding someone to transport it from Switzerland.

I have recently found an old advertisement selling fabric from the *Running Fence* with photographs.

People do all kinds of things. Several of the ranchers sold the fabric and the poles. There was also an incredible man in Paris who bought postcards of *The Pont Neuf Wrapped* and put French postage stamps on the front, and had the post office stamp them with the cancellation day of *The Pont Neuf Wrapped,* and he sells these postcards with the permission of our photographer, Wolfgang Volz. There have been all kinds of commercial endeavors, some with permission, some without. Sometimes we try to stop them if they are not really good, but sometimes it is difficult, and we discover these things only later.

As with your previous projects, your are going to finance this one entirely by yourself. What is the reason you strictly refuse outside sponsoring or funds?

For many reasons. The first is very basic: I would like to keep my freedom to do what *I* want to do. By keeping that freedom, I retain my intellectual individuality, and in a pragmatic way, also total financial control. I don't know how much the project will cost. The final cost, one-and-a-half or two years from now, is one thing, but if you calculate how much money we've spent on engineering, traveling, going and discussing the project for over ten years, who would pay us back for that? Because it is my idea, my decision, I don't think any others can be involved with that project. It costs so much of my life and my blood that I don't want to give one millimeter of credit for that project to anybody else. If we do the *Reichstag* project, no money can buy the wrapping of

the *Reichstag,* even if they pay all the 1988 costs, because it is nothing compared to the idea, the effort, the energy, and the importance of that project for me and the people who have worked for years towards that project. This is the reason why, for example, I would not like the wrapping of the Reichstag to occur during any other significant event in Berlin. Next year is the 750th anniversary of the founding of the city of Berlin, and I made it clear to the authorities and the West German government that the wrapping of the building will not take place at that particular moment. It is very important that the building have its own dimension, its own calling, its own time, not related to any other event. That involves physical, visual, and economic freedom. By doing this project myself, I really keep my integrity. On the other hand, there is no way anyone else can be involved with a project like this. In 1972 when we started the project, there were so many people against it that no foundations, government agencies or institutions would want to be involved with something so controversial, doubtful and difficult. Yet all of that is part of the reality of my project. The subversive dimension of my work usually makes people not want to be engaged with it.

In Paris last year, some collectors who were there to see *The Pont Neuf Wrapped* commented that they were very pleased to have bought your drawings, since part of the wrapped bridge was financed by their purchases.

Of course, I think so too. There are hundreds of friends, collectors, dealers. I think it is very important that they know that — more people should know that. I can only do these projects because I have people who buy my work. Certainly, we always recognize that without them I would never be able to do these projects.

Have you had any exhibitions of the *Reichstag* project?

In 1977, there was the first *Wrapped Reichstag* exhibition at the Annely Juda Gallery in London, and in 1978 I had two small exhibitions about the *Reichstag* project in museums — one in Zurich, and one in Brussels, with a scale model, photographs, collages, and drawings. These small exhibitions were not as complete as the Annely Juda exhibition. Then there was the first refusal in 1977, which was followed by the second one in 1978. The exhibition at the Satani gallery is important in updating my project, because this is the first time since 1979 that we are having a show about the *Reichstag* project.

What is your purpose in having an exhibition of a project in progress?

There are many reasons. You should understand that when I do an exhibition there are partly financial reasons, but more importantly it is a means of applying pressure on the German people about the significance of the project. For example, recently the minister of culture of Cologne came to see some of my drawings, and I told him that there will be an exhibition of the *Reichstag* project in Japan. And he said, "What's this? In Japan? Who is interested in the Reichstag in Japan?" And I was happy to tell him, "I made the Japanese people interested in the Reichstag. No Germans ever did that, but I, Christo, did that." That pressures the Germans vis-à-vis the international image that the project has, which is beyond the boundary of German politics and culture. This is why I am very eager to have the catalogue and broad public attention for this exhibition just a few months before the final decision is made in Bonn. There will be elections in Germany in January 1987, and the decision about the *Reichstag* project will probably be made just after that. I hope that having the *Wrapped Reichstag* exhibition in October 1986 at Satani Gallery in Tokyo will be very instrumental in generating support. The last time my work was shown at Satani Gallery, it was about the *Pont Neuf* project, just a few months before getting the permit for Paris. It could well be that the good omen will repeat itself for Berlin.

Christo and Jeanne-Claude Christo in front of the Reichstag in Berlin, 1993. Photograph by Wolfgang Volz

Michael S. Cullen **Chronology of the Reichstag Project (1971–1993)**

1971 **August** While working in Rifle, Colorado, Christo receives a postcard of the Reichstag from Michael S. Cullen, an American living in Berlin, suggesting that Christo wrap the Reichstag.

November Jeanne-Claude Christo, the artist's wife and collaborator, sends a letter to Cullen informing him that the artist is interested in the idea, but is at this time concentrating on the *Valley Curtain* project.

December Christo and Cullen meet for the first time on December 4th in Zurich. Christo decides that permission should be obtained before working out the technical problems. The spring and summer of 1973 are selected for the realization of the *Wrapped Reichstag, Project for Berlin*.

1972 **Spring** The artist makes the first drawings of the *Wrapped Reichstag, Project for Berlin*.

August Christo realizes *Valley Curtain, Rifle, Colorado, 1970–1972*, and starts his *Running Fence* project.

1973 **Fall** Cullen establishes an office for the *Reichstag* project at the Bethany Art House (Künstlerhaus Bethanien) in Kreuzberg, Berlin.

1974 **February** *The Wall – Wrapped Roman Wall, Rome, 1974* is realized.

August *Ocean Front, Newport, Rhode Island, 1974* is realized.

1975 *The Pont Neuf Wrapped, Project for Paris* is begun.

1976 **February** On February 12th, the artist visits Berlin for the first time. Christo, Wolfgang Volz (his friend and project photographer), and Cullen inspect the Reichstag, except for the towers and the roof.
Christo holds his first press conference about *Wrapped Reichstag, Project for Berlin*. He explains his current *Running Fence* project and emphasizes that he finances all his projects himself.
On February 14th, Christo meets with representatives of the Berlin Christian Democratic Union (CDU), the Social Democratic Party (SPD), as well as one of the Reichstag building administrators, Hans-Jürgen Hess. The CDU cultural spokesman, Dieter Biewald, declares his party's support for the project. No results emerge from the SPD meeting. Hess promises to arrange an appointment with Annemarie Renger, the president of the Bundestag.

Christo talking to then SPD Chairman Willy Brandt and Michael S. Cullen in
Brandt's office in the parliament building in Bonn, 1977
Photograph by Wolfgang Volz

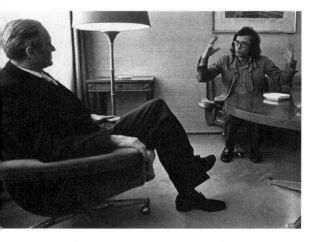

Christo explaining his *Reichstag* project to then Federal President Karl Carstens
in Carstens's office in the parliament building in Bonn, January 1977
Photograph by Wolfgang Volz

June During Christo's second visit to Berlin, he meets again with cultural spokesmen
from the CDU, SPD, and the Free Democratic Party (FDP), as well as the two adminis-
trators of the Reichstag, Hess and Edmund Mattig, on June 23rd. The three politicians
agree with Christo's idea, while the Reichstag administrators remain skeptical.
Christo meets with Bundestag President Annemarie Renger (SPD). Christo, Cullen, and
Karl Ruhrberg, director of the German Academic Exchange Service (DAAD), explain
Christo's art and show the *Valley Curtain* film by the Maysles Brothers. At this point they
are only aiming for political approval, not the actual permits. Also at this meeting, Paul
Baumgarten, the architect for the Reichstag reconstruction, welcomes the project.
Renger explains that she can't make the decision alone, the Allies also have a part to
play, and she must await the results of the federal elections in October.
After the meeting, with the permission of Renger, Christo is allowed to inspect the roof
and towers of the Reichstag.

September Christo realizes *Running Fence, Sonoma and Marin Counties, California,
1972–76.*

November As a result of the election, Karl Carstens (CDU) becomes the new president of
the Bundestag.

January Christo begins the *Wrapped Walk Ways* project for Kansas City, Missouri. 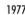 **1977**
In Berlin, Christo meets the mayor, Klaus Schütz, at the press ball on January 15th. Mayor
Schütz feels the *Reichstag* project is worth supporting. Christo hopes that Berlin politi-
cians can exercise influence in Bonn.
A vote on the *Reichstag* project in the Bundestag Presidium (Bundestag President
Carstens, and the four vice-presidents, Renger, Hermann Schmitt-Vockenhausen,
Richard Stücklen, and Liselotte Funke) on January 17th produces a negative result.
Christo attends a meeting of the Cultural Affairs Comittee of the Berlin parliament, the
senate. CDU officials actively oppose the project, seeing nothing positive in Christo's
"shock therapy," while nearly all the SPD members are in favor of it. The committee,
which, in the case of the Reichstag has only advisory powers, decides to remain silent for
the time being.
In Bonn on January 18th, Christo meets Schmitt-Vockenhausen, who opposes the project
and tells Christo that Carstens has received many unfavorable letters. During a meeting
with Christo on January 20th, Carstens tells him he thinks "as a citizen" that the wrapping
of the Reichstag is a good idea, but not as president of the Bundestag. Carstens
describes the Reichstag as a symbol of German unity. The artist counters that his work is
not meant as an insult but rather as an apotheosis and gesture of respect. They agree to
show the *Valley Curtain* film to the Presidium.
Christo meets with Willy Brandt, SPD chairman and former mayor of Berlin, who favors
the project and promises to talk to Schütz, the current mayor.

February Hans (Johnny) Klein, a member of the Bundestag Arts Committee, visits Cullen
on February 24th. Klein promises to speak with Richard Stücklen and to bring the project
up for discussion at the upcoming Arts Committee meeting.

March At the Bundestag in Bonn on March 14th, Christo presents his proposal for Berlin
and shows the *Valley Curtain* film to Carstens and members of the Presidium. Carstens
promises a decision within two weeks (the answer is actually given on May 27th).
The following day, Christo meets members of the SPD Arts Committee, who volunteer
their help. The *Valley Curtain* film is shown at the Bonn Parliamentary Society and is favor-
ably received.

West German broadcastings of "Feeding Allowed" (a radio survey) and television interviews with representatives of the SPD, CDU, and FDP indicate that a majority of Germans are in favor of the project.

April Schütz resigns as mayor of Berlin. Dietrich Stobbe (SPD) succeeds him.

May Christo participates in a panel discussion in front of a crowd at the Academy of Arts in Berlin on May 22nd.
The following day, he again attends a discussion at the Cultural Affairs Committee of the Berlin parliament. Although the majority is in favor of the project, this is not made known to Bonn.
With James Fuller and Dimiter Zagoroff, his friends and engineers, the artist meets with representatives of the Allies. They say that it is an internal German question in which they do not wish to interfere. At the restaurant in the Reichstag, the artist holds a press conference on May 24th to clarify that no tax money is required.
The next day, Christo, Cullen, Fuller, Volz, and Zagoroff go to East Berlin to speak with Günter Gaus, the permanent representative of the Federal Republic of Germany in East Berlin. He opposes the project.
Carstens formally refuses Christo's proposal on May 27th. While reiterating his respect for Christo's art, he gives two reasons: the first is that he feels the discussion surrounding the wrapping of the Reichstag has been harmful; the second, never publicly stated, is his fear of difficulties with East Berlin.
The following day, Christo declares to the press that he will not give up.

June Christo and his supporters make it clear that they are not treating Carstens's decision as final. In the Berlin newspaper *Der Abend* on June 14th, Willy Brandt expresses his hope that the project will be realized, while Carstens claims that the majority of citizens is against it.
The mayor, Deitrich Stobbe, states to the press on June 23rd that Christo's project is a "positive provocation." He writes to Cullen to arrange a meeting with the artist.
During a session on June 28th, the Berlin senate (council of city commissioners) declines either to agree or disagree with Carstens's decision.

July In Berlin on July 22nd, Christo has a constructive meeting with Stobbe.

September At Brandt's suggestion, Christo lends an original *Wrapped Reichstag* collage to Brandt's office in Bonn, on September 14th, in order to familiarize visitors with the *Reichstag* proposal. Brandt promises to urge his party colleagues to visit Christo's art exhibition opening at the Landesmuseum in Bonn.
At the press conference in the Landesmuseum, Christo states his firm intention to continue his work in Berlin. Renger gives one of the opening speeches at the exhibition "Running Fence, Sonoma and Marin Counties, California, 1972–76" in the Landesmuseum, which also includes a small exhibition about the *Reichstag* project.

October The *Frankfurter Allgemeine Zeitung* publishes an article by Tilmann Buddensieg, a revised version of which is presented on pp. 15–19 of this book. Efforts by the SPD to show the "Wrapped Reichstag" exhibition at the Schöneberg City Hall in Berlin are unsuccessful. Even though he has not changed his opinion, Carstens visits Christo's exhibition at the Landesmuseum on October 13th.
Through the efforts of Gerold Benz (CDU), Bundestag Arts Committee member, the *Wrapped Reichstag* scale model is installed for two weeks in the Bundestag lobby on October 19th.

November The exhibition "Wrapped Reichstag, Project for Berlin" at the Annely Juda Gallery in London is well attended, and reaction in the British press is generally positive.

Christo with then president of the Bundestag, Annemarie Renger, with a model of the *Wrapped Reichstag*, Rheinisches Landesmuseum, Bonn, September 1977
Photograph by Wolfgang Volz

On the roof of the West German legation in East Berlin, May 1972. From left to right: Dimiter Zagoroff, Christo, Rainer Haarmann, and Christian Nakonz. In the background, the Reichstag. Photograph by Wolfgang Volz

Meeting of the *Kuratorium für Christos Projekt Reichstag* in the office of publisher Gerd Bucerius, September 1978. From left to right: Christo, Karl Ruhrberg, Heinrich Senfft, Wieland Schmied, Jeanne-Claude Christo, Petra Kipphoff, Ernst Hauswedell, and Countess Marie-Christine von Metternich. Photograph by Wolfgang Volz

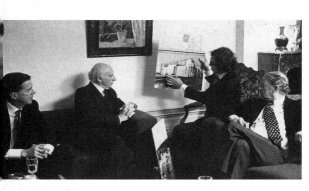

Meeting of the Kuratorium at the home of Otto Wolff von Amerongen, December 1980. From left to right: Count Peter von Metternich, former German Federal President Walter Scheel, Christo, and Otto Wolff von Amerongen Photograph by Wolfgang Volz

April The *Kuratorium für Christos Projekt Reichstag* (Board for Christo's Reichstag Project) is founded in Hamburg. The Kuratorium consists of leading German citizens from various walks of life. Present at the inaugural meeting are Christo and his wife Jeanne-Claude, Gerd Bucerius (publisher of *Die Zeit*), Countess Marie-Christine von Metternich, Heinrich Senfft, Ernst Hauswedell, Petra Kipphoff, Tilmann Buddensieg, Wieland Schmied, Karl Ruhrberg, Wolfgang Volz, and Michael S. Cullen.
Exhibitions on the *Reichstag* project are held in the Kunstgewerbemuseum in Zurich and the Palais des Beaux-Arts in Brussels.

October Christo realizes *Wrapped Walk Ways, J. L. Loose Memorial Park, Kansas City, Missouri, 1977–78.*

The artist begins *The Mastaba of Abu Dhabi, Project for the United Arab Emirates* (in progress).

May Karl Carstens becomes the president of the Federal Republic of Germany. Richard Stücklen (Christian Social Union, CSU) succeeds to the Bundestag presidency. After taking office, Stücklen issues a second refusal of the project to wrap the Reichstag, acceding to his predecessor's decision.

Christo begins *The Gates, Project for Central Park, New York.*

October The artist is informed that Carstens has changed his mind. However, it is now up to his successor Stücklen to decide.

December *Surrounded Islands, Project for Biscayne Bay, Greater Miami, Florida* is begun. On December 6th, Christo, Jeanne-Claude, Cullen, and Volz attend a meeting of the Kuratorium in Cologne. The Kuratorium resolves to talk directly to Stücklen.
Walter Scheel has a discussion with Stücklen, who states that he may change his mind if Carstens will speak with him directly.

January Stobbe resigns as mayor of Berlin.

February Carstens expresses a willingness to speak to Stücklen.

March Otto Wolff von Amerongen, member of the Kuratorium and a leading German businessman, learns from an East German source that the GDR government has no objection to the *Wrapped Reichstag* project.

April Stücklen continues to refuse to see the artist, and remains opposed to the wrapping of the Reichstag.

May Richard von Weizsäcker (CDU) is elected mayor of Berlin.

September The opening of the exhibition "Christo: Urban Projects 1961–1981" at the Museum Ludwig in Cologne revives discussion in the press about the artist's proposal for the *Wrapped Reichstag.*

February The German magazine *Art* publishes a letter from Stücklen expressing his fear that Christo's wrapping of the Reichstag would be misunderstood.

May The "Urban Projects" exhibition in Berlin at the Bethany Art House (Künstlerhaus Bethanien) is a great success.

June In front of supporters and opponents, the artist is interviewed on the "Arena" program of SFB (Free Berlin TV) on June 15th. After watching the program, Richard von Weizsäcker feels that Christo has stronger arguments, and asks Cullen to arrange a meeting with the artist.

September Christo, Jeanne-Claude, Cullen, and Volz meet Weizsäcker at a dinner party on September 13th at the home of Marianne and Wilhelm A. Kewenig, Berlin senator for cultural affairs. Weizsäcker promises to talk with Stücklen.

1983 **May** Christo realizes *Surrounded Islands, Biscayne Bay, Greater Miami, Florida, 1980–83.*

1984 Upon learning that he is to be elected to the presidency of the Federal Republic, Weizsäcker steps down as mayor of Berlin and is succeeded by Eberhard Diepgen (CDU).

February At a meeting on February 21st in the house of the Cologne industrialist Otto Wolff von Amerongen, Rainer Barzel, the new Bundestag president, suggests September 1985 for the realization of the project, but wants to limit the time to four months between the official approval and the realization. Christo explains that at least a year of preparation is needed. In Berlin the following day, Christo meets Volker Hassemer, the new senator for cultural affairs, who favors the project. Willy Brandt, accompanied by Dietrich Stobbe and Klaus-Henning Rosen (Brandt's chief staff member), visits Jeanne-Claude and Christo at their home in New York on May 20th.

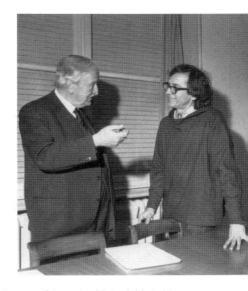

Christo with banker Hermann Josef Abs, member of the board of the Städel Museum in Frankfurt am Main, February 1982
Photograph by Wolfgang Volz

July Mayor Diepgen, among others, speaks at the opening of the exhibition "Christo: Surrounded Islands, Biscayne Bay, Greater Miami, Florida, 1980–83" at the Berlin Nationalgalerie on July 8th.
After Renger obtains the necessary permission, Christo, Jeanne-Claude, Cullen, and Volz inspect the roof of the Reichstag on July 9th with their American engineers and collaborators Vahé Aprahamian, Theodore Dougherty, Thomas Golden, August Huber, Harrison Rivera-Terreaux, Jürgen Sawade, and Josy Kraft.

August After nine years of negotiations, written approval is given by the mayor of Paris, Jacques Chirac, for Christo to realize *The Pont Neuf Wrapped.*

September In order to prepare for a September 1985 realization of the Berlin project, Christo requests architectural plans of the Reichstag, foreseeing that Diepgen will delay approval until after the March 1985 Berlin elections. Christo surveys the roof of the Reichstag again.

Inaugural discussion at the exhibition "Christo: Urban Projects 1961–81," in the Bethany Art House (Künstlerhaus Bethanien), Berlin, May 1982
Photograph by Wolfgang Volz

October/November Barzel's approval becomes meaningless when he resigns as Bundestag president and Philipp Jenninger is elected to succeed him.
Christo concentrates on the *Pont Neuf* project.
Jenninger refuses to support the *Reichstag* project in his reply to a letter from newspaper publisher Gerd Bucerius asking for support of the project.

December Christo begins *The Umbrellas, Project for Japan and USA.*
On January 31st, Wilhelm Kewenig attempts to change Jenninger's mind. Jenninger states that his approval would be conditional on Christo's keeping intact the functional use and symbolic aspects of the Reichstag.

1985 **April** Elmar Pieroth, Berlin's senator for economic affairs, suggests the summer of 1986 for the realization of the wrapping, and begins to pressure Jenninger to give approval by the summer of 1985.

May In a letter to Jenninger on May 28th, the Berlin senator for cultural affairs, Hassemer, suggests that the wrapping of the Reichstag take place in the summer or fall of 1987 as part of the rededication of the building during Berlin's 750th anniversary celebration.

At the home of Jeanne-Claude and Christo in New York, May 20th, 1984. From left to right: Dietrich Stobbe, Klaus-Henning Rosen, Jeanne-Claude Christo, Willy Brandt, and Christo
Photograph by Wolfgang Volz

July Hassemer meets Jenninger at the Reichstag on July 19th to discuss the renovation, the rebuilding of the dome, and the opening of the west portal, as well as Christo's temporary work of art.

Diepgen appears on "Abendschau" (a TV program) on July 24th, and says that he welcomes the numerous discussions about the project.

August Jenninger writes to Hassemer on August 31st to oppose the opening of the west portal and to refuse the wrapping proposal.

September The CDU/CSU faction of the Bundestag holds a session in the Reichstag. Chancellor Helmut Kohl declares himself against Christo's proposal. Jenninger does not categorically oppose wrapping the building, but says his approval would depend on the modification of the Reichstag and the surrounding area. Diepgen lets it be known that he would approve the project as long as the public favors it.

On September 22nd, Christo realizes *The Pont Neuf Wrapped, Paris, 1975–85*. The reporting of the project gives rise to sympathy and support for Christo in Germany.

In Paris, Hassemer assures Christo that the *Reichstag* project can benefit from the success of the now-realized *Pont Neuf Wrapped*. Hassemer, who believes that Jenninger secretly supports the project, recommends an information campaign.

October A program broadcast on Berlin television on October 16th seems to conclude that the only argument against the wrapping of the Reichstag is Berlin's public opinion. Jenninger says in a radio interview in the American Sector on October 23rd that he could agree to Christo's project if, after the wrapping, the building were to be viewed as new. The following day, "Abendschau" reports the satisfaction of the Paris Chamber of Commerce over the realization of the *The Pont Neuf Wrapped*.

December Christo and Jeanne-Claude arrive in Berlin on December 18th at the request of Hassemer, who feels that Christo can best convince the authorities. Two days later, Roland Specker, a German businessman, proposes to Christo and Jeanne-Claude his idea to establish a committee called *Berliner für den Reichstag* (Berliners for the Reichstag), consisting of fifty active members.

On December 21st, Diepgen suggests the period between May and June 1988 for the realization of the wrapping, but asks Christo to shorten the period between the approval and the realization.

March SFB Radio broadcasts interviews with Diepgen and all twelve Berlin senators about the *Reichstag* project. Seven of the senators are for the wrapping, five are against it, and the mayor is noncommittal. Subsequently, three of those opposed are replaced. One of the new senators is in favor of the project, thereby assuring a majority of eight.

June At a press conference in Berlin on June 24th, Specker announces the formation of *Berliner für den Reichstag*, which begins to collect signatures in support of the project.

August The date August 13th marks the 25th anniversary of the building of the Berlin Wall.

September Diepgen visits Christo and Jeanne-Claude in their home in New York on September 21st.

October Christo writes to Jenninger, president of the Bundestag, asking for an appointment.

The exhibition "Christo: Wrapped Reichstag, Project for Berlin" opens at the Satani Gallery in Tokyo on October 20th.

Dinner at the Deutsche Bank, Berlin, December 1985. From left to right: Christo, Jeanne-Claude Christo, Walter Scheel, and Walter Rasch, former FDP chairman of Berlin
Photograph by Wolfgang Volz

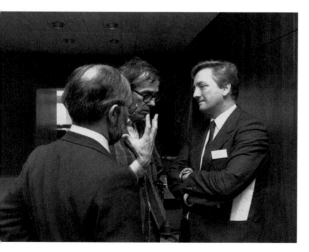

Christo speaking to Michael S. Cullen and then general secretary of the CDU in Berlin, Klaus Landowsky, Berlin, December 1985
Photograph by Wolfgang Volz

November Christo is present in the Nationalgalerie in Berlin at the installation of his large scale model of the *Wrapped Reichstag* on November 22nd.

Discussion with three CDU Berlin senators, Volker Hassemer, Bernhard Schneider, Jeanne-Claude Christo, Christo, Countess Marie-Christine von Metternich, and Stefan Javachev
Photograph by Wolfgang Volz

1987 Berlin celebrates its 750th anniversary.

February Christo meets the United States ambassador to Germany, Richard Burt, who promises his support. Christo learns from a friend that Jenninger has replied to his letter of October, but the artist has not yet received the letter.

March Christo finally receives Jenninger's letter, and replies that he would like to meet with him.

April Jenninger suggests a time, but Christo cannot accept the proposed date.

May Jenninger suggests June 17th in his office; Christo accepts.

June The Berlin newspaper *Der Tagesspiegel* runs a story about Jenninger on June 3rd. Among other things, he says that he will tell Christo his reasons for not permitting the *Reichstag* project when he sees him on June 17th.
In Berlin on June 12th, Roland Specker gives Jenninger a notarized statement showing that 70,000 signatures in favor of the project have been collected by the committee *Berliner für den Reichstag*.
Two days later, Christo informs Jenninger that he cannot come to Bonn.

July In Japan, Christo announces his forthcoming work *The Umbrellas, Project for Japan and USA* on July 18th.

1988 **November** Jenninger has to resign from his office as president of the Bundestag. He is succeeded by Dr. Rita Süssmuth, formerly minister of family affairs.

1989 Klaus-Henning Rosen gives Süssmuth a copy of the book *Christo – Der Reichstag,* edited by Michael S. Cullen and Wolfgang Volz.
The Federal Republic of Germany and the German Democratic Republic prepare to celebrate, independently, their forty years of existence.

September Roland Specker and Marianne Kewenig are received by Süssmuth in Bonn on September 7th. She intimates that she likes the project, but she is very cautious and will not commit herself at this time.

November The Berlin Wall falls on November 9th. Christo is just as excited as everybody in Berlin; he feels that the time has finally come for his project.

1990 **January** Christo, very busy with *The Umbrellas* project, has little time to give any attention to Berlin.

February Christo learns from Richard Hunt, marshal of Harvard University and a friend of Helmut Kohl, that the chancellor has little or no interest in the arts, but also that he would probably never say anything either for or against the project.

October Germany is reunited on October 3rd. The debate on whether Berlin should once again become the capital is initiated.

June The Bundestag votes on June 20th to make Berlin the capital of Germany and to make it the seat of government and parliament.

The following day, Bundestag member Friedbert Pflüger (CDU) publicly suggests that Christo wrap the Reichstag and, when he unwraps the building, it thereafter be renamed "the Bundestag."

July In Bonn, Bundestag President Rita Süssmuth receives project director Michael S. Cullen in her office on July 1st. She informs him that she is very much interested in helping Christo realize his dream.

October Christo realizes *The Umbrellas, Japan–USA, 1984–91* on October 9th.

December In a letter of December 20th, Süssmuth invites Jeanne-Claude and Christo to visit her in Bonn. She writes that she is interested in helping them realize the *Wrapped Reichstag*. Christo begins *Over the River, Project for Western USA.*

February A working lunch takes place in Bonn on February 9th, in the Bundestag president's residence. In addition to Mrs. Süssmuth, Peter Conradi (member of the Bundestag), Mr. Jung and Mr. Müller of Mrs. Süssmuth's staff, Christo, Jeanne-Claude, Wolfgang and Sylvia Volz, Roland Specker, and Michael S. Cullen are present. A general feeling of trust is established. Mrs. Süssmuth learns that Christo needs about eighteen months' advance notice. She says that she will fight to get the project realized and that an exhibition of Christo's work in Bonn would be very helpful, but that she will have to confer with the party whips before definitely giving a green light.

In the early fall, Peter Conradi suggests that the competition juries for the transformation of the Reichstag and for the urban development of the governmental buildings around the Reichstag recommend the realization of the Christo project.

October Willy Brandt dies on October 8th. He had been a loyal supporter of Christo for fifteen years.

November Christo, Jeanne-Claude, Wolfgang and Sylvia Volz, Michael S. Cullen, Roland Specker, and Reichstag director Hans-Jürgen Hess discuss with Rita Süssmuth the timetable of the permit process during a working breakfast at the Reichstag in the Bundestag president's office on November 9th.

January On January 6th, Christo discusses the project with foreign journalists and then gives a press conference in the gallery of the Arts Academy at the Marstall. Later the same day, he gives a lecture at the Urania Hall in Berlin.

The following day, the Reichstag architecture competition jury convenes at the Reichstag, and at noon Bundestag President Rita Süssmuth inaugurates Christo's exhibition at the Marstall.

A dinner is held at Renate and Roland Specker's home with Rita Süssmuth, Peter Conradi, Dietmar Kansy (member of the Bundestag), Süssmuth's assistants Dieter Biehoff and Thomas Läufer, Hans-Jürgen Hess, Christo, Wolfgang and Sylvia Volz, Josy Kraft (curator of Christo's exhibitions), and the collectors Torsten and Kris Lilja, Carl Flach, Leila Voight, Yannik Piel, and Manfred and Mrs. Hohl.

On January 11th, Chancellor Kohl and CDU/CSU party whip Wolfgang Schäuble publicly state that they oppose the project.

The Reichstag architecture competition jury convenes again on January 27th. Christo and Jeanne-Claude arrive in Berlin.

Two days later, the Reichstag competition jury recommends to the Bundestag the realization of the *Wrapped Reichstag.*

Working lunch at the office of Bundestag President Rita Süssmuth in Bonn, February 1992. From left to right: Peter Conradi (member of the Bundestag), Rita Süssmuth, Jeanne-Claude Christo, two members of Rita Süssmuth's staff, Michael S. Cullen, Christo, Roland Specker, and Sylvia Volz
Photograph by Wolfgang Volz

February The urban development competition jury also recommends to the Bundestag on February 19th that the project be realized. Süssmuth decides to show, in the Reichstag, the scale model alongside the architectural designs selected for the transformation of the Reichstag.

Two days later, the scale model is installed in the Reichstag assembly hall.

March In the lobby of the Bundestag in Bonn on March 22nd, Süssmuth inaugurates the architectural models and Christo's scale model of the *Wrapped Reichstag, Project for Berlin*.

May The scale model for the *Wrapped Reichstag* is installed on May 18th at the Kunstmuseum in Bonn.

June The exhibition "Christo: The Reichstag and Urban Projects" opens in the KunstHausWien on June 8th.

On June 23rd, in memory of Willy Brandt, Jeanne-Claude and Christo donate to the Kunstmuseum in Bonn the original *Wrapped Reichstag* collage which they had lent to him in 1977. On the property of Dieter and Marie-Christine von Metternich, the Christos, Wolfgang and Sylvia Volz, and Michael S. Cullen tested a 1,800-square-foot sample of silver-gray metallic fabric to be used to wrap the Reichstag.

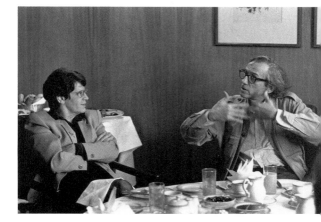

Working breakfast in the office of the Bundestag president in the Reichstag, November 9th, 1992: Rita Süssmuth and Christo discussing the time plan for approval procedures. Photograph by Wolfgang Volz

This article first appeared in the exhibition catalogue *Christo: Wrapped Reichstag, Project for Berlin,* edited by Harriet Irgang and Masahiko Yanagi, Satani Gallery, Tokyo. Events since 1986 were added for the present volume.

Rita Süssmuth

Speech given by Dr. Rita Süssmuth, president of the German Bundestag, at the opening of the exhibition "Christo in Berlin," Akademiegalerie im Marstall, Berlin, January 7, 1993

Rita Süssmuth and Christo during a dinner at the home of Renate and Roland Specker in Berlin, January 7th, 1993
Photograph by Wolfgang Volz

Ladies and gentlemen,

There could be no more appropriate time for the opening of this exhibition and for Christo's return to Berlin; thank you, Christo, for coming. As you know, many people in Berlin are enthusiastic about your project, as well as about your past work. I am among them.

Let me add that the members of the jury who are meeting this morning at the Berlin Reichstag decided unanimously to interrupt their meeting to take part in this exhibition opening. This clearly demonstrates the interest which your exhibition and this project are generating. I should also like to add that, according to the media, New Yorkers, too, are very interested in the exhibition, as well as in the Reichstag and its reconstruction.

Your interest in the Reichstag building, however, dates back much further. You developed this idea back in 1971, at a time when the attitude toward this building was very ambivalent and uncertain. The building symbolized the fact that the question of unifica-

tion was still open. Even when the architect Baumgarten won the competition to rebuild the Reichstag, the announcement made no mention of the term "Reichstag," so as to avoid any irritation. You did not allow this uncertain situation to shake your conviction. You were always certain that this is an extraordinary structure, and that the realization of your Reichstag idea was worth the struggle. When someone pursues a plan with persistency for twenty years, it is not a fleeting fixation, but a concept which, over those twenty years, has crystallized and matured. Who else, then, should realize this idea today but the man who has canvased and worked for it continuously for twenty years, and who can now connect it with an altered situation, one that we in Germany still do not fully grasp. It was the people who finally liberated this city and this nation, and this sense of freedom should take a stronger hold on us all. There are no longer any ambivalent feelings toward the Reichstag. It has been decided that it is to be the seat of the German Parliament.

Your wrapping project, which is to be realized before the rebuilding of the Reichstag, will be a cultural event. While it is

unparalleled, it is also a successful combination of art and politics. On this note, a word should be said about the arts in Berlin, because Berlin's extraordinary cultural significance is not limited only to its flourishing in the 1920s. When we visited Berlin as academics during the 1970s for symposia and conferences, for example, it was always important for us to combine work and the arts, to benefit from the great culture Berlin has to offer.

Just as some people are working hard to attract the Olympics to Berlin, I feel it is just as important to ensure that this artistic and cultural event, whose significance, immediate effect, and resonance can reach far beyond Berlin, should take place. To those people who repeatedly said we could wrap the Wall rubble or ugly buildings and hide something unattractive – to those people I say: that is precisely what this is *not* about. This is not about hiding, it is about setting apart.

It is not about covering something with packaging as an act of revenge, as it were; moreover the word "packaging" is inappropriate. We should instead describe it as a "veiling." The project – and I would like to repeat once again what Christo said last night and what Michael Cullen has stressed in many of his conversations – the project is not about devaluing something, but rather about emphasizing it. It is about a deeply felt piety.

What will take place at the veiling? It will be a moment of transformation, and at the same time a sharpening of perception. But it is also a social act in which those who have conceptu-ally accompanied the veiling from the beginning come into contact with those who have worked together throughout the entire project. The public, the media, interested people, supporters as well critics, will know of it and will discuss it. Those who will carry out the technical aspects of the veiling are also involved. They will all be curious to see something no one has yet witnessed, something that will have been changed, that through the veil has come to acquire a different quality.

I would like to close with a word of thanks to the director and the cultural foundation. It is my wish that everyone who has come to the opening today will seek support for you and this project, and that it will find broad public acceptance – even though surely not everyone will agree, because it would be dreadful if, particularly in the world of art, everyone had the same opinions. That is why conflicting views must and should be expressed. But the most important thing now is to make this art object possible. I support it. I may not be in the majority, but I am convinced that we will win a majority in the committees of the German Parliament. I believe that the right time to wrap the Reichstag is prior to its reconstruction. It will create a Berlin event, a German event, an international event. My wish for you, Christo, and for us is that, with this exhibition, you will be able to come decisively closer to reaching a decision in your discussions with those whose job it is to decide. And I am convinced that we will achieve our purpose through our shared efforts.

Catalogue

Wrapped Reichstag, Project for Berlin

1–26

THE REICHSTAG

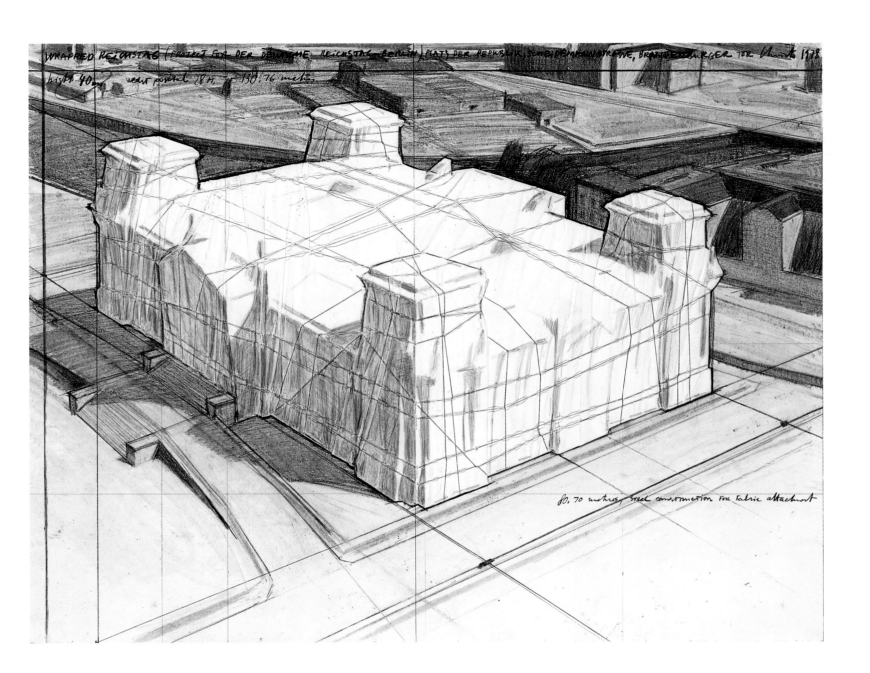

WRAPPED REICHSTAG (PROJECT FOR DER DEUTSCHE REICHSTAG BERLIN) PLATZ DER REPUBLIK, SCHEIDEMANNSTRASSE, BRANDENBURGER TOR *Christo* 1978

height 40m weist portal 78 M. or 130. 76 meters.

80. 70 metres, steel construction for fabric attachment

1

Collage 1978
22 x 28 in.
Pencil, fabric, twine, pastel, charcoal,
and crayon

Photograph by Wolfgang Volz
Collection of Jeanne-Claude Christo, New York

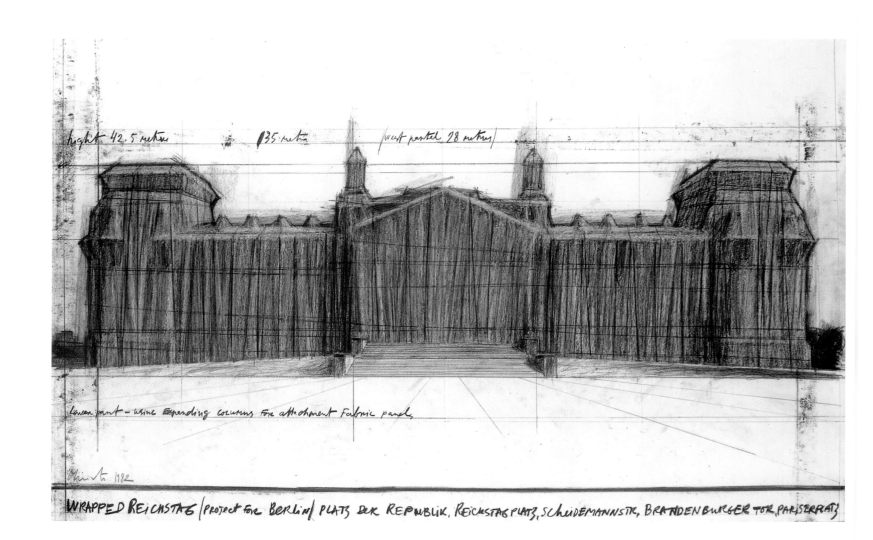

height 42.5 metres 135 metres (west portal 28 metres)

Lower part — using expanding columns for attachment fabric panels

Christo 1982

WRAPPED REICHSTAG (Project for Berlin) PLATZ DER REPUBLIK, REICHSTAGPLATZ, SCHEIDEMANNSTR, BRANDENBURGER TOR, PARISERPLATZ

2

Drawing 1982
26 x 41 in.
Pencil, charcoal, pastel, and crayon

Photograph by Wolfgang Volz
Collection of Jeanne-Claude Christo, New York

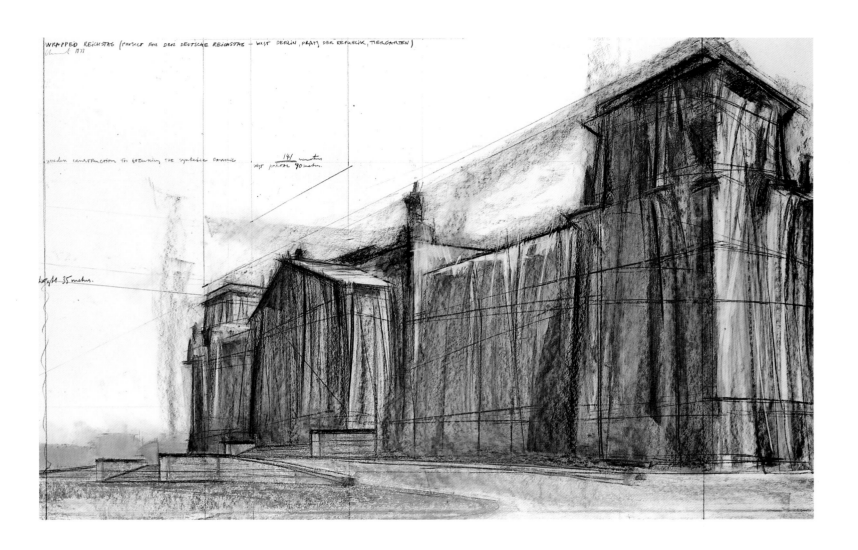

WRAPPED REICHSTAG (PROJECT FOR DER DEUTSCHE REICHSTAG — WEST BERLIN, PLATZ DER REPUBLIK, TIERGARTEN)
Christo 1977

wooden construction for securing the synthetic fabric 141 meters
 west portal 90 meters

height 35 meters.

3

Drawing 1977

42 x 65 in.

Pencil, charcoal, and pastel

Photograph by Wolfgang Volz

Collection of Jeanne-Claude Christo, New York

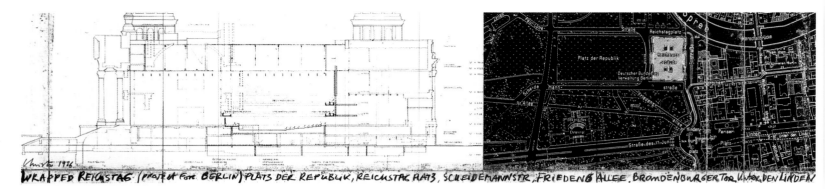

WRAPPED REICHSTAG (project for BERLIN) PLATZ DER REPUBLIK, REICHSTAG PLATZ, SCHEIDEMANNSTR., FRIEDENS ALLEE, BRANDENBURGER TOR, UNTER DEN LINDEN

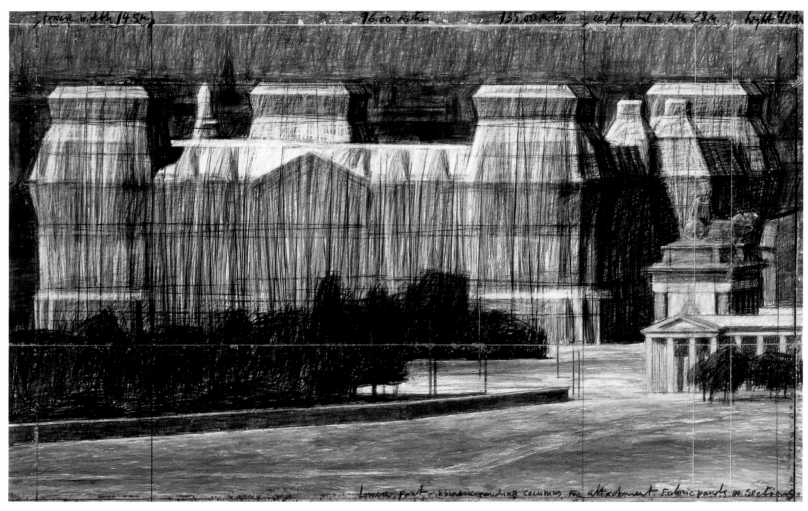

4

Drawing in two parts 1986
15 x 65 in. and 42 x 65 in.
Pencil, charcoal, crayon, pastel, technical
data, and map
Photograph by Wolfgang Volz
Collection of Jeanne-Claude Christo, New York

5

Collage 1987
11 x 8 ½ in.
Pencil, enamel paint, photograph by
Michael Cullen, crayon, charcoal, and map
Photograph by Michael Cullen
Collection of Jeanne-Claude Christo, New York

height 42.5 meter | 135.76 meter | south portal 20.00 m. 96.00 meter

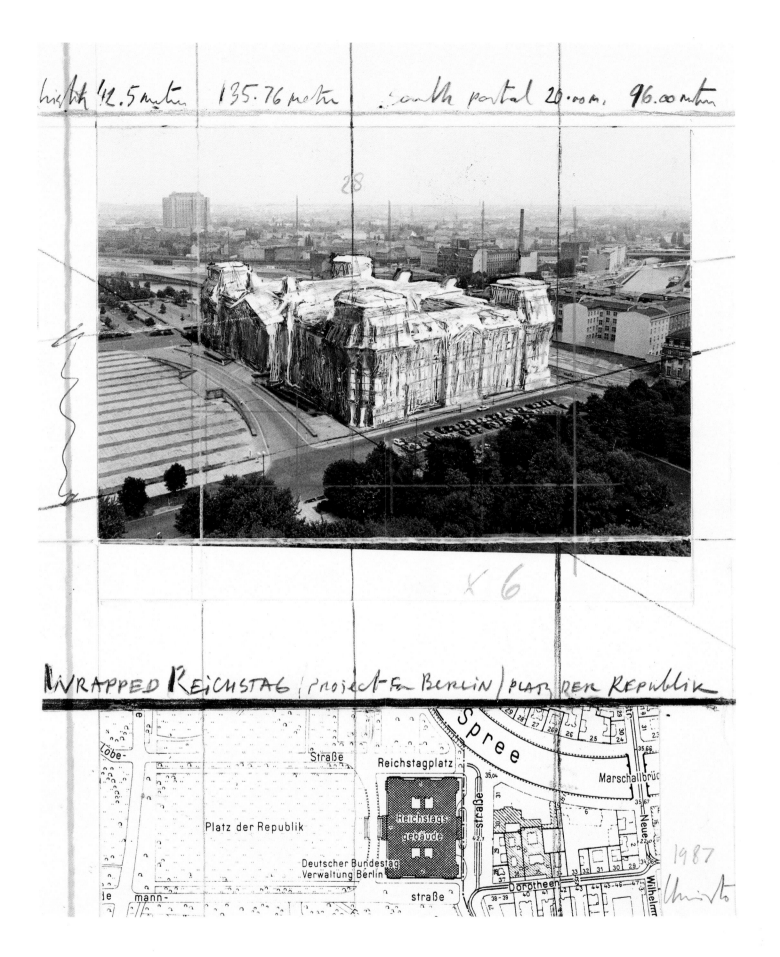

WRAPPED REICHSTAG (Project for Berlin) PLATZ DER REPUBLIK

1987

Christo

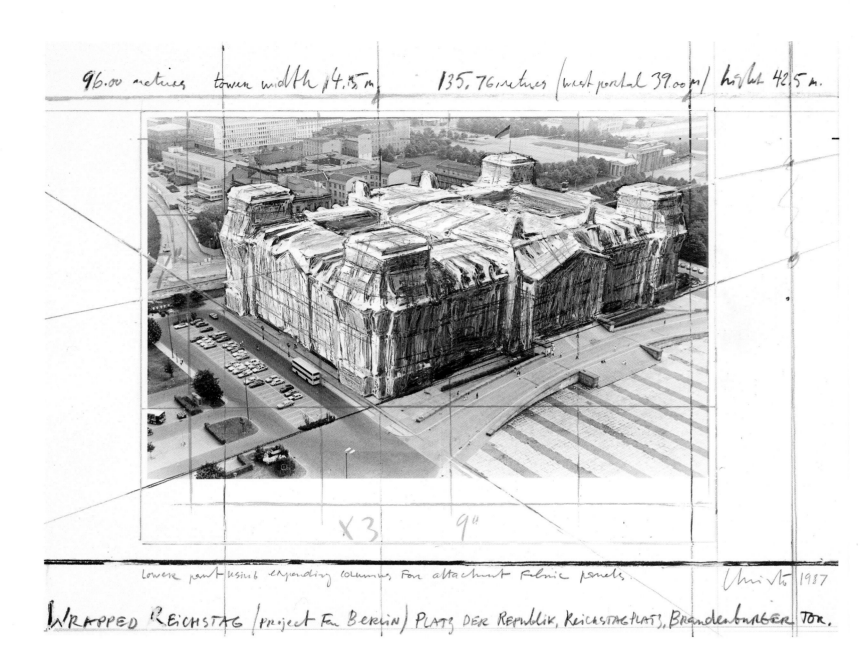

96.00 metres tower width 14.15 m, 135.76 metres (west portal 39.00 m) height 42.5 m.

lower part using expending columns for attachment fabric panels. Christo 1987

WRAPPED REICHSTAG (PROJECT FOR BERLIN) PLATZ DER REPUBLIK, REICHSTAGPLATZ, BRANDENBURGER TOR.

6
Collage 1987
11 x 14 in.
Pencil, enamel paint, photograph by
Michael Cullen, crayon, and charcoal

Photograph by Michael Cullen
Collection of Jeanne-Claude Christo, New York

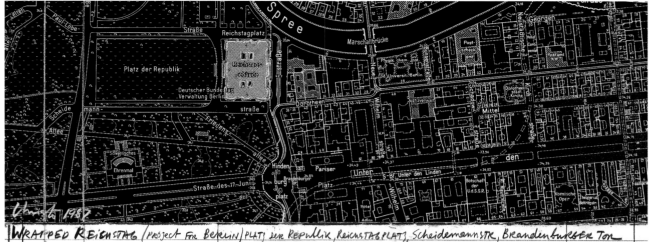

WRAPPED REICHSTAG (PROJECT FOR BERLIN) PLATS zer REPUBLIK, REICHSTAGPLATS, Scheidemannstr, Brandenburger Tor

height 42,5m. west partal 28m. 135.00 meters 96.00 meters tower width 14,5 meters

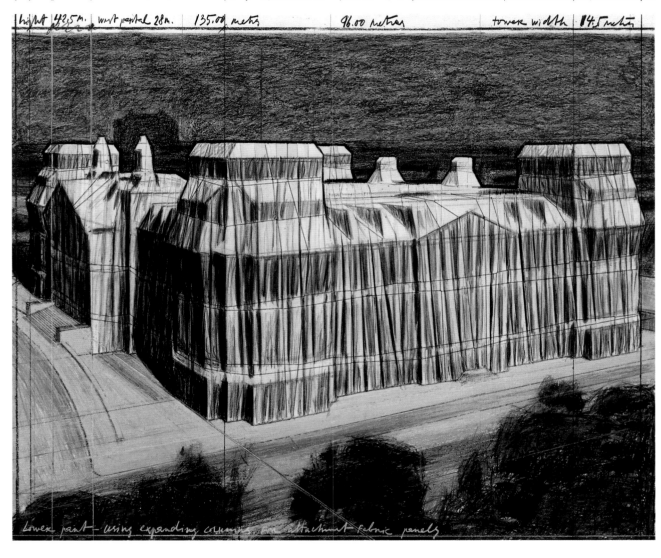

7

Collage in two parts 1987
12 x 30 ½ in. and 26 ¼ x 30 ½ in.
Pencil, fabric, twine, pastel, charcoal, crayon,
and map

Photograph by Wolfgang Volz
Collection of Jeanne-Claude Christo, New York

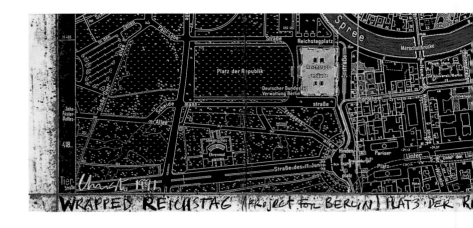

WRAPPED REICHSTAG (PROJECT FOR BERLIN) PLATS DER R

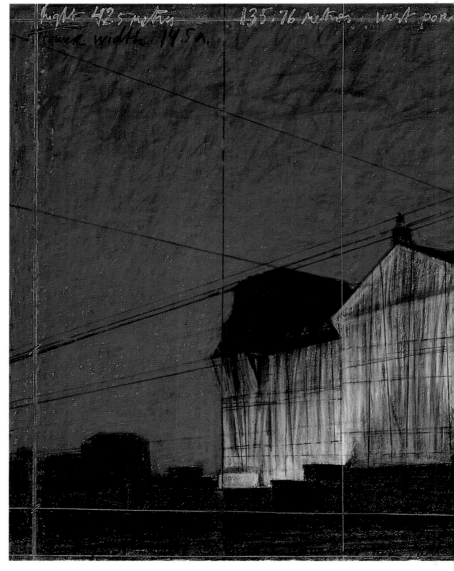

8
Drawing in two parts 1991
15 x 96 in. and 42 x 96 in.
Pencil, charcoal, crayon, pastel, technical data,
and map
Photograph by Wolfgang Volz
Collection of Jeanne-Claude Christo, New York

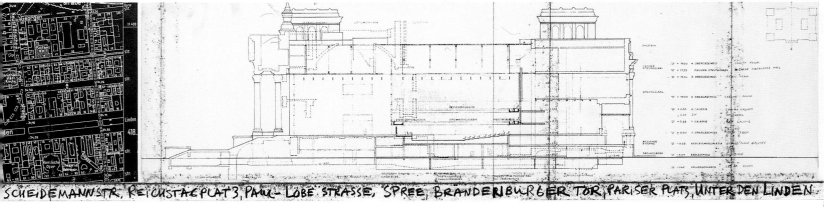

SCHEIDEMANNSTR. REICHSTACPLATZ, PAUL- LÖBE STRASSE, SPREE, BRANDENBURGER TOR, PARISER PLATZ, UNTER DEN LINDEN

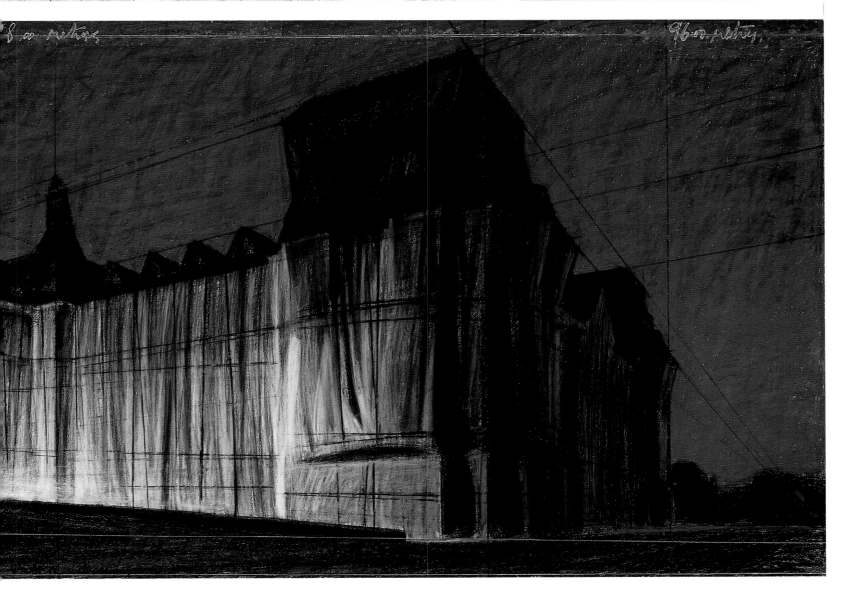

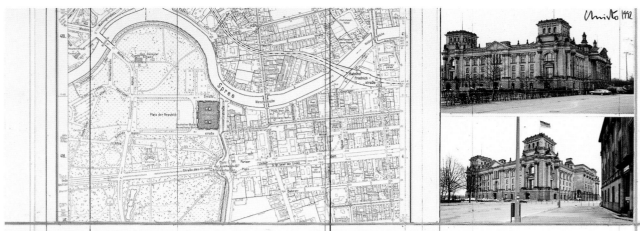

WRAPPED REICHSTAG (PROJECT FOR BERLIN) PLATZ DER REPUBLIK, REICHSTAGPLATZ, Paul- LÖBE STR. Scheidemann STR. BRANDENBURGER Tor, SPREE

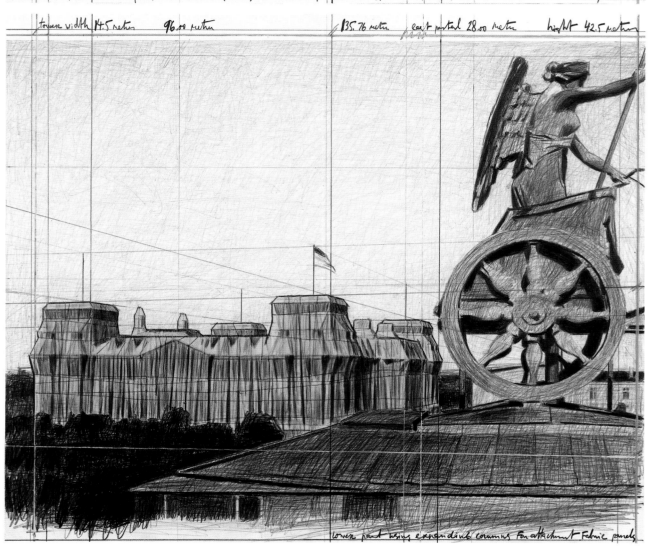

9
Collage in two parts 1992
12 x 30 ½ in. and 26 ¼ x 30 ½ in.
Pencil, fabric, twine, charcoal, crayon, pastel,
two photographs by Wolfgang Volz, and map

Photograph by Wolfgang Volz
Collection of Jeanne-Claude Christo, New York

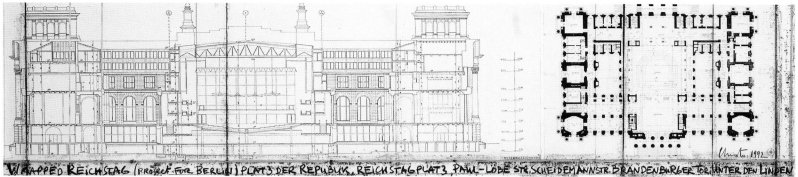

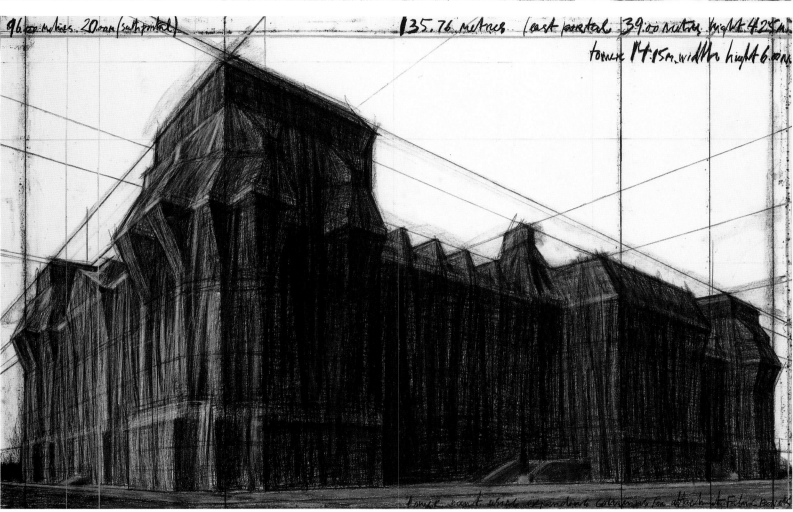

10

Drawing in two parts 1992
15 x 65 in. and 42 x 65 in.
Pencil, charcoal, crayon, pastel, and technical data

Photograph by Wolfgang Volz
Collection of Jeanne-Claude Christo, New York

11

Collage in two parts 1992
12 x 30 ½ in. and 26 ¼ x 30 ½ in.
Pencil, fabric, twine, charcoal, pastel, and map

Photograph by Wolfgang Volz
Collection of Jeanne-Claude Christo, New York
(next page)

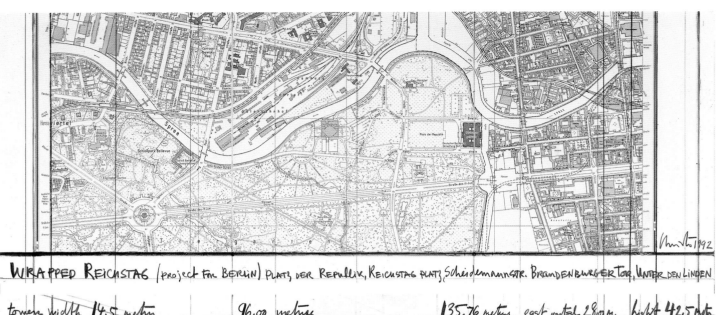

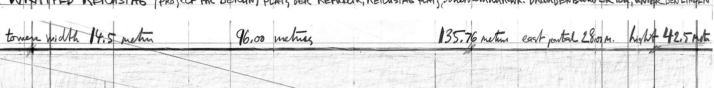

WRAPPED REICHSTAG (PROJECT FOR BERLIN) PLATZ DER REPUBLIK, REICHSTAG PLATZ, Scheidemannstr. BRANDENBURGER TOR, UNTER DEN LINDEN

towers width 14.5 metres 96.00 metres 135.76 metres east portal 28.00 m. height 42.5 mtr.

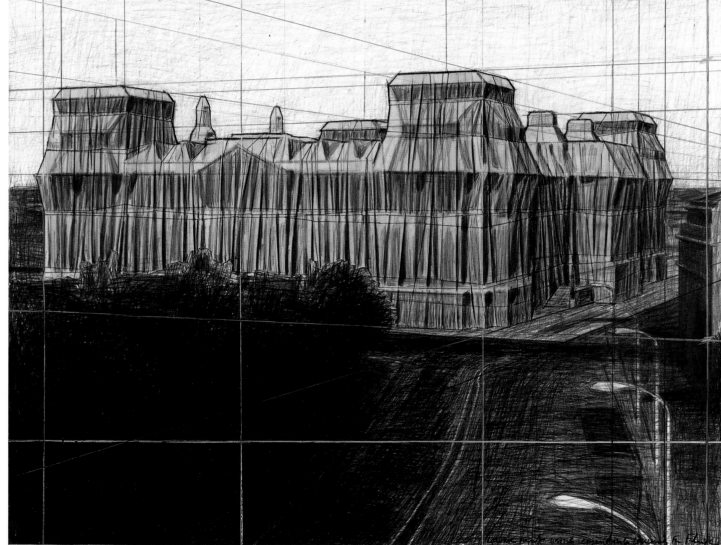

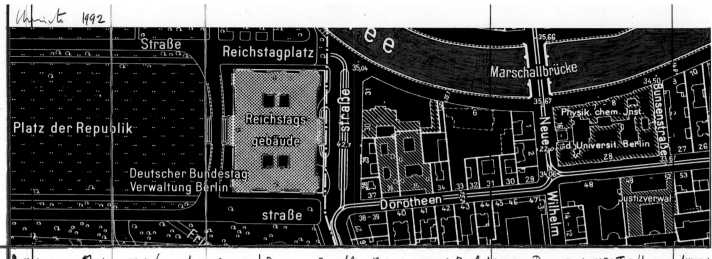

WRAPPED REICHSTAG (PROJECT FOR BERLIN) PLATZ DER REPUBLIK, REICHSTAGPLATZ, Paul-LÖBESTR. BRANDENBURGER TOR, UNTER DEN LINDEN

height 42.5 meter west portal 28.00 meter 135.76 meter 96.00 meter tower width 14.5 m.

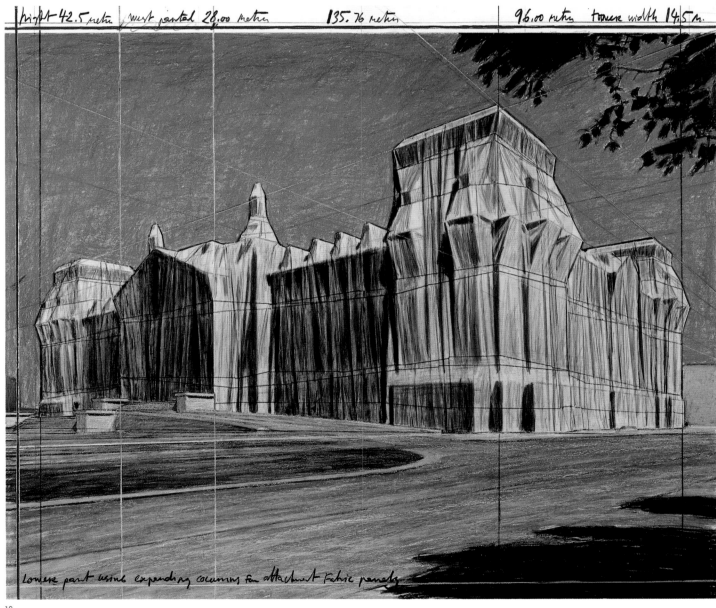

Lowere part using expanding columns for attachment Fabric panels

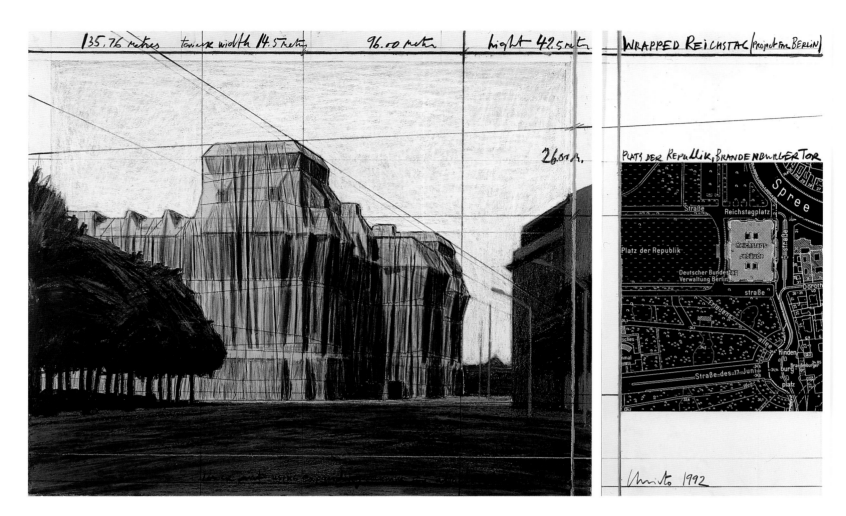

13
Collage in two parts 1992
26 ¼ x 30 ½ in. and 26 ¼ x 12 in.
Pencil, fabric, twine, pastel, charcoal, crayon,
and map
Photograph by Wolfgang Volz
Collection of Jeanne-Claude Christo, New York

12
Collage in two parts 1992
12 x 30 ½ in. and 26 ¼ x 30 ½ in.
Pencil, fabric, twine, pastel, charcoal, crayon,
and map
Photograph by Wolfgang Volz
Private collection, Berlin
(previous page)

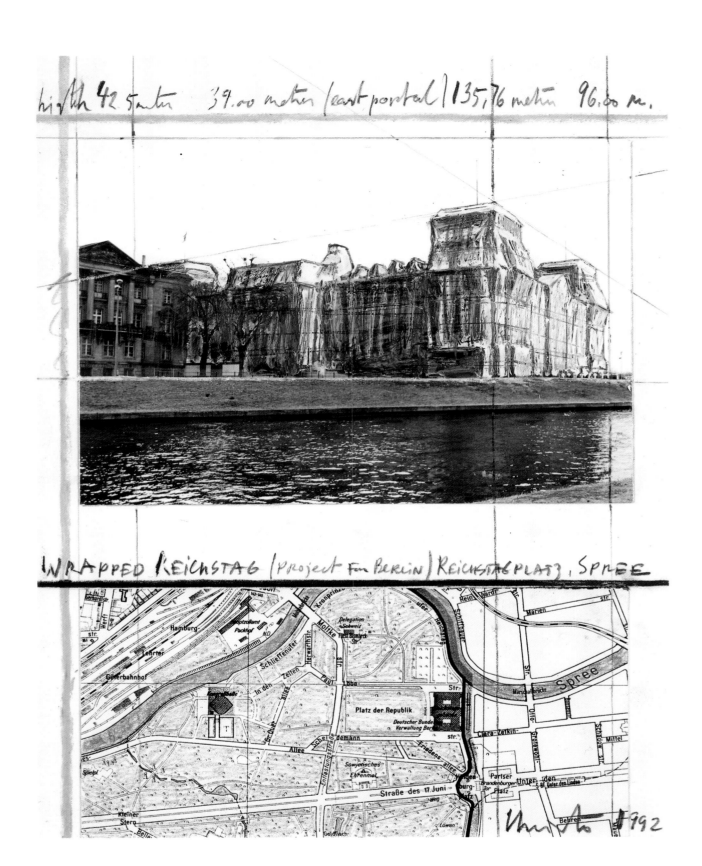

14
Collage 1992
11 x 8 ½ in.
Pencil, enamel paint, photograph by Wolfgang
Volz, charcoal, crayon, and map

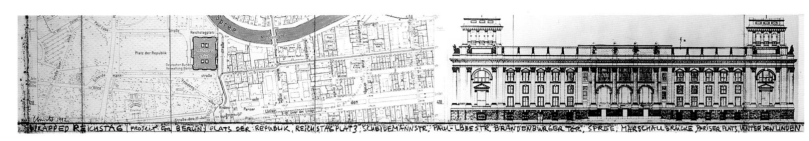

WRAPPED REICHSTAG (PROJECT FOR BERLIN) PLATS DER REPUBLIK, REICHSTAGPLATZ, SCHEIDEMANNSTR., PAUL-LÖBE STR., BRANDENBURGER TOR, SPREE, MARSCHALL BRÜCKE, PARISER PLATS, UNTER DEN LINDEN

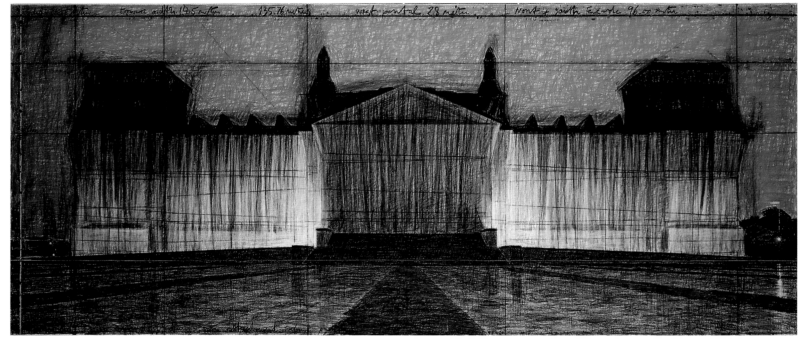

15
Drawing in two parts 1992
15 x 96 in. and 42 x 96 in.
Pencil, charcoal, crayon, pastel, technical data,
and map

Photograph by Wolfgang Volz
Private collection, Berlin

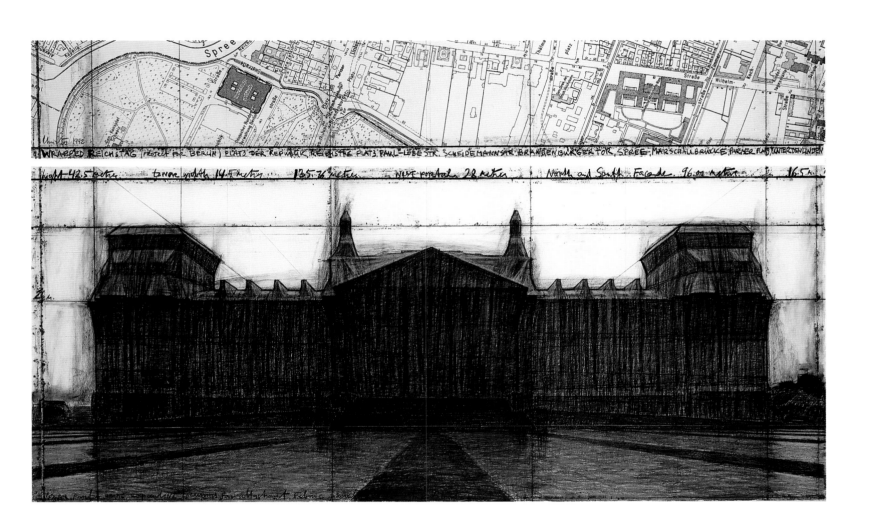

16
Drawing in two parts 1992
15 × 96 in. and 42 × 96 in.
Pencil, charcoal, crayon, pastel, and map

Photograph by Wolfgang Volz
Private collection, Berlin

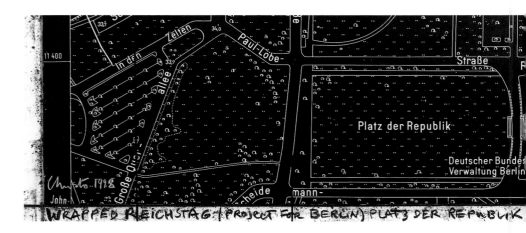

WRAPPED REICHSTAG (PROJECT FOR BERLIN) PLATZ DER REPUBLIK

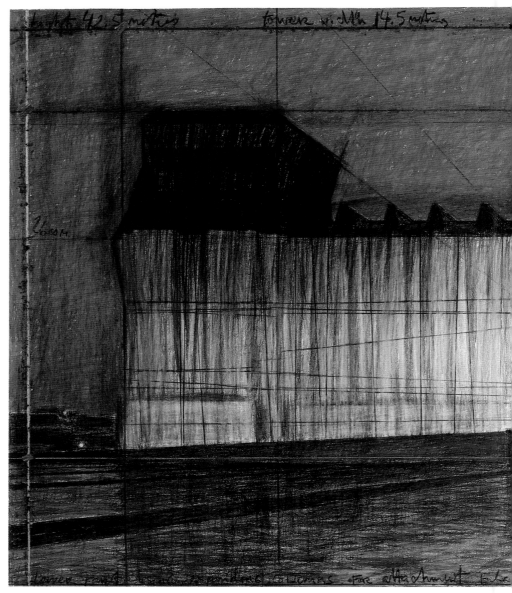

17

Drawing in two parts 1992
15 x 96 in. and 42 x 96 in.
Pencil, charcoal, pastel, photograph by
Wolfgang Volz, crayon, and map

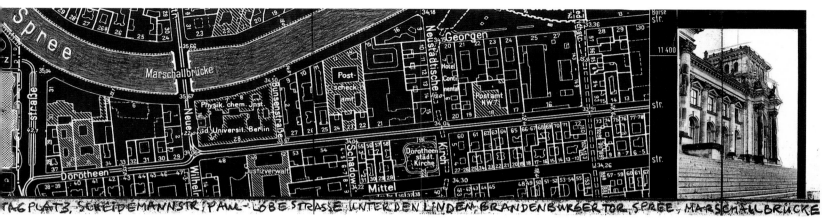

TAG PLATZ, SCHEIDEMANNSTR. PAUL - LÖBE STRASSE, UNTER DEN LINDEN, BRANDENBURGER TOR, SPREE, MARSCHALLBRÜCKE

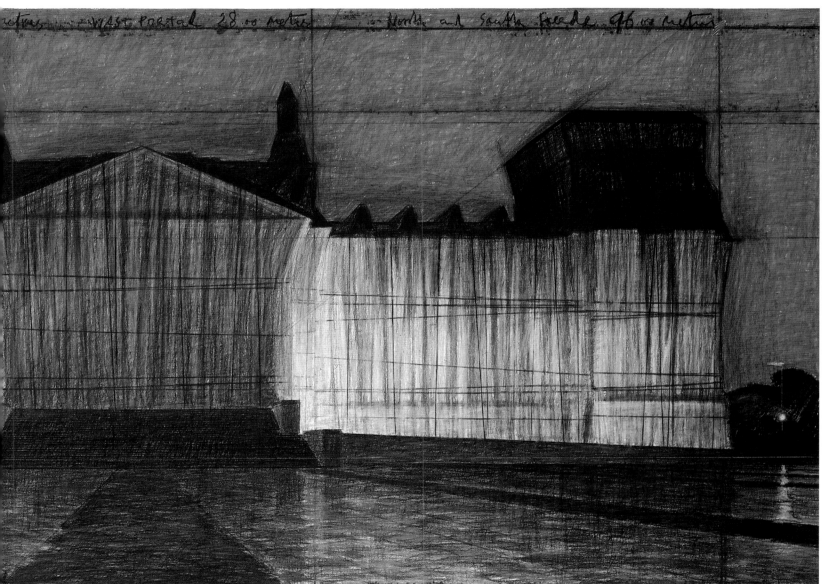

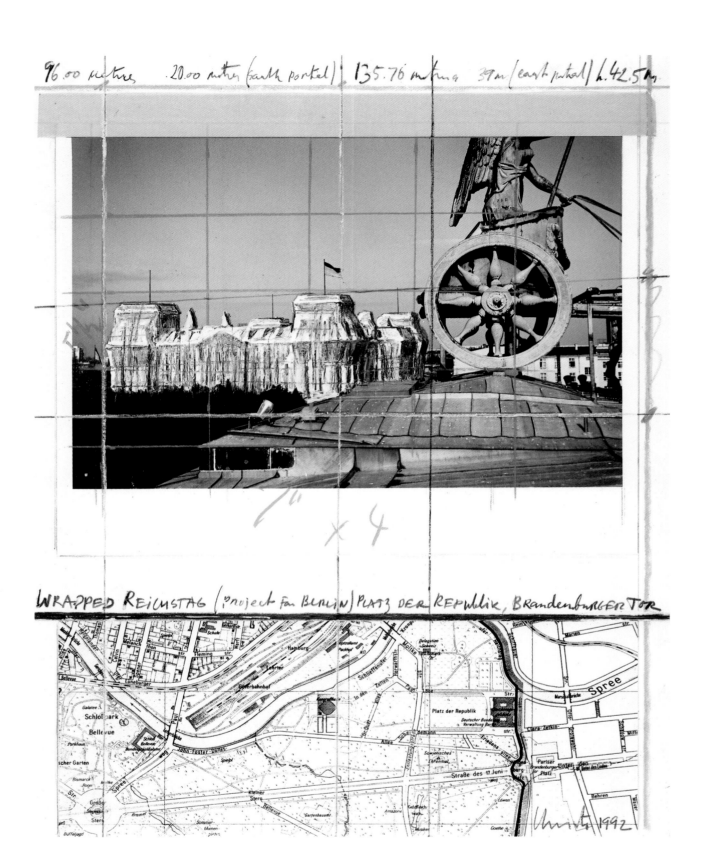

96.00 metres 20.00 metres (earth portal) 135.76 metres 39 m (earth portal) h. 42.5 m

WRAPPED REICHSTAG (project for BERLIN) PLATZ DER REPUBLIK, BRANDENBURGER TOR

Christo 1992

18
Collage 1992
14 x 11 in.
Pencil, enamel paint, photograph by Wolfgang
Volz, charcoal, crayon, map, and tape
Photograph by Wolfgang Volz
Private collection, Berlin

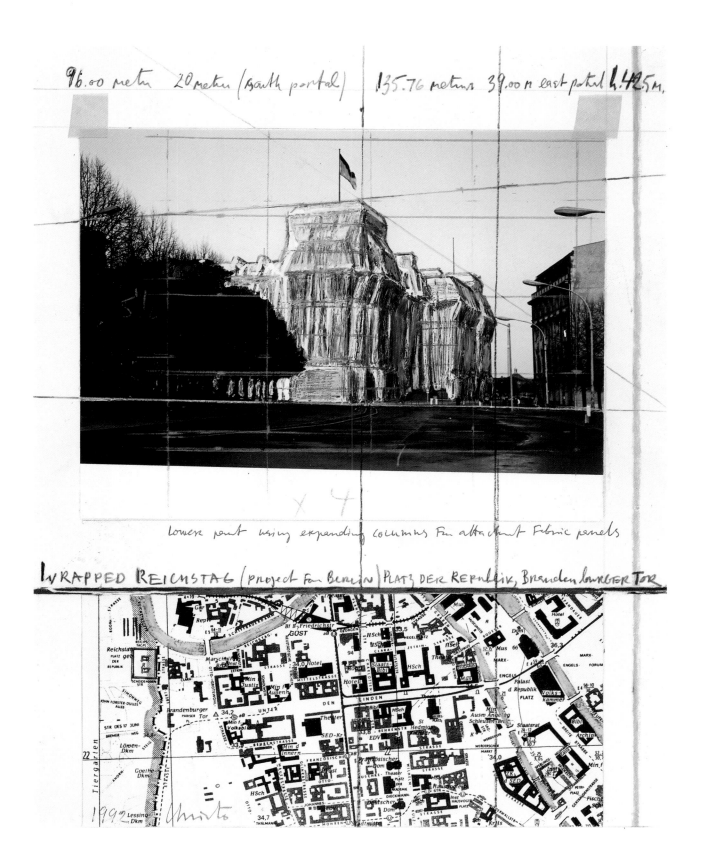

96.00 meter 20 meter (south portal) 135.76 meters 39.00 m east portal 4.425m.

x 4

lower point using expanding columns for attachment fabric panels

WRAPPED REICHSTAG (project for Berlin) PLATZ DER REPUBLIK, Brandenburger Tor

1992 Christo

19

Collage 1992

14 x 11 in.

Pencil, enamel paint, photograph by Wolfgang
Volz, charcoal, crayon, map, and tape

Photograph by Wolfgang Volz
Private collection, Berlin

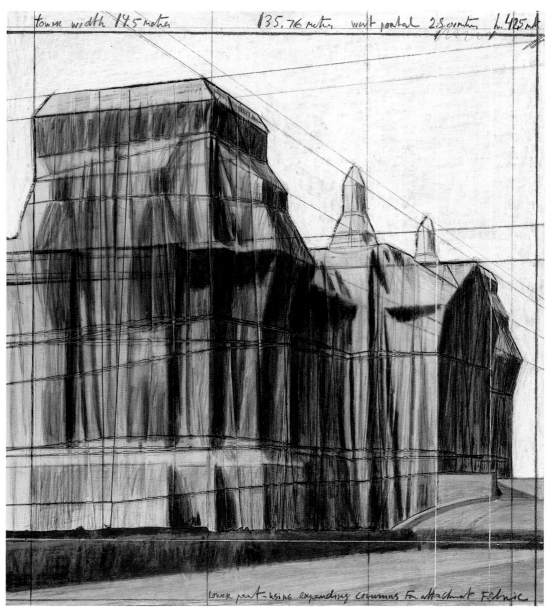

tower width 14.5 meter *135.76 meter* *west portal 2.3 meter* *h. 4.25 mt*

lower part—using expanding columns for attachment technic

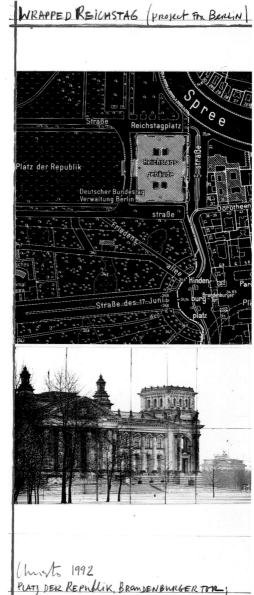

WRAPPED REICHSTAG (project for Berlin)

Christo 1992
PLATZ DER REPUBLIK, BRANDENBURGER TOR;

20

Collage in two parts 1992
30 ½ x 26 ¼ in. and 30 ½ x 12 in.
Pencil, fabric, twine, charcoal, crayon, pastel,
photograph by Wolfgang Volz,
and map

Photograph by Wolfgang Volz
Collection of Jeanne-Claude Christo, New York

21

Collage in two parts 1993
12 x 30 ½ in. and 26 ¼ x 30 ½ in.
Pencil, fabric, twine, charcoal, crayon, pastel,
photograph by Wolfgang Volz, tape, and tech-
nical data

Photograph by Wolfgang Volz
Collection of Jeanne-Claude Christo, New York

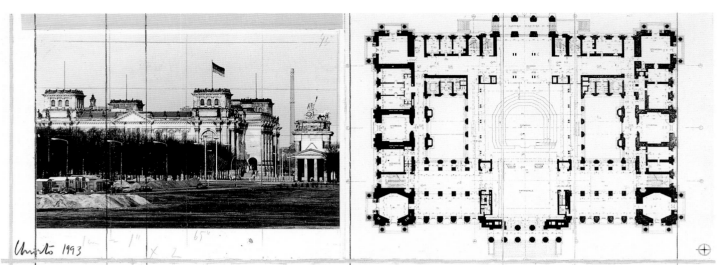

Christo 1993

WRAPPED REICHSTAG (PROJECT FOR BERLIN) PLATZ DER REPUBLIK, REICHSTAGPLATZ, BRANDENBURGER TOR, SPREE, PARISER PLATZ

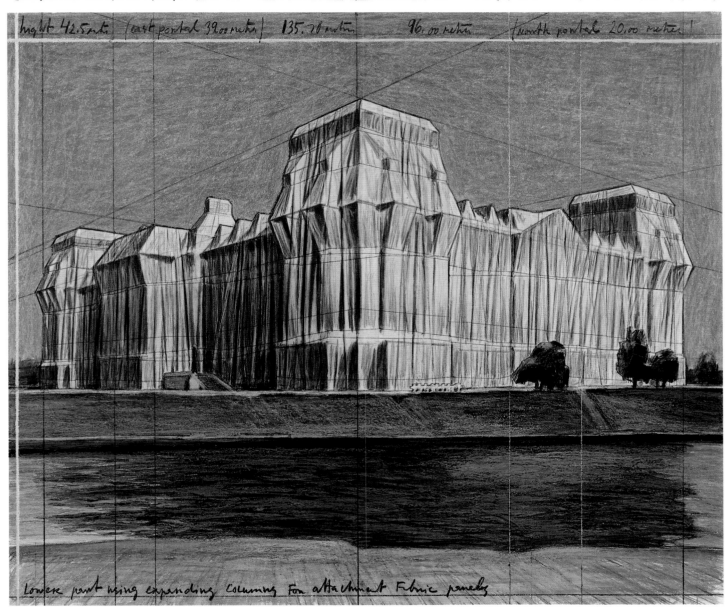

height 42.5 mts (east portal 39.00 meter) 135.70 meter 96.00 meter (north portal 20.00 meter)

Lower part using expending columns for attachment fabric panels

96.00 meter | 20.00 meter (South portal) 135.76 meters 39 m east portal hight 42.5 m.

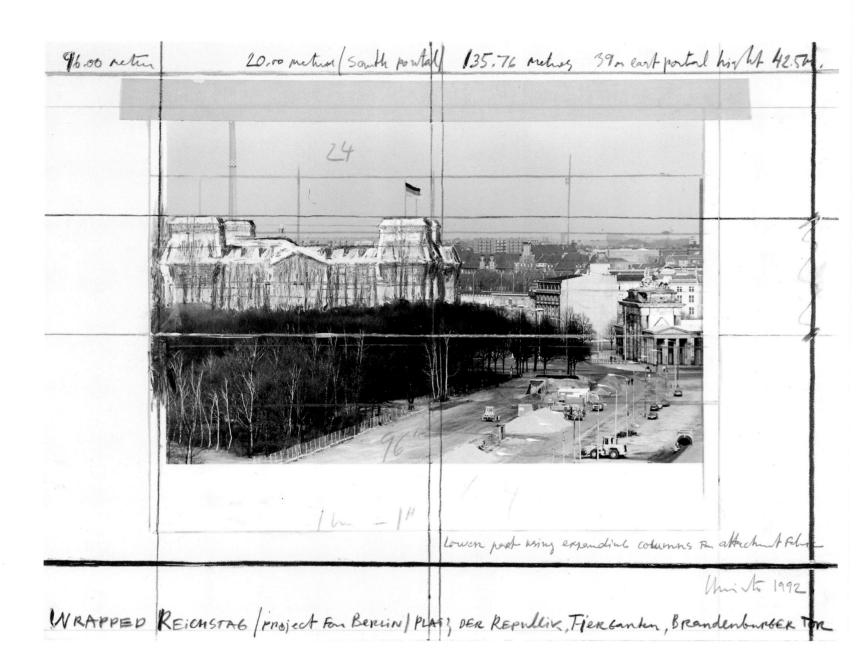

24

96 m

1 km – 1"

lower part using expanding columns for attachment fabric

Christo 1992

WRAPPED REICHSTAG (Project For Berlin) PLATZ DER REPUBLIK, TIERGARTEN, BRANDENBURGER TOR

22
Collage 1992
11 x 14 in.
Pencil, enamel paint, photograph by Wolfgang
Volz, charcoal, crayon, ballpoint pen, and tape

Photograph by Wolfgang Volz
Private collection, Berlin

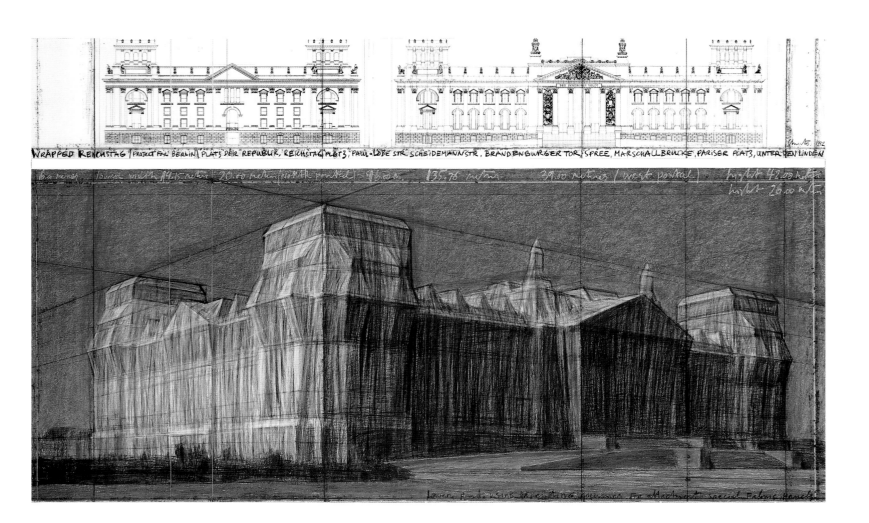

23

Drawing in two parts 1992
15 x 96 in. and 42 x 96 in.
Pencil, charcoal, crayon, pastel, and technical
data

Photograph by Wolfgang Volz
Collection of Jeanne-Claude Christo, New York

You who are monarch in the stone
What law resides in your sanctuary?
Tribes touch the tomb of your soul
And prey on you in a stare of exile.
We are the guardians who wear
The cloak of your captive legacy.
We are the prisoners of your haven
Divided between the savior and the slayer
And the wall that clings
To your eminence and your dissolution.
A wind is redeemed
In the storm of your state
And the specter you engulf
Has risen between the fortress and the night.

From *The Whispering Veils*
New York: Hugh Lauter Levin Publications

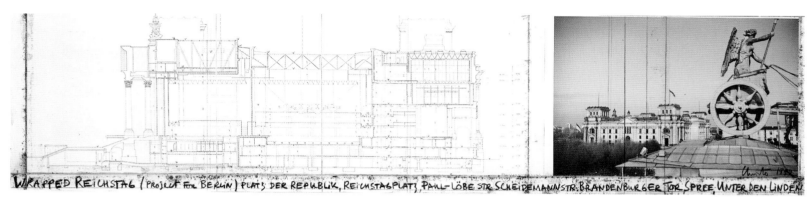

WRAPPED REICHSTAG (PROJECT FOR BERLIN) PLATZ DER REPUBLIK, REICHSTAGPLATZ, PAUL-LÖBE STR. SCHEIDEMANNSTR. BRANDENBURGER TOR SPREE, UNTER DEN LINDEN

towers width 14.5 metres. 96.00 metres 20 metres (south portal) 135.76 metres 39.00 M. (east portal) height 42.5 M.
height 26.00 M.

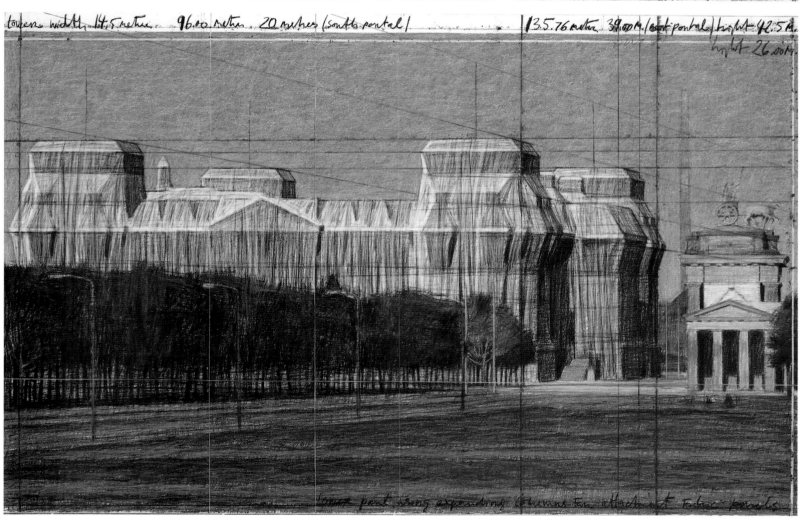

24
Drawing in two parts 1992
15 x 65 in. and 42 x 65 in.
Pencil, charcoal, photograph by Wolfgang Volz,
crayon, pastel, and technical data
Photograph by Wolfgang Volz
Private collection, Berlin

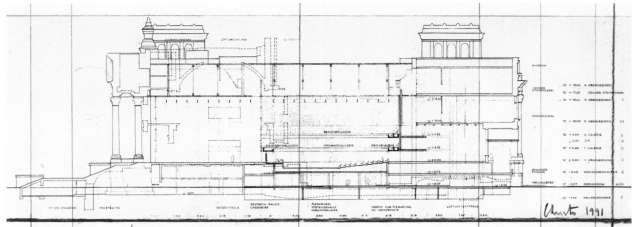

WRAPPED REICHSTAG (PROJECT FOR BERLIN) PLATZ DER REPUBLIK, REICHSTAGPLATZ, FRIEDENS ALLEE, BRANDENBURGER TOR, UNTER DEN LINDEN

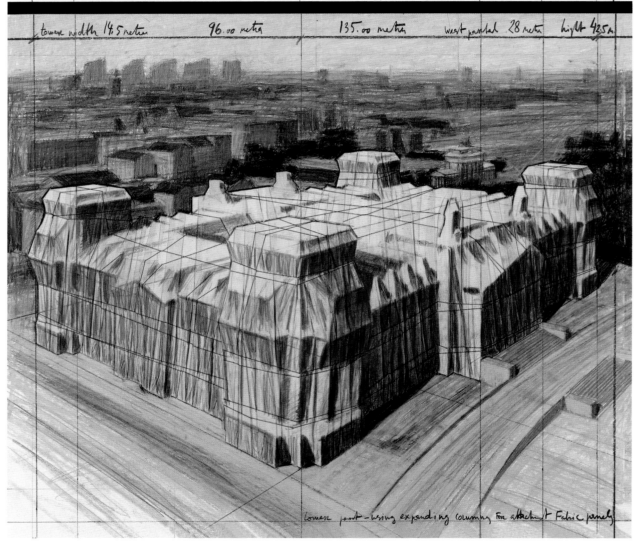

25

Collage in two parts 1991
12 x 30 ½ in. and 26 ¼ x 30 ½ in.
Pencil, fabric, twine, pastel, charcoal, crayon,
and technical data

Photograph by Wolfgang Volz
Collection of Jeanne-Claude Christo, New York

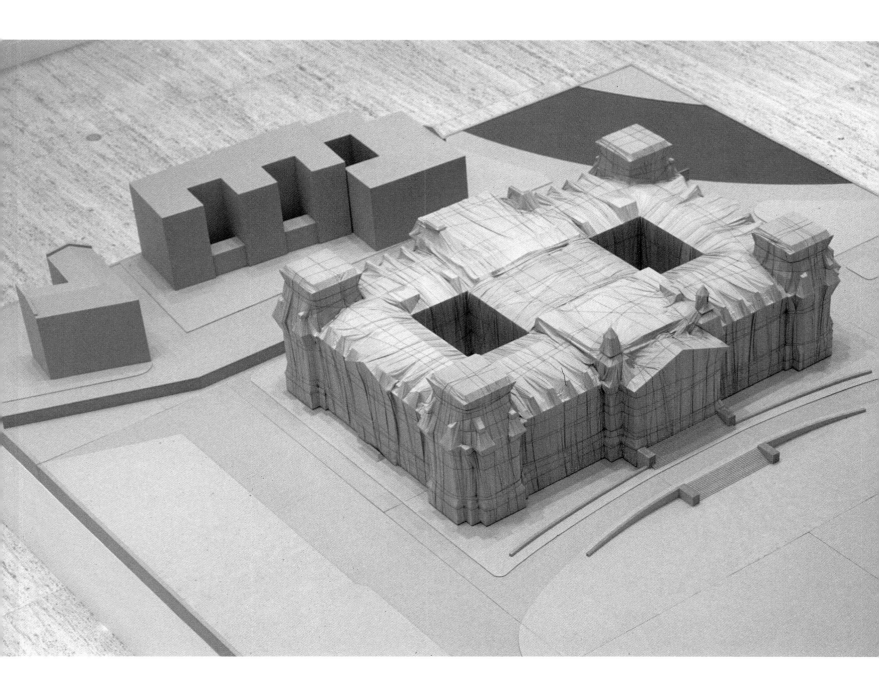

26

Scale model 1981
26 x 60 x 76 in. (height x breadth x depth)
Base: 33 x 167 x 190 in.
Total area: 29 ½ x 196 ¾ x 169 ¼ in.
Fabric, rope, paint, and wood

Photograph by Wolfgang Volz
Collection of Jeanne-Claude Christo, New York
(Following two pages: detail of 26)

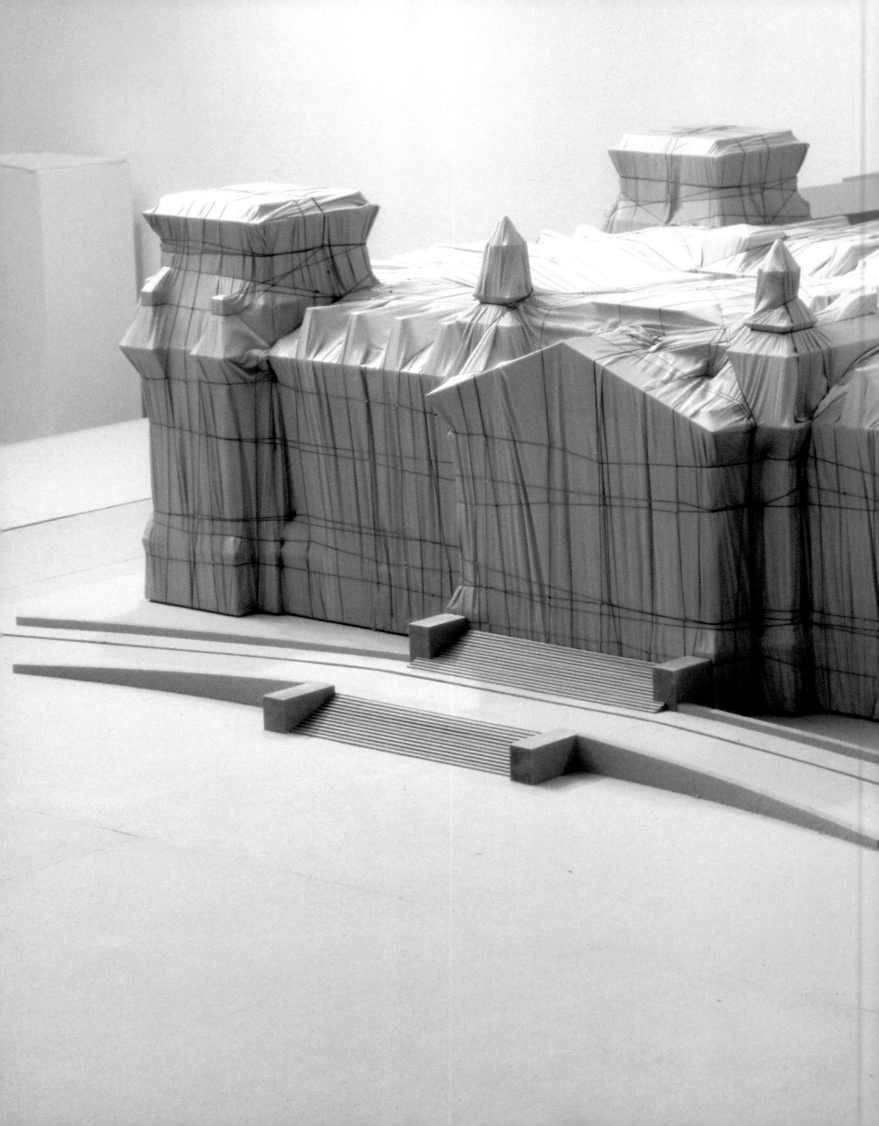

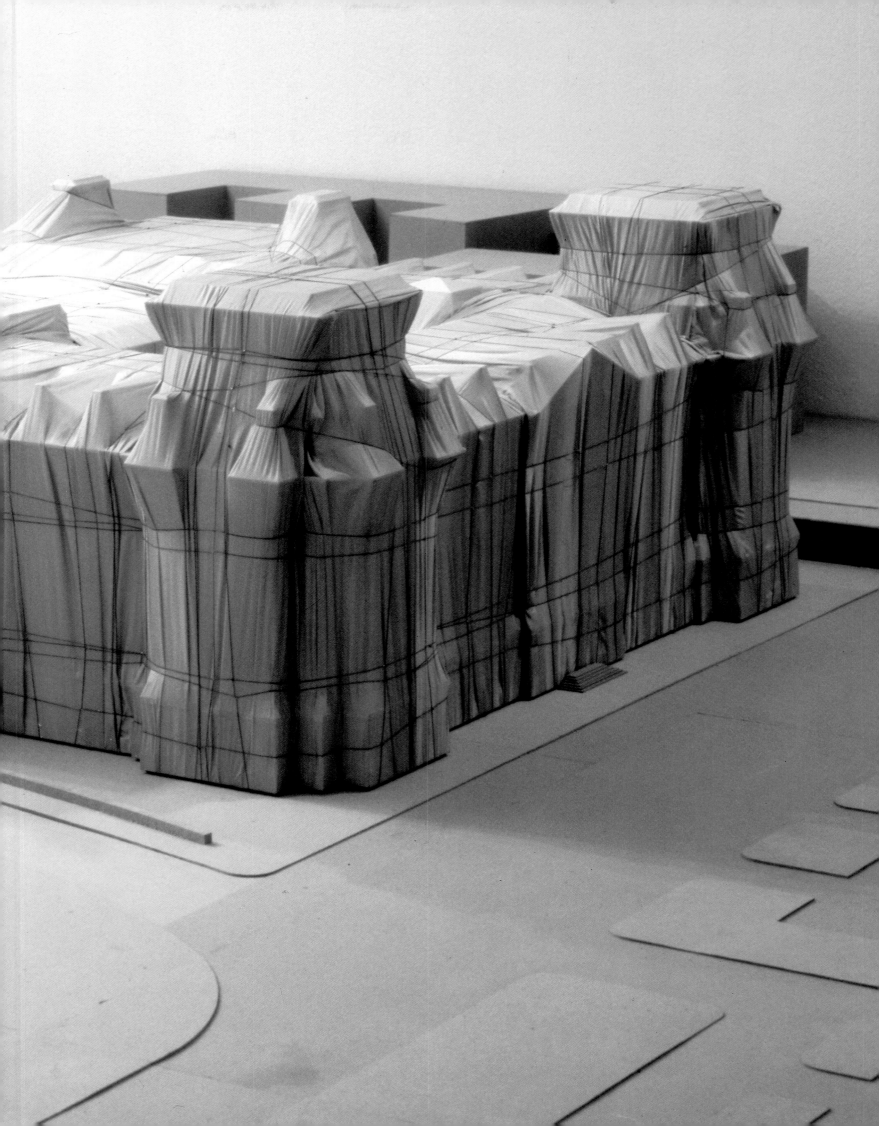

URBAN PROJECTS

"IKON CURTAIN WALL OF OIL BARRELS
RUE VISCONTI, PARIS 1962"

"WRAPPED KUNSTHALLE, BERNE 1968"

"5600 CUBICMETER PACKAGE, DOCUMENTA
4, KASSEL 1968"

"WRAPPED MUSEUM OF CONTEMPORARY ART
CHICAGO 1969"

"WRAPPED MONUMENT TO LEONARDO DA
VINCI, PIAZZA SCALA, MILANO 1970"

"WRAPPED MONUMENT TO VITTORIO
EMANUELE, PIAZZA DUOMO, MILANO 1970"

"THE WALL, WRAPPED ROMAN WALL, VIA V.
VENETO AND VILLA BORGHESE, ROME, 1974"

"WRAPPED WALK WAYS, JACOB L. LOOSE
PARK, KANSAS CITY, MISSOURI 1977-78"

"SURROUNDED ISLANDS, BISCAYNE BAY
, GREATER MIAMI, FLORIDA 1980-83"

"THE PONT NEUF, WRAPPED, PARIS
1975-85"

Christo submitted the following text to the prefect of Paris to apply for official permission.

Project for a Temporary Wall of Oil Barrels
(Rue Visconti, Paris, 6th arrondissement)

Rue Visconti is a one-way street, between Rue Bonaparte and Rue de Seine, 462 feet long with an average width of 10 feet. The street ends at number 26 on the left side and at 26 on the right. It has few shops: a bookstore, a modern art gallery, an antique shop, an electrical supply shop, and a grocery store. ". . . At the angle of Rue Visconti and Rue de Seine, the Cabaret du Petit More (or Maure) was opened in 1618. The poet Saint-Amant, an assiduous customer, died there. The art gallery that now stands on the site of the tavern has fortunately retained the facade and the seventeenth-century sign" (Rocheguid/Clébert, *Promenades dans les rues de Paris, Rive Gauche,* Editions Denoel, p. 134).

The wall will be built between numbers 1 and 2, completely closing the street to traffic, and will cut all communications between Rue Bonaparte and Rue de Seine. Constructed with 13-gallon barrels, the wall will be 14 feet high, and will be as wide as the street.

This iron curtain can be used as a barricade during a period of public work in the street, or to transform the street into a dead end. Finally, its principle can be extended to a whole area or an entire city.

Christo, Paris, October 1961

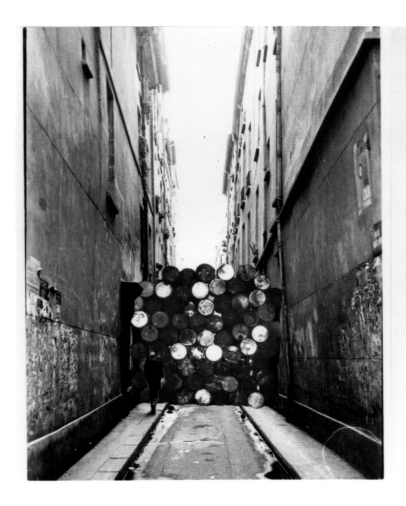

PROJET DU MUR PROVISOIRE DE TONNEAUX METALLIQUES
(Rue Visconti, Paris 6)

Entre la rue Bonaparte et la rue de Seine, la rue Visconti, à sens unique, longue de 14o m., a une largeur moyenne de 3m. Elle se termine au numéro 25 à gauche et au 26 à droite.

Elle compte peu de commerces: une librairie, une galerie d'art moderne, un antiquaire, un magasin d'électricité, une épicerie... "à l'angle de la rue Visconti et de la rue de Seine le cabaret du Petit More (ou Maure) a été ouvert en 1618. Le poète du Saint-Amant qui le fréquentait assidûment y mourut. La galerie de peinture qui remplace la taverne a heureusement conservé la façade, la grille et l'enseigne du XVll ème. siècle" (p.134, Rochegude/Clébert - Promenade dans les rues de Paris, Rive gauche, édition Denoël).

Le Mur sera élevé entre les numéros 1 et 2, fermera completement la rue à circulation, coupera toute communication entre la rue Bonaparte et la rue de Seine.

Exclusivement construit avec les tonneaux métalliques destinés au transport de l'essence et de l'huile pour voitures, (estampillés de marques diverses: ESSO, AZUR, SHELL, BP et d'une contenance de 5o l. ou de 2oo l.) le Mur, haut de 4 m., a une largeur de 2,9o m. 8 tonneaux couchés de 5o l., ou 5 tonneaux de 2oo l., en constituent la base. 15o tonneaux de 5o l., ou 8o tonneaux de 2oo l. sont necessaires à l'éxécution du Mur.

Ce "rideau de fer" peut s'utiliser comme barrage durant une période de travaux publiques, ou servir à transformer définitivement une rue en impasse. Enfin son principe peut s'étendre à tout un quartier, voir à une cité entière.

CHRISTO
Paris, Octobre 1961

27
The Iron Curtain – Wall of Oil Barrels
Rue Visconti, Paris
Photocollage 1961
9 ½ x 16 in.
Collage with two photographs and
a typewritten text
Photograph by Harry Shunk
Collection of Jeanne-Claude Christo, New York

Iron Curtain – Wall of Oil Barrels,
Rue Visconti, Paris (1961–62)

For eight hours on the evening of June 27th, 1962, Christo closed the Rue Visconti with 240 oil barrels. The street, on the Left Bank, is one of the narrowest in the city, and its main claim to fame is that, since the sixteenth century, many illustrious artists and writers have lived there (e.g., Racine, Adrienne Lecouvreur, Delacroix, and Balzac).

The art barricade was 14 feet high, 13 feet wide, and 6 feet deep. The artist did not alter the industrial colors of the oil barrels, leaving the brand names and rust visible.

The Berlin Wall was built in August 1961, and many Algerian War protest demonstrations and barricades were taking place in Paris at the same time as Christo's temporary work of art.

28

The Iron Curtain – Wall of Oil Barrels
Rue Visconti, Paris, June 27th, 1962
240 oil barrels
14 x 12 ½ x 5 ½ feet
Photograph by Jean-Dominique Lajoux

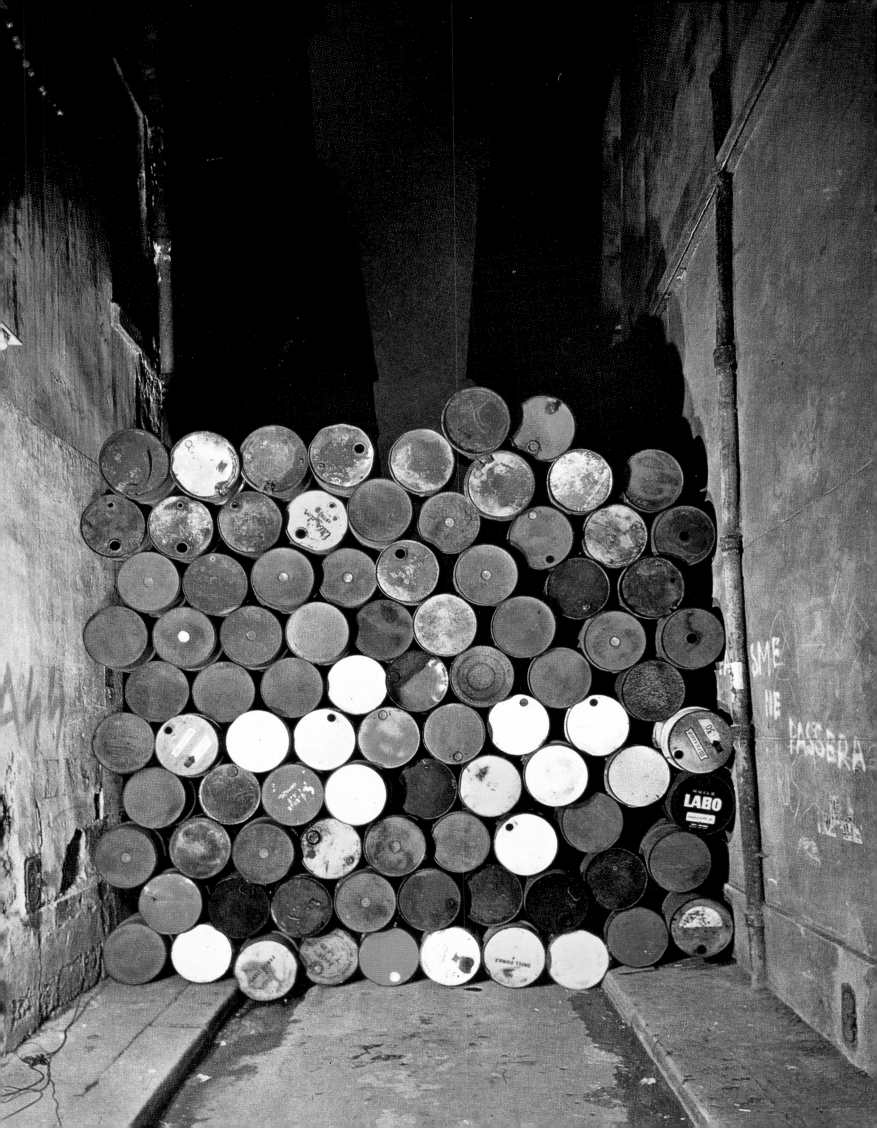

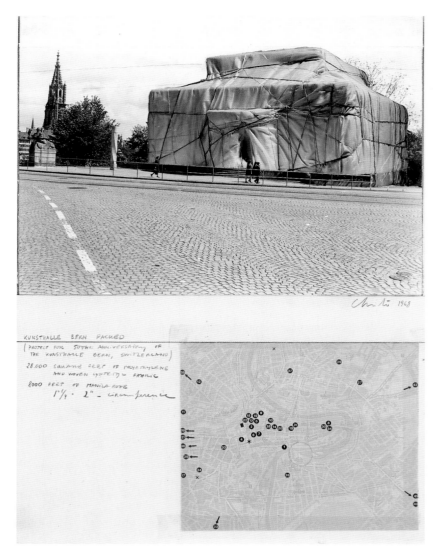

29

Wrapped Kunsthalle, Project for Bern

Photocollage 1968

17 1/2 x 13 1/4 in.

Photographs, pencil, map, and tape

Photograph by Harry Shunk

Collection of Jeanne-Claude Christo, New York

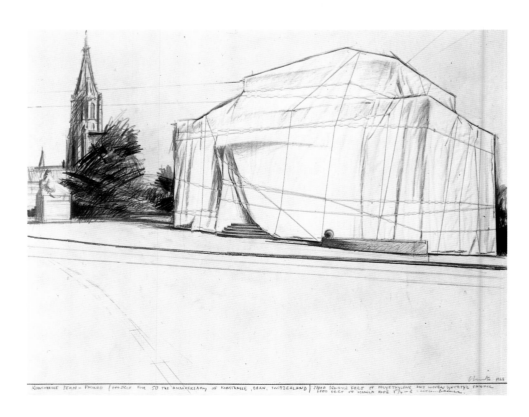

30

Wrapped Kunsthalle, Project for Bern

Collage 1968

22 x 28 in.

Pencil, fabric, twine, charcoal, and crayon

Photograph by Harry Shunk

Collection of Jeanne-Claude Christo, New York

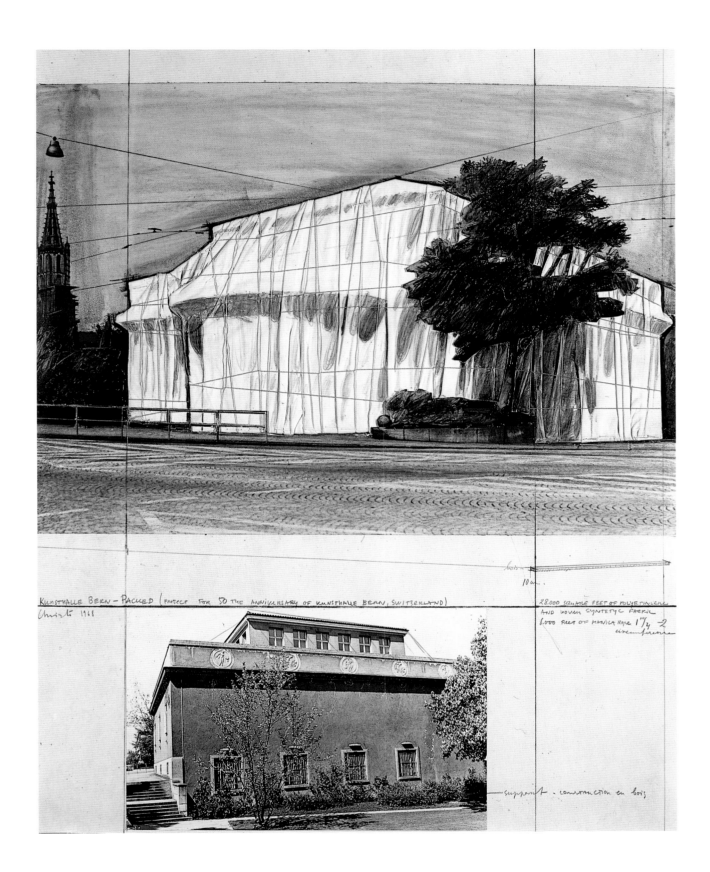

31

Wrapped Kunsthalle, Project for Bern

Collage 1968

28 x 22 in.

Pencil, fabric, twine, photograph by Harry
Shunk, charcoal, and crayon

Wrapped Kunsthalle, Bern, 1968

A Swiss art museum, the Kunsthalle in Bern, gave Christo his first opportunity to fully package an entire building. July 1968 marked the fiftieth anniversary of the museum, and the event was celebrated with an international group show of environmental works by twelve artists. As one of the dozen participants, Christo showed nothing inside the museum, but literally packaged the entire show. "I took the environments of eleven other artists," he remarked with amusement, "and packaged them. I had my whole environment inside." Christo shrouded the Kunsthalle with 27,000 square feet of reinforced polyethylene, which was left over from the discarded first skin of the Kassel air package, secured it with 10,000 feet of nylon rope, and made a slit in front of the main entrance so visitors could enter the building. The Kunsthalle is a bulky-looking building, despite its curved walls and sloping roof, but its hulking silhouette was considerably softened by the mantle of translucent polyethylene. The only architectural elements that remained visible with any sharpness and clarity were the contours of the roof and cornices. The sides of the building were luxuriously swagged and the fabric veiling was continually animated by soft, billowing folds and an always-changing pattern of glimmering highlights.

The wrapping process took six days with the help of eleven construction workers. Because no nails could be driven into the building, special wooden supports had to be built for fastening the fabric to the building and, at one point, to facilitate work on the roof, the local fire brigade was called upon to lend a hydraulic ladder. Insurance companies refused to underwrite the Kunsthalle and its valuable contents during the period it was to be wrapped, so to guard against possible fire and vandalism, museum director Harald Szeemann had six watchmen posted around the building at all times. As this proved to be quite expensive, the building was unwrapped after one week (David Bourdon, *Christo,* New York, 1970, p. 40).

32

Wrapped Kunsthalle, Bern, July 1968

Photograph by Thomas Cugini

33

Wrapped Kunsthalle, Bern, July 1968

Photograph by Thomas Cugini
(Following two pages)

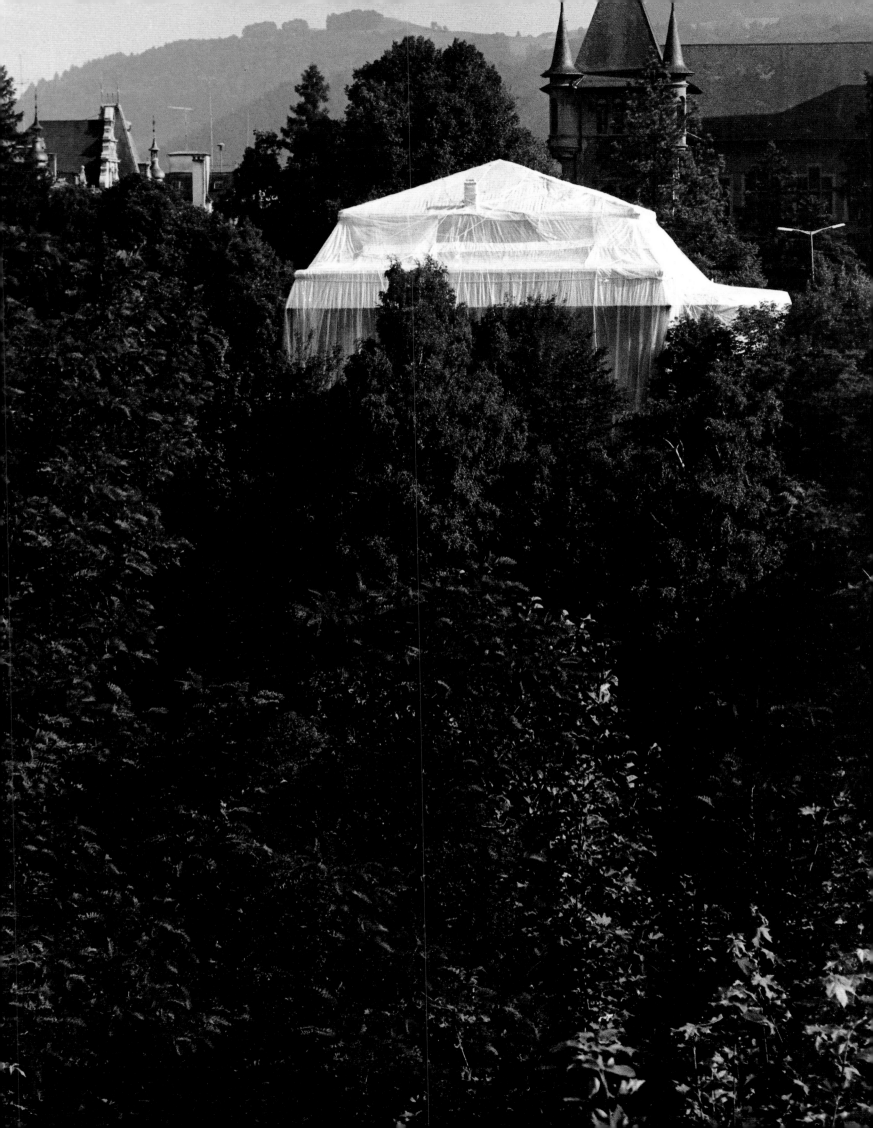

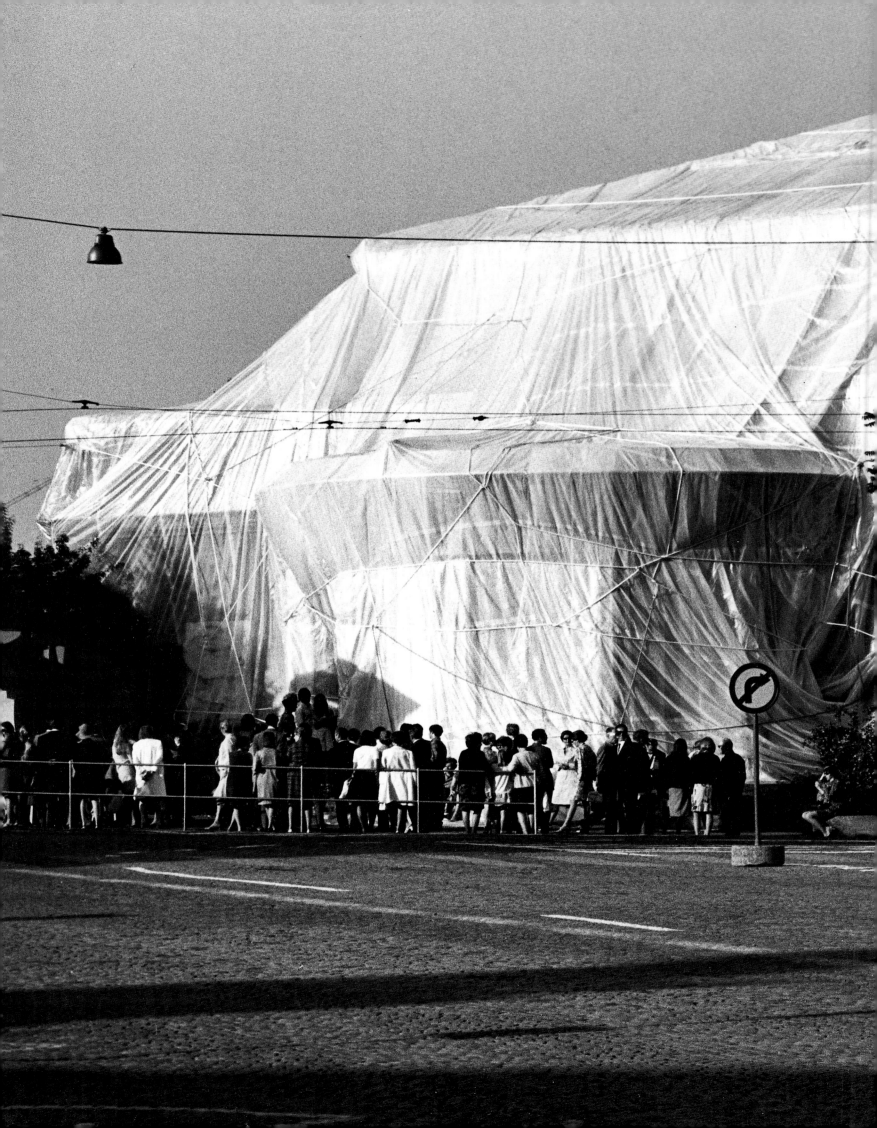

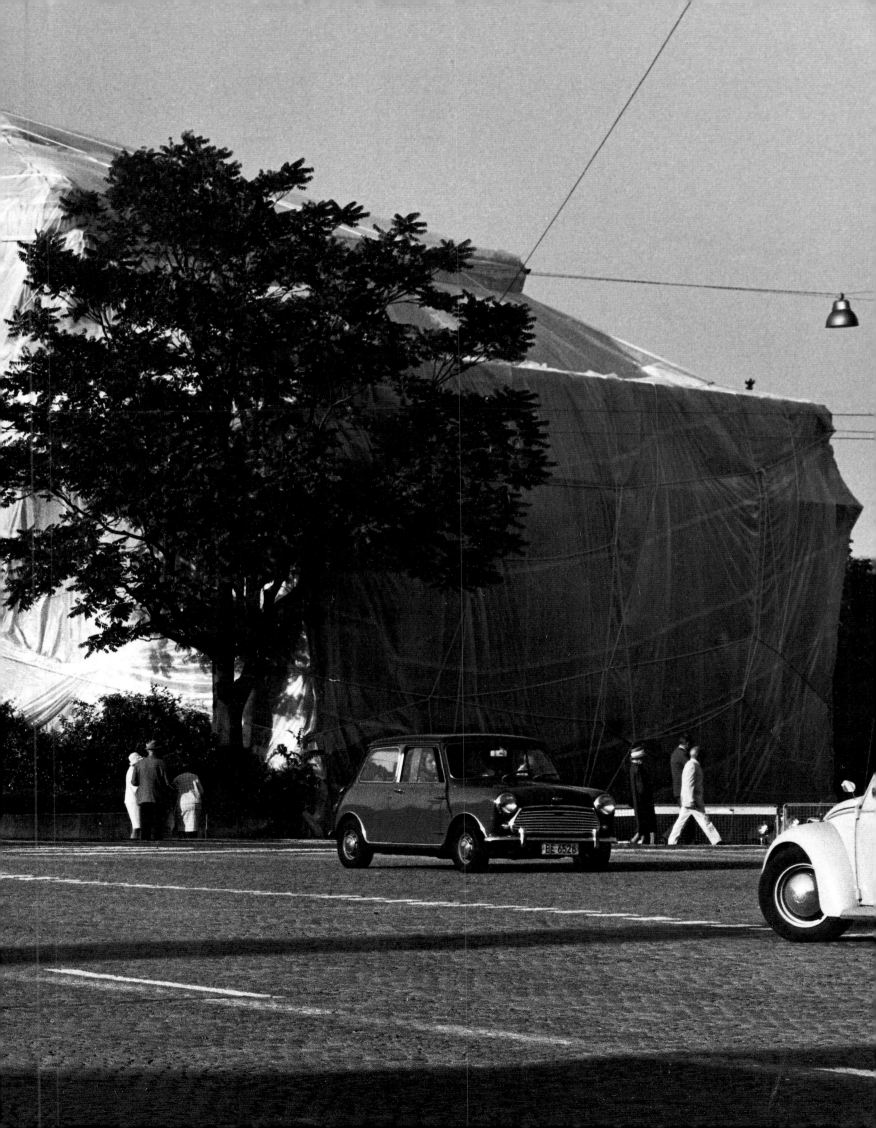

34

5,600 Cubicmeter Package, Project for documenta 4, Kassel
Scale model 1968
32 ½ x 48 ¼ x 24 in.
Polyethylene, twine, wood, cardboard, metal, and paint

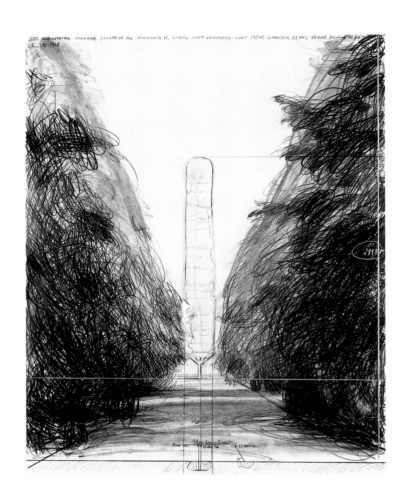

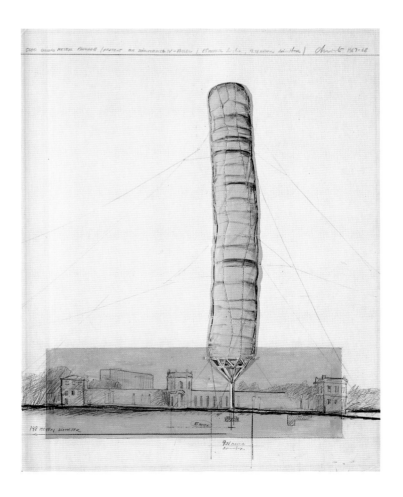

5,600 Cubicmeter Package, Project for documenta 4, Kassel
Collage 1968
28 x 22 in.
Pencil, fabric, and twine
Photograph by Harry Shunk
Collection of Jeanne-Claude Christo, New York

36

5,600 Cubicmeter Package, Project for documenta 4, Kassel
Collage 1968
28 x 22 in.
Pencil, fabric, twine, polyethylene, charcoal,
crayon, and cardboard
Photograph by Eeva-Inkeri
Collection of Jeanne-Claude Christo, New York

37

5,600 Cubicmeter Package, Project for documenta 4, Kassel
Collage 1967–68
28 x 22 in.
Pencil, coated fabric, twine, tracing paper,
charcoal, crayon, and cardboard
Photograph by Harry Shunk
Collection of Jeanne-Claude Christo, New York

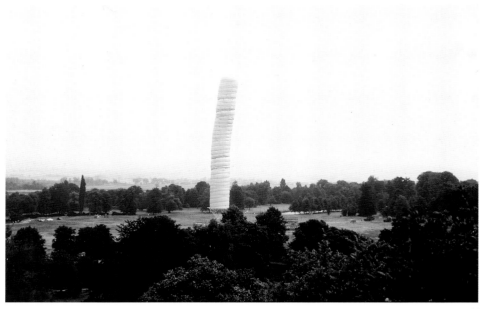

38

5,600 Cubicmeter Package

Christo's largest air package was his contribution to documenta 4, Kassel, Germany. For three months, an oblong-shaped "balloon" with 21,500 square feet of coated fabric and 2 miles of rope was secured by steel cables to 6 concrete bases. The air package, weighing 13,000 pounds, was 279 feet high and 33 feet in diameter.
Engineer: Dimiter Zagoroff

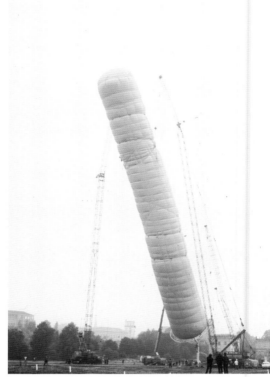

39

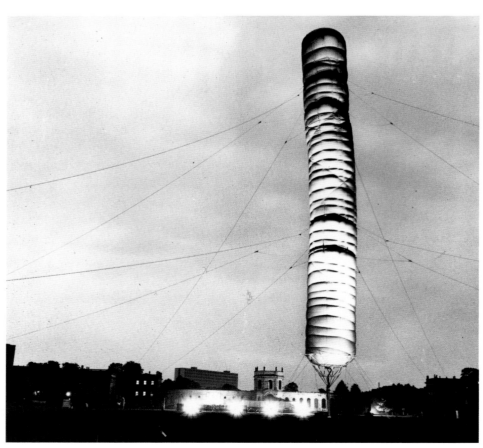

40

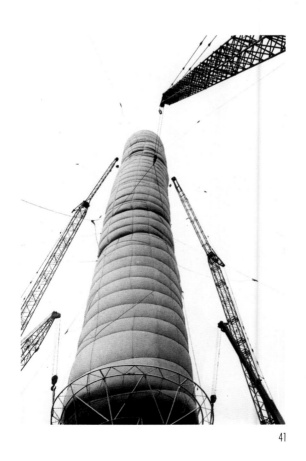

41

38–42

5,600 Cubicmeter Package, documenta 4, Kassel, 1967–68

Photographs by Klaus Baum

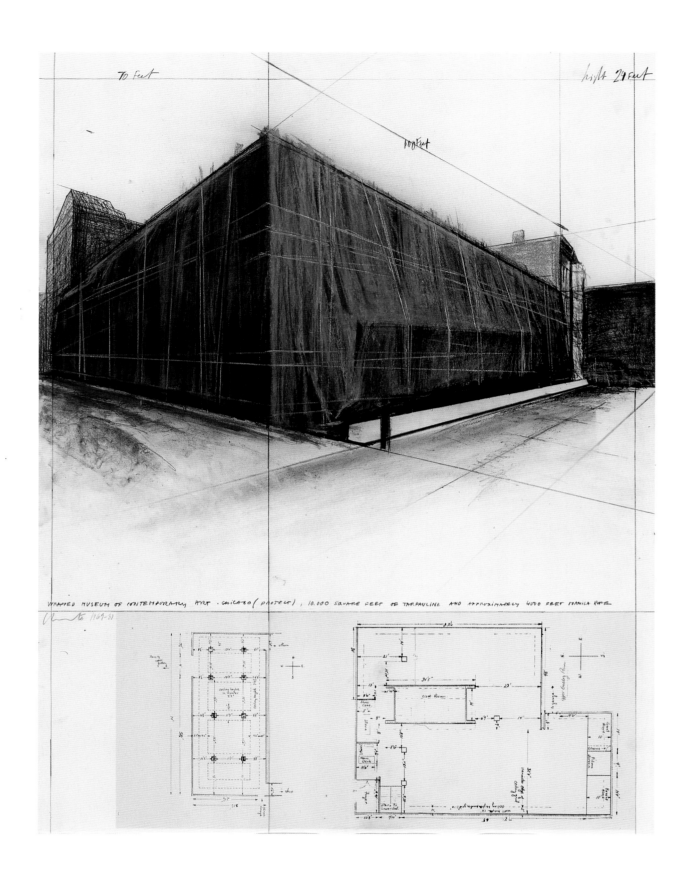

43

Wrapped Museum of Contemporary Art, Project for Chicago

Drawing, collage 1969—81

42 1/8 x 32 3/4 in.

Pencil, charcoal, crayon, and technical data

Photograph by Harry Shunk
Collection of Jeanne-Claude Christo, New York

44

Wrapped Floor, Museum of Contemporary Art, Chicago, 1969

Photograph by Harry Shunk

Wrapped Floor (1969)

A complementary work to the *Wrapped Museum of Contemporary Art, Chicago*. The floor and staircases in the main gallery of the museum were covered with 2,800 square feet of drop cloth. Christo also created *Wrapped Floors* at museums in Krefeld (Germany), Tokyo, and Basel.

45

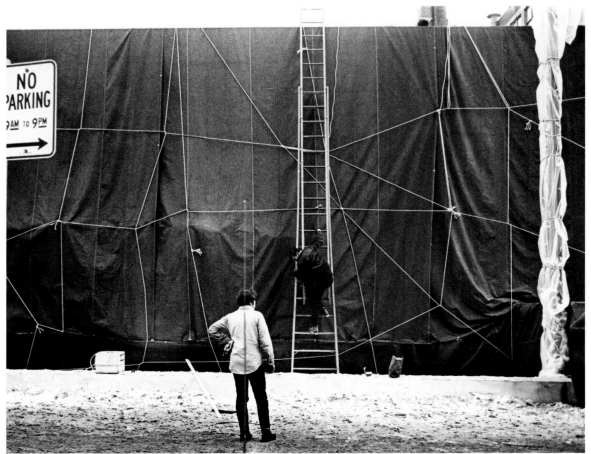

46

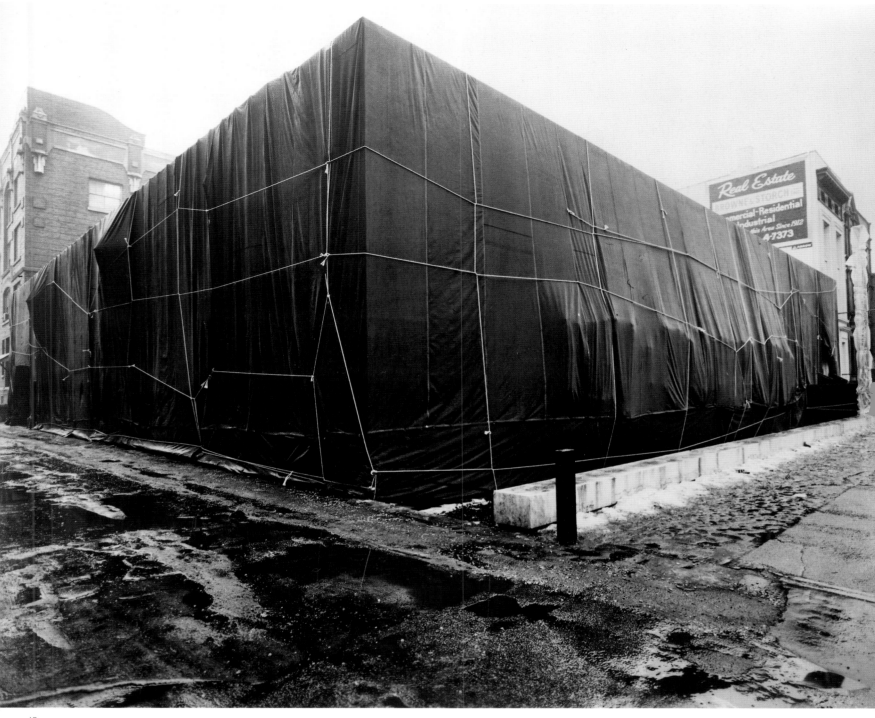

47

45 – 47

Wrapped Museum of Contemporary Art, Chicago, 1969

Photographs by Harry Shunk

Wrapped Museum of Contemporary Art, Chicago (1969)

The first large-scale project realized in the United States. The rectangular, single-story building was covered with 10,000 square feet of dark brown tarpaulins and tied with 3,600 feet of rope. The sign by the entrance was enveloped in clear plastic. The museum remained wrapped for forty-five days.

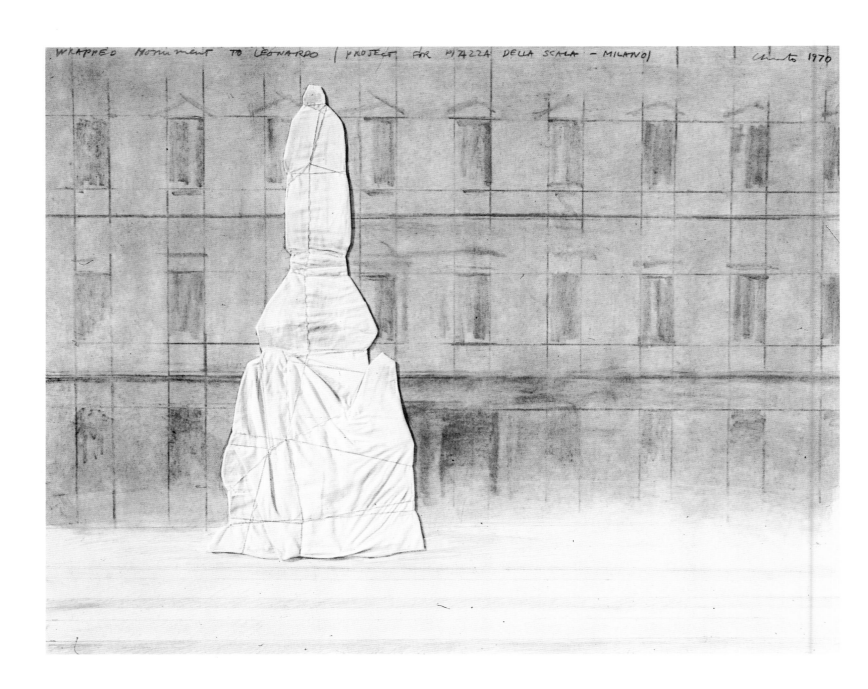

WRAPPED MONUMENT TO LEONARDO (PROJECT FOR PIAZZA DELLA SCALA - MILANO) Christo 1970

48

**Wrapped Monument to Leonardo da Vinci, Project for the
Piazza della Scala, Milan**

Collage 1970

22 x 28 in.

Pencil, fabric, twine, and charcoal

Photograph by Harry Shunk
Collection of The Lilja Art Fund Foundation

49

**Wrapped Monument to Vittorio Emanuele, Project for the
Piazza del Duomo, Milan**

Collage 1970

28 x 22 in.

Pencil and crayon

Photograph by Harry Shunk
Collection of Jeanne-Claude Christo, New York

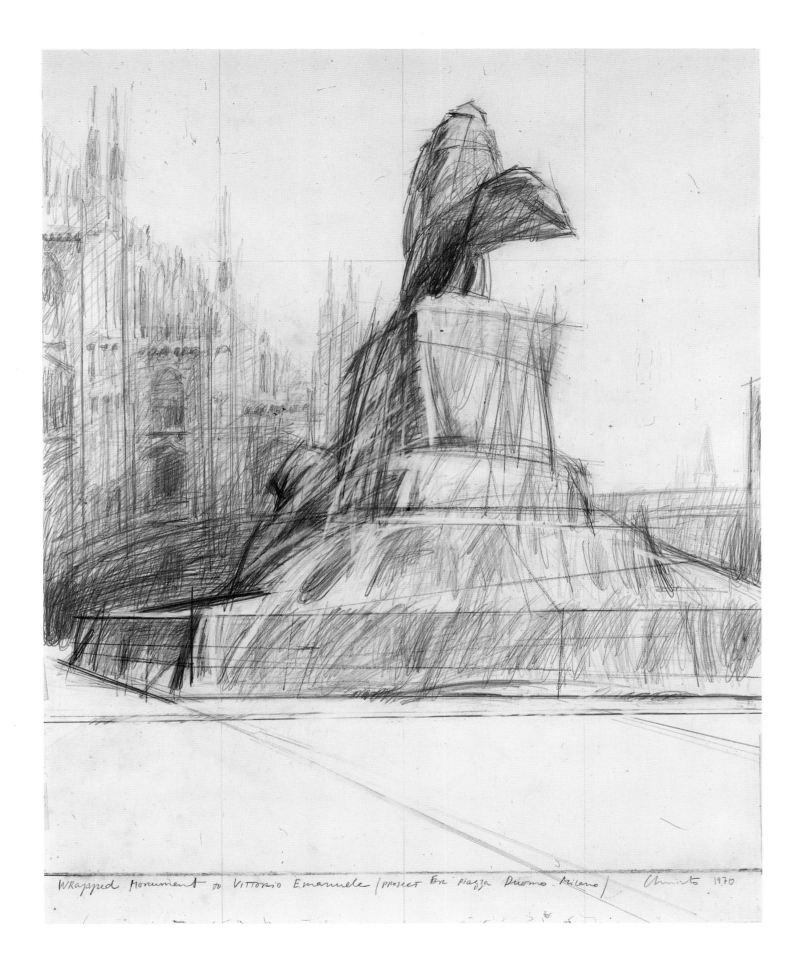

Wrapped Monument to Vittorio Emanuele (project for Piazza Duomo, Milano) Christo 1970

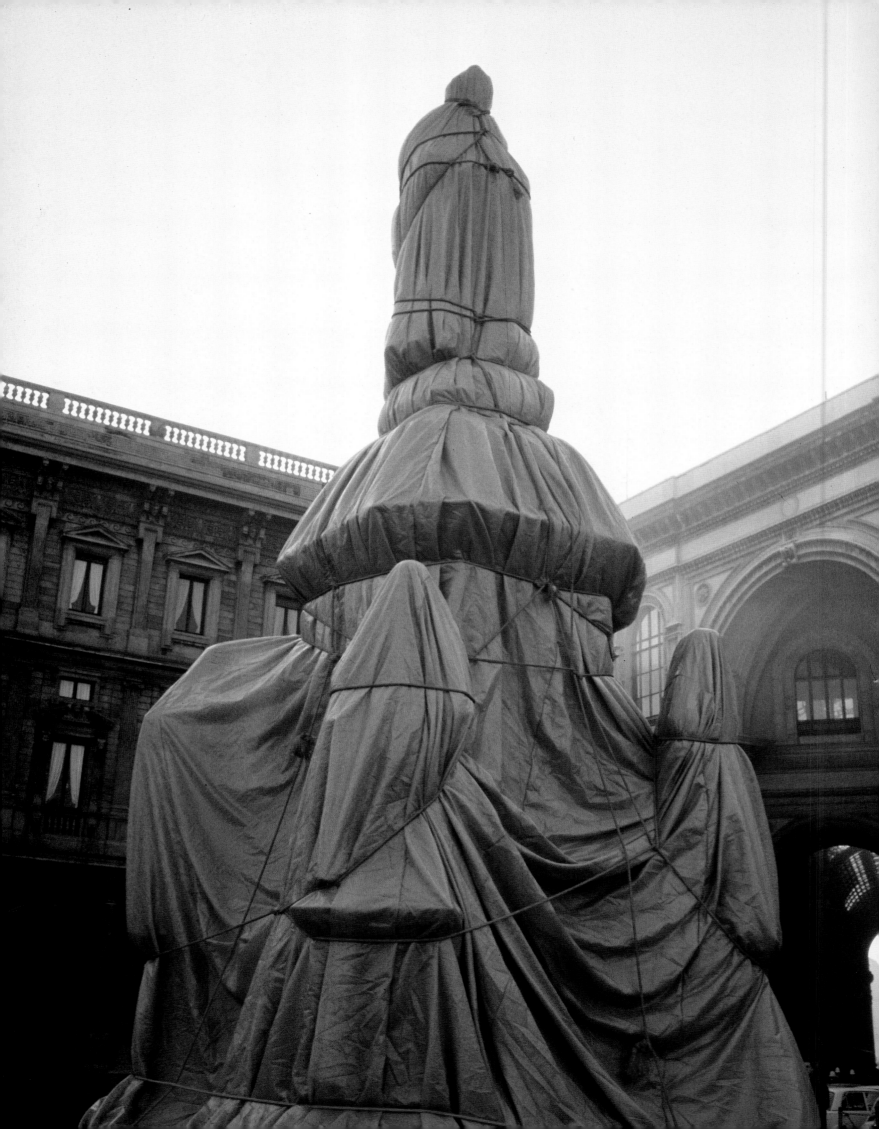

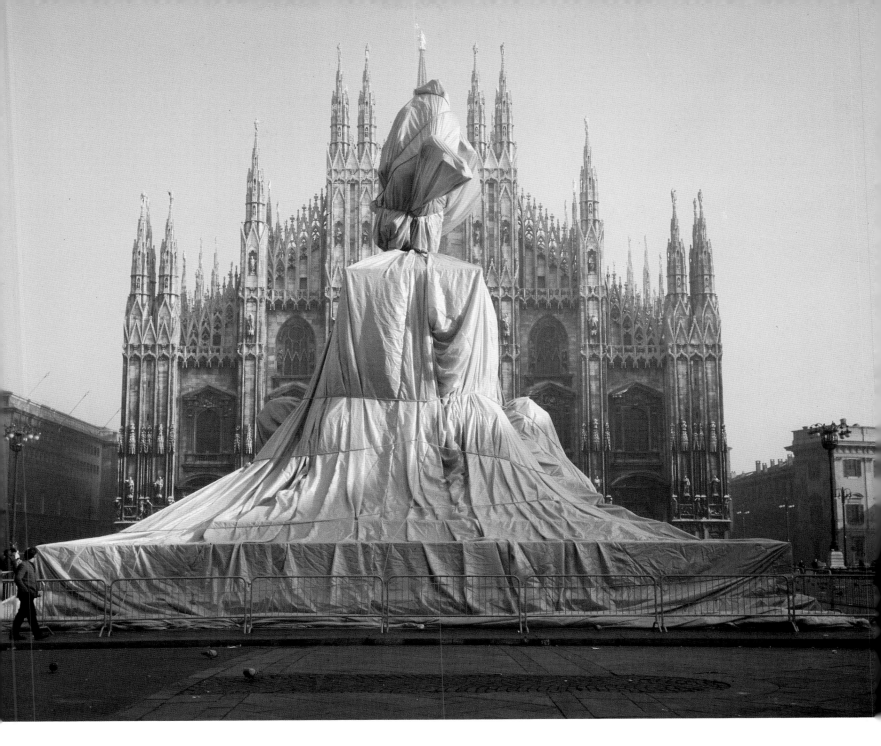

51

Wrapped Monument to Vittorio Emanuele,
Piazza del Duomo, Milan, 1970

Photographs by Harry Shunk

50

Wrapped Monument to Leonardo da Vinci,
Piazza della Scala, Milan, 1970

Photograph by Harry Shunk

Wrapped Monument to Leonardo da Vinci and **Wrapped
Monument to Vittorio Emanuele (1970)**

Two temporary works concurrent with a major exhibition of Nouveau
Réalisme in Milan. The statue of Leonardo da Vinci on the Piazza della Scala
remained enveloped in fabric for several days, while the statue of the last
king of Italy, Vittorio Emanuele, on the Piazza del Duomo was wrapped for
only forty-four hours. In both cases, synthetic fabric and rope were used.

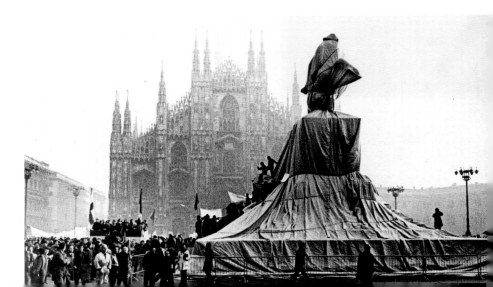

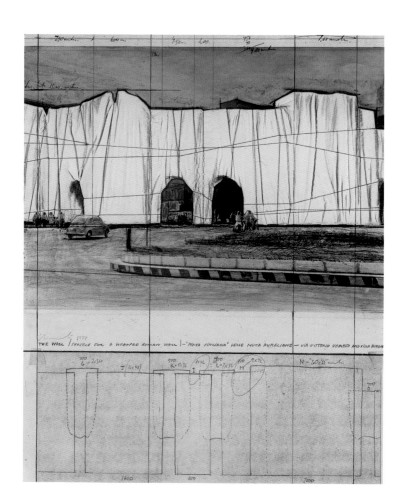

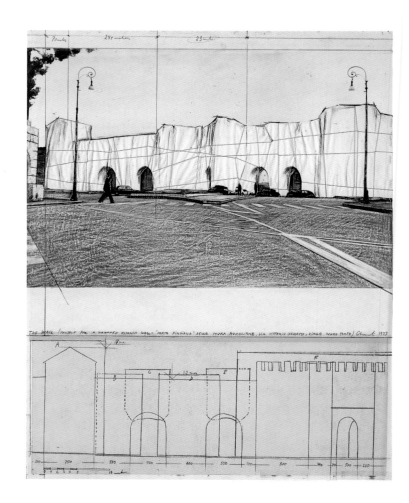

52

The Wall, Project for a Wrapped Roman Wall

Collage 1974

28 x 22 in.

Pencil, fabric, twine, charcoal, crayon, pastel, photograph by Harry Shunk, and map

Photograph by Harry Shunk
Collection of Jeanne-Claude Christo, New York

53

The Wall, Project for a Wrapped Roman Wall

Collage 1973

28 x 22 in.

Pencil, fabric, twine, photostat from a photograph by Harry Shunk, charcoal, crayon, pastel, tracing paper, and tape

Photograph by Harry Shunk
Collection of Jeanne-Claude Christo, New York

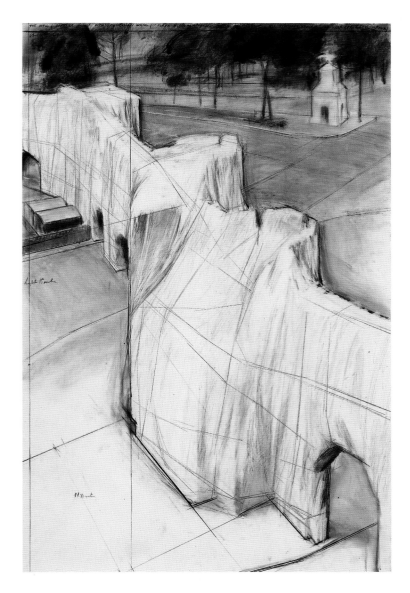

54

The Wall, Project for a Wrapped Roman Wall
Collage 1974
28 x 22 in.
Pencil, fabric, twine, charcoal, crayon, pastel,
tracing paper, tape, and ballpoint pen

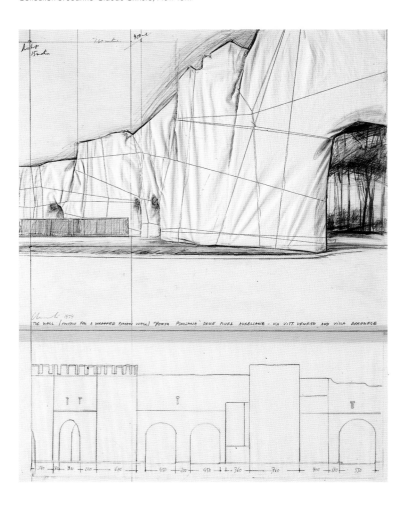

55

The Wall, Project for a Wrapped Roman Wall
Drawing 1974
65 x 42 in.
Pencil, charcoal, and crayon

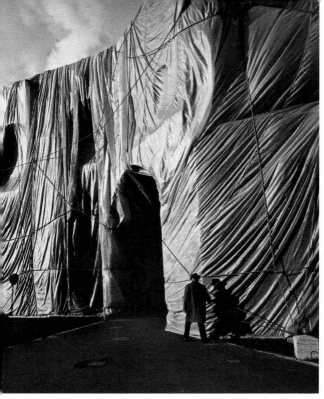

The Wall, Wrapped Roman Wall, Via Veneto and Villa Borghese, Rome (1974)

A temporary work of art situated at the end of the Via Veneto, one of the busiest avenues of Rome, and at the edge of the gardens of the Villa Borghese. The two-thousand-year-old wall was built by the emperor Marcus Aurelius; 50 feet high and 1,100 feet long, it was completely wrapped in polypropylene fabric and rope for forty days. Of the four arches that were wrapped, three continued to be used by traffic, while one was reserved for pedestrians.

56, 57

The Wall, Wrapped Roman Wall, 1974

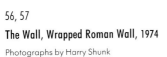

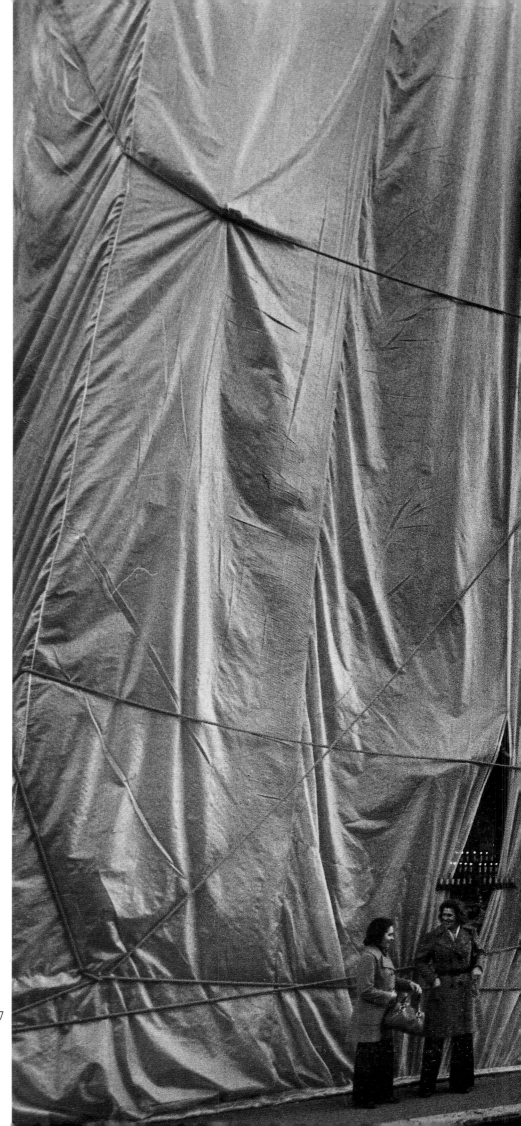

58

Wrapped Walk Ways, Project for the J. L. Loose Memorial Park, Kansas City, Missouri

Collage in two parts 1978

28 x 11 in. and 28 x 22 in.

Pencil, fabric, photograph by Wolfgang Volz, charcoal, crayon, pastel, and technical data

Photograph by Wolfgang Volz
Collection of The Lilja Art Fund Foundation

59

Wrapped Walk Ways, Project for the J. L. Loose Memorial Park, Kansas City, Missouri

Collage in two parts 1978

28 x 22 in. and 28 x 22 in.

Pencil, fabric, photograph by Wolfgang Volz, charcoal, crayon, pastel, and map

Photograph by Wolfgang Volz
Collection of The Lilja Art Fund Foundation

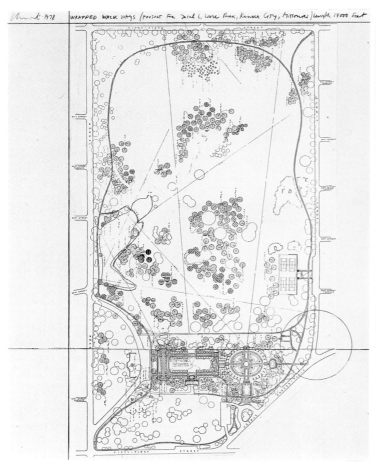

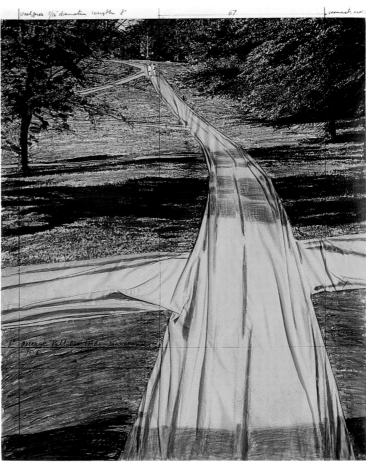

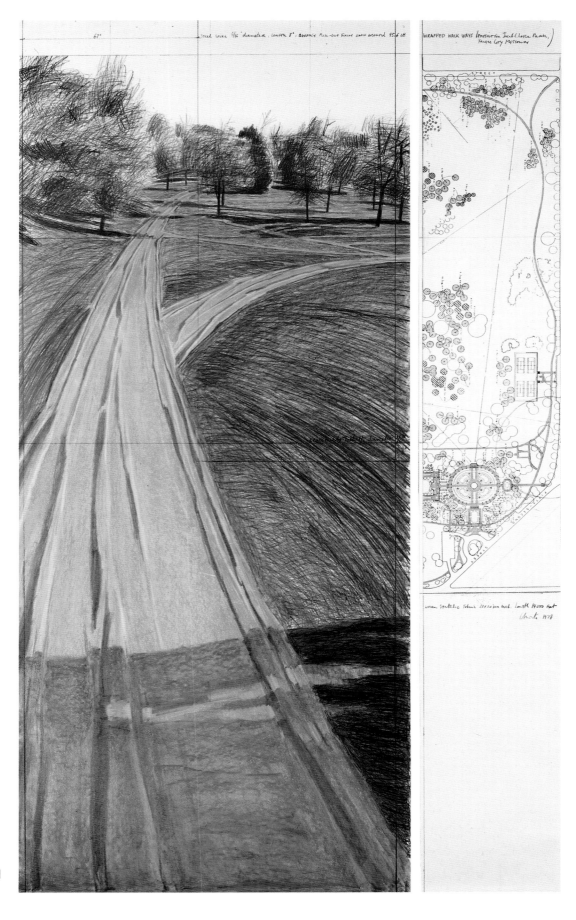

60

**Wrapped Walk Ways, Project for the J. L. Loose Memorial
Park, Kansas City, Missouri**
Drawing in two parts 1978
96 x 42 in. and 96 x 15 in.
Pencil, charcoal, crayon, pastel, and map

Photograph by Wolfgang Volz
Collection of The Lilja Art Fund Foundation

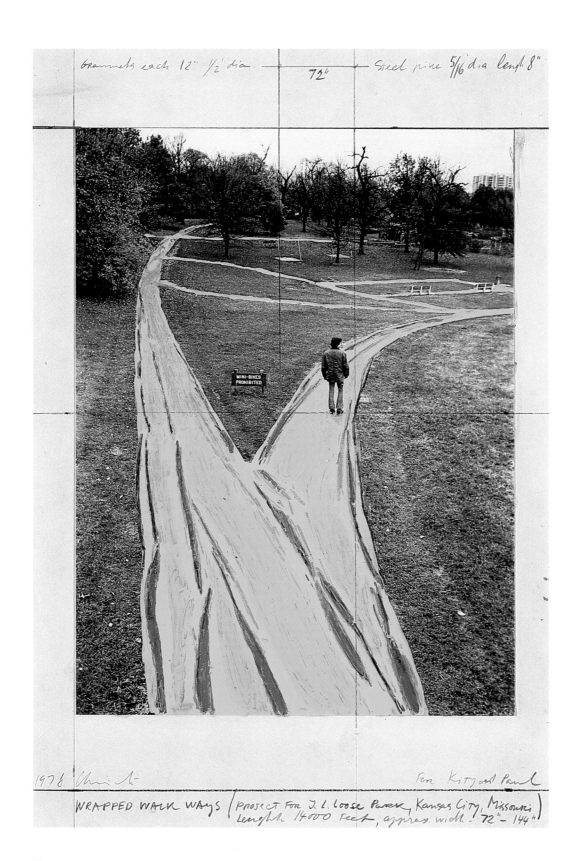

61

Wrapped Walk Ways, Project for the J. L. Loose Memorial Park, Kansas City, Missouri

Collage 1978

15 x 11 in.

Pencil, enamel paint, photograph by Wolfgang Volz, charcoal, and crayon

Photograph by Wolfgang Volz

Collection of Jeanne-Claude Christo, New York

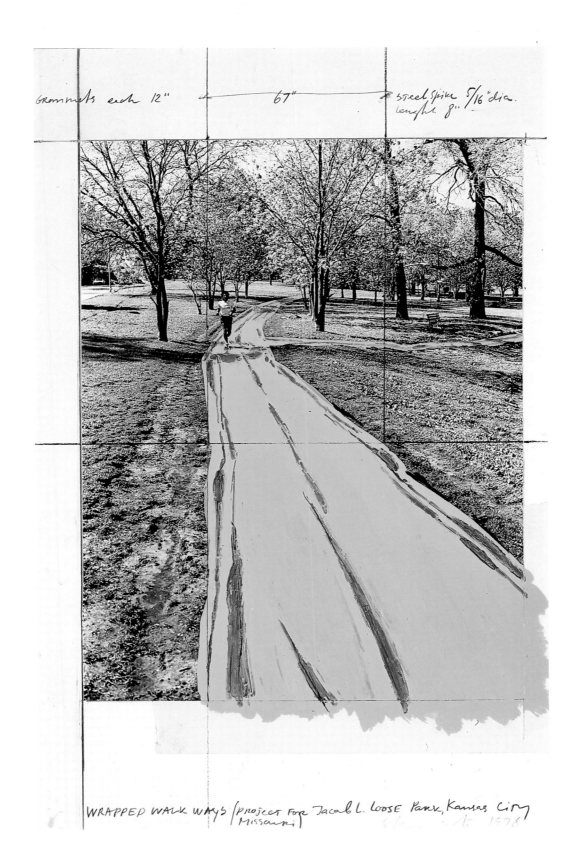

Grommets each 12" 67" steel spike 5/16" dia.
length 8".

WRAPPED WALK WAYS (project for Jacob L. Loose Park, Kansas City
Missouri) 1978

62

**Wrapped Walk Ways, Project for the J. L. Loose Memorial
Park, Kansas City, Missouri**
Collage 1978
15 x 9 ½ in.
Pencil, enamel paint, photograph by Wolfgang
Volz, charcoal, crayon, and tape
Photograph by Wolfgang Volz
Collection of Jeanne-Claude Christo, New York

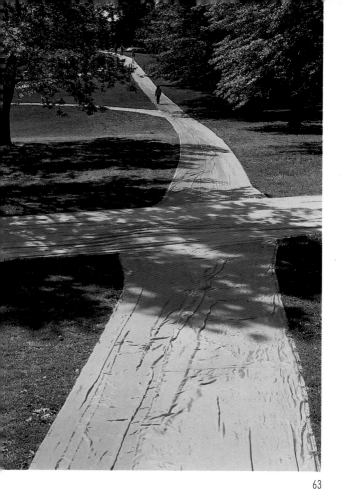
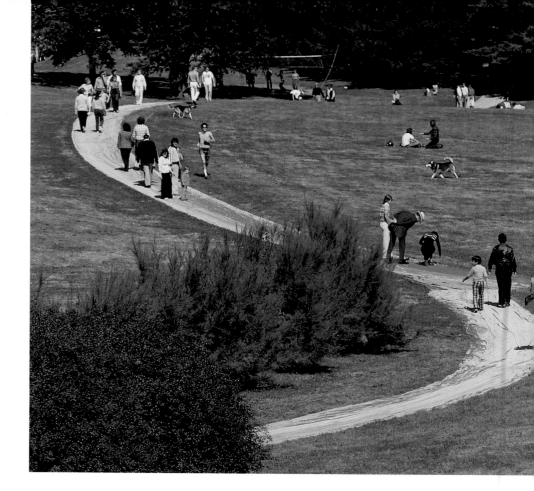

63 – 66

Wrapped Walk Ways, J. L. Loose Memorial Park,
Kansas City, Missouri, 1977–78

Photographs by Wolfgang Volz

Wrapped Walk Ways, J. L. Loose Memorial Park, Kansas City, Missouri (1977–78)

Christo's *Wrapped Walk Ways* in J. L. Loose Memorial Park, Kansas City, consisted of the installation of 136,000 square feet of saffron-colored nylon cloth covering some 105,000 square feet of formal garden walkways and jogging paths. Installation began on Monday, Monday, October 2nd, and was completed on Wednesday, October 4th. The Kansas City building contractor commissioned to install the fabric employed eighty-four people for the task, including thirteen construction workers and four professional seamstresses. The cloth was secured by 34,500 steel spikes 7× ⅛ inches, driven into the soil through brass grommets in the fabric, and 40,000 staples into wooden edges on the stairways. After over 52,000 feet of seams and hems were sewn in a West Virginia factory, professional seamstresses, using portable sewing machines and aided by many assistants, completed the sewing in the park. The Contemporary Art Society of the Nelson Gallery, which was instrumental in getting the construction permits, sponsored an exhibition "Wrapped Walk Ways" at the Nelson-Atkins Museum of Art.

The project remained in the park until October 16th, when the material was removed and given to the Kansas City Parks Department. This project, too, was financed exclusively by Christo.

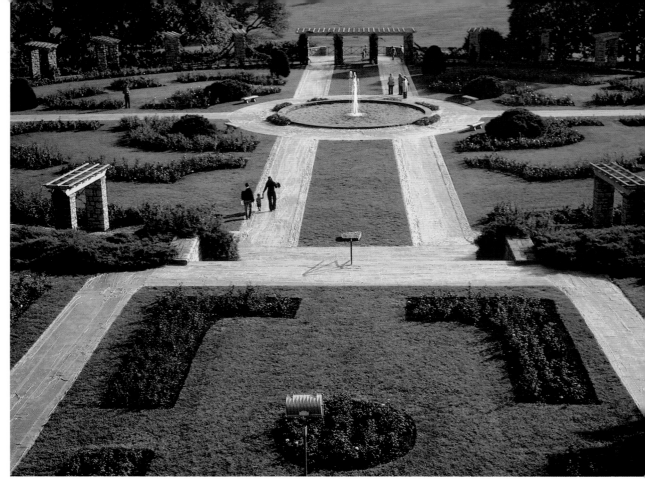

64 65

66

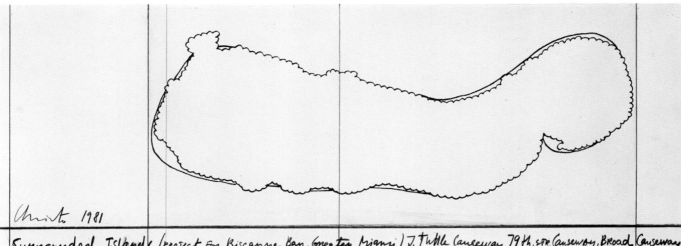

Christo 1981

Surrounded Islands (Project for Biscayne Bay, Greater Miami) J. Tuttle Causeway, 79th, str. Causeway, Broad Causeway

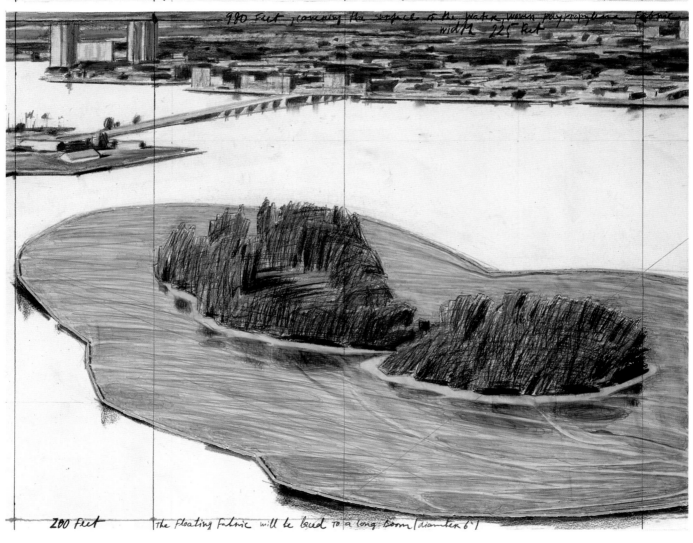

980 Feet, covering the surface of the Water, woven polypropylene Fabric
width 225 Feet

200 Feet The Floating Fabric will be laced to a long Boom (diameter 6°)

67

**Surrounded Islands, Project for Biscayne Bay,
Greater Miami, Florida**

Collage in two parts 1981

11 x 28 in. and 22 x 28 in.

Pencil, fabric, charcoal, crayon, pastel, and
technical drawing

Photograph by Wolfgang Volz
Collection of Jeanne-Claude Christo, New York

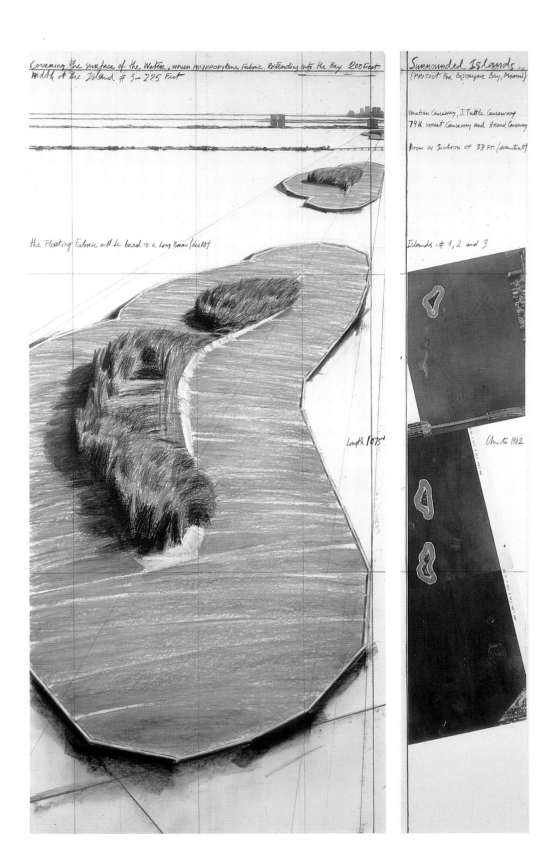

Covering the surface of the Water, woven polypropylene Fabric, extending into the Bay 200 Feet
Width of the Island #3 — 225 Feet

the Floating Fabric will be laced to a Long Boom (dia 10')

Length 1075'

Surrounded Islands
(PROJECT FOR Biscayne Bay, Miami)

Venetian Causeway, J. Tuttle Causeway
79th street Causeway and Broad Causeway

Boom in Section of 33 Ft. (drawn full)

Islands #1, 2 and 3

Christo 1982

68

**Surrounded Islands, Project for Biscayne Bay, Greater
Miami, Florida**

Drawing in two parts 1982

96 x 42 in. and 96 x 15 in.

Pencil, charcoal, crayon, pastel, aerial photo-
graph, and paint

Photograph by Wolfgang Volz
Collection of Jeanne-Claude Christo, New York

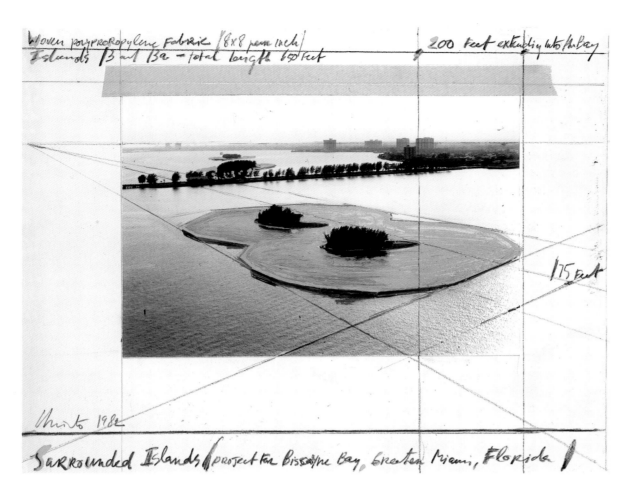

Handwritten annotations on the collage:

Woven polyproropylene Fabric (8 x 8 per inch)
Islands B and Ba – total length 650 feet

200 feet extending into the Bay

175 feet

Christo 1982

Surrounded Islands (project for Biscayne Bay, Greater Miami, Florida)

69

Surrounded Islands, Project for Biscayne Bay, Greater Miami, Florida

Collage 1982

11 x 14 in.

Pencil, enamel paint, photograph by Wolfgang Volz, charcoal, crayon, and tape

Photograph by Wolfgang Volz
Collection of Jeanne-Claude Christo, New York

Surround Islands, Biscayne Bay, Greater Miami, Florida, 1980–83

On May 7th, 1983, the installation of *Surrounded Islands* was completed. In Biscayne Bay, between the city of Miami, North Miami, the village of Miami Shores, and Miami Beach, eleven of the islands situated in the area of Bakers Haulover Cut, Broad Causeway, 79th Street Causeway, Julia Tuttle Causeway, and Venetian Causeway were surrounded with pink woven polypropylene fabric covering the surface of the water, floating and extending out 200 feet from each island into the bay. In two cases, a pair of islands were wrapped together to form a unit.

For two weeks *Surrounded Islands,* spreading over seven miles, was seen, approached, and enjoyed by the public, from the causeways, the land, the water, and the air. The luminous pink color of the shiny fabric harmonized with the tropical vegetation of the uninhabited verdant islands, the light of the Miami sky, and the colors of the shallow waters of Biscayne Bay.

From April 1981, attorneys Joseph Z. Fleming, Joseph W. Landers, marine biologist Dr. Anitra Thorhaug, ornithologists Dr. Oscar Owre and Meri Cummings, mammal expert Dr. Daniel Odell, marine engineer John Michel, four consulting engineers, and builder/contractor Ted Dougherty of A & H Builders, Inc. worked on the preparation of the project. The marine and land crews picked up debris from the eleven islands, putting refuse in bags and carting it away after they had removed some forty tons of varied garbage: refrigerator doors, tires, kitchen sinks, mattresses, and an abandoned boat. The clean-up team also found sacrificial altars, and carcasses of many dead animals, mostly chickens and dogs – evidence, apparently, of gruesome voodoo ceremonies.

Permits were obtained from the following governmental agencies: the governor of Florida and his cabinet, the Dade County Commission, the Department of Environmental Regulation, the City of Miami Commission, the City of North Miami, the village of Miami Shores, the U.S. Army Corps of Engineers, and the Dade County Department of Environmental Resource Management. From November 1982 to April 1983, 6,500,000 square feet of woven polypropylene fabric were sewn into 79 different patterns to follow the contours of the eleven islands. A flotation strip was sewn into each seam. The sewn sections were accordion-folded at the Opa Locka Blimp Hangar to ease the unfurling on the water.

The outer edge of the floating fabric was attached to an octagonal boom 12 inches in diameter, in sections of the same color as the fabric. The boom was connected to the radial anchor lines extending from the anchors at the island to the 610 specially-made anchors, spaced at 50-foot intervals, 250 feet beyond the perimeter of each island, and driven into the limestone at the bottom of the bay. Earth anchors were driven into the land, near the foot of the trees, to secure the inland edge of the fabric, covering the surface of the beach and disappearing under the vegetation. The floating rafts of fabric and booms, varying from 12 to 22 feet in width and from 400 to 600 feet in length, were towed through the bay to each island. As with Christo's previous art projects, *Surrounded Islands* is entirely financed by the artist, through the sale of his preparatory pastel and charcoal drawings, his lithographs, collages, and early works by C.V.J. Corporation (Jeanne-Claude Christo-Javacheff, president). On May 4th, 1983, a work force of 430 began to unfurl the pink fabric. *Surrounded Islands* was tended day and night by 120 monitors in inflatable boats.

Surrounded Islands was a work of art which underlined the various elements and ways in which the people of Miami live, between land and water.

Christo, May 1983

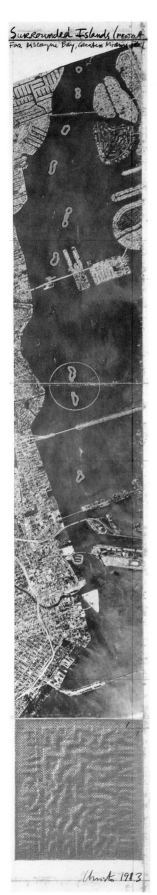

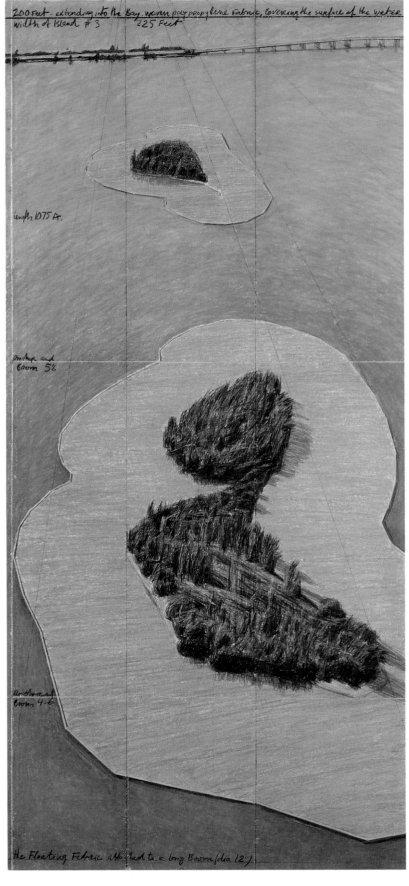

70

**Surrounded Islands, Project for Biscayne Bay,
Greater Miami, Florida**

Drawing in two parts 1983

96 x 15 in. and 96 x 42 in.

Pencil, charcoal, crayon, pastel, enamel paint,
aerial photograph, and fabric sample

Photograph by Wolfgang Volz
Collection of Simon Chaput, New York

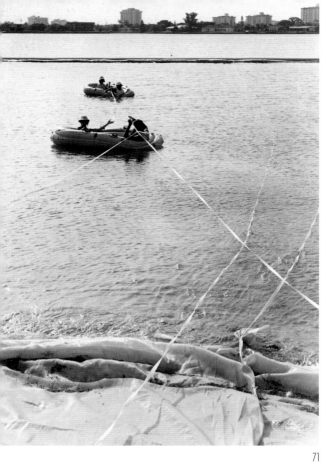
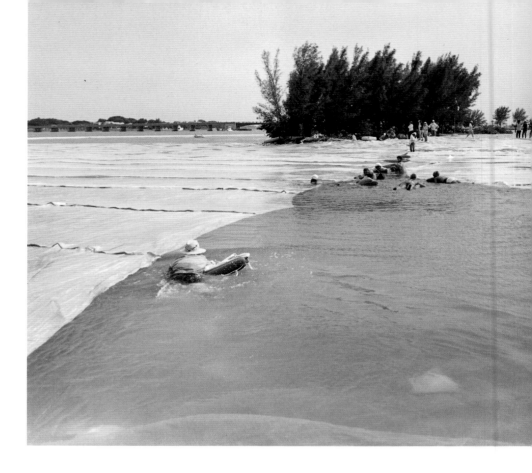

71–75

Surrounded Islands, Biscayne Bay, Greater Miami,
Florida, 1980–83

Photographs by Wolfgang Volz

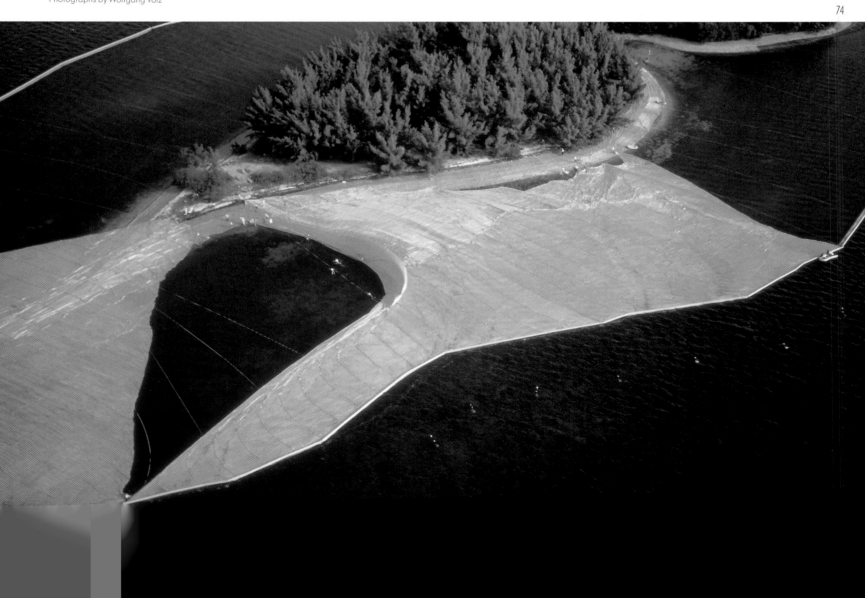

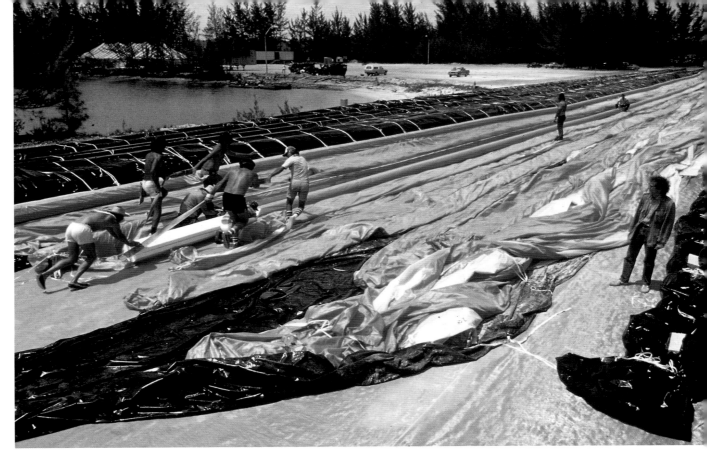

72 73

75

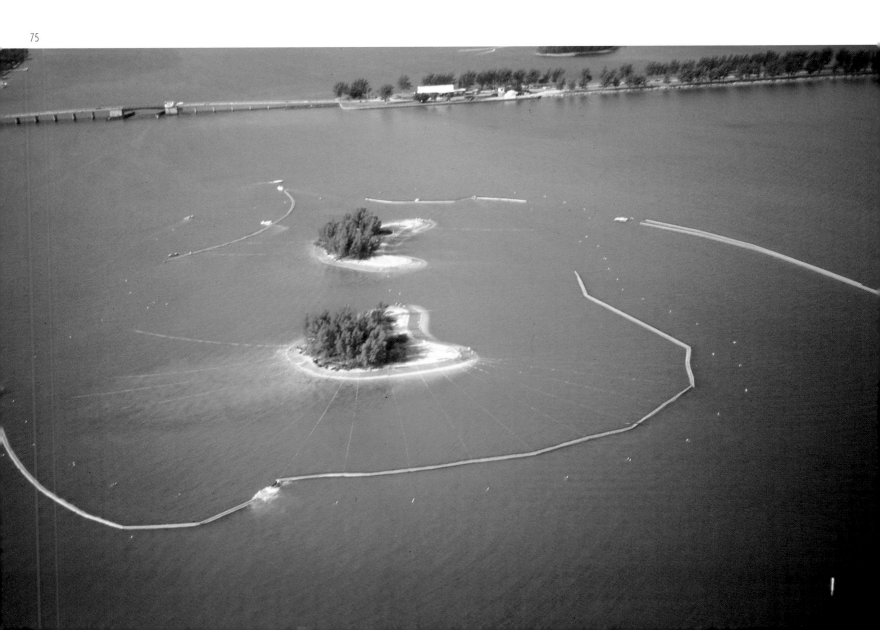

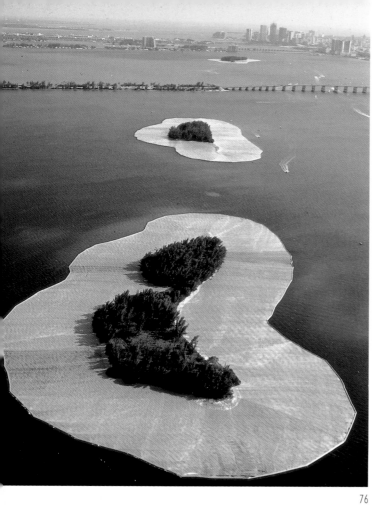

76–78

**Surrounded Islands, Biscayne Bay, Greater Miami,
Florida, 1980–83**

Photographs by Wolfgang Volz

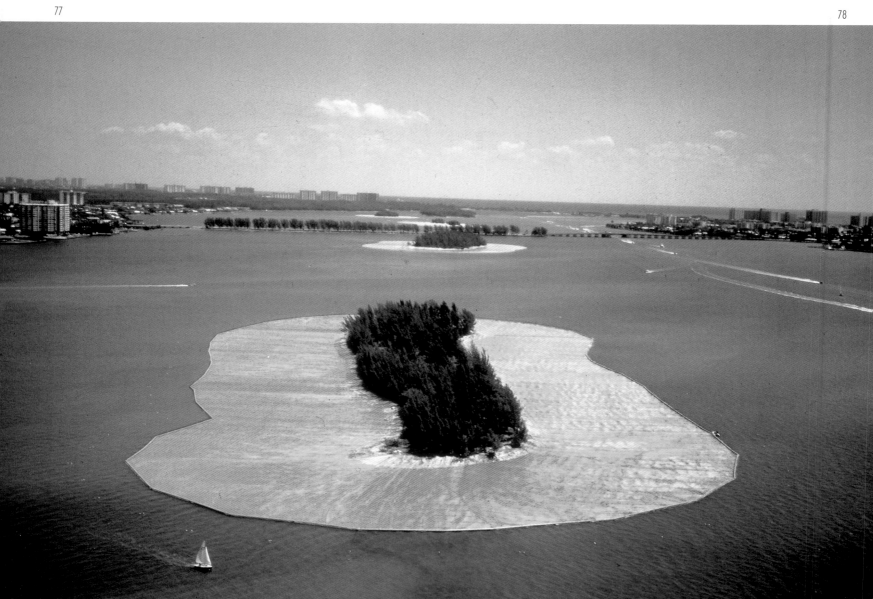

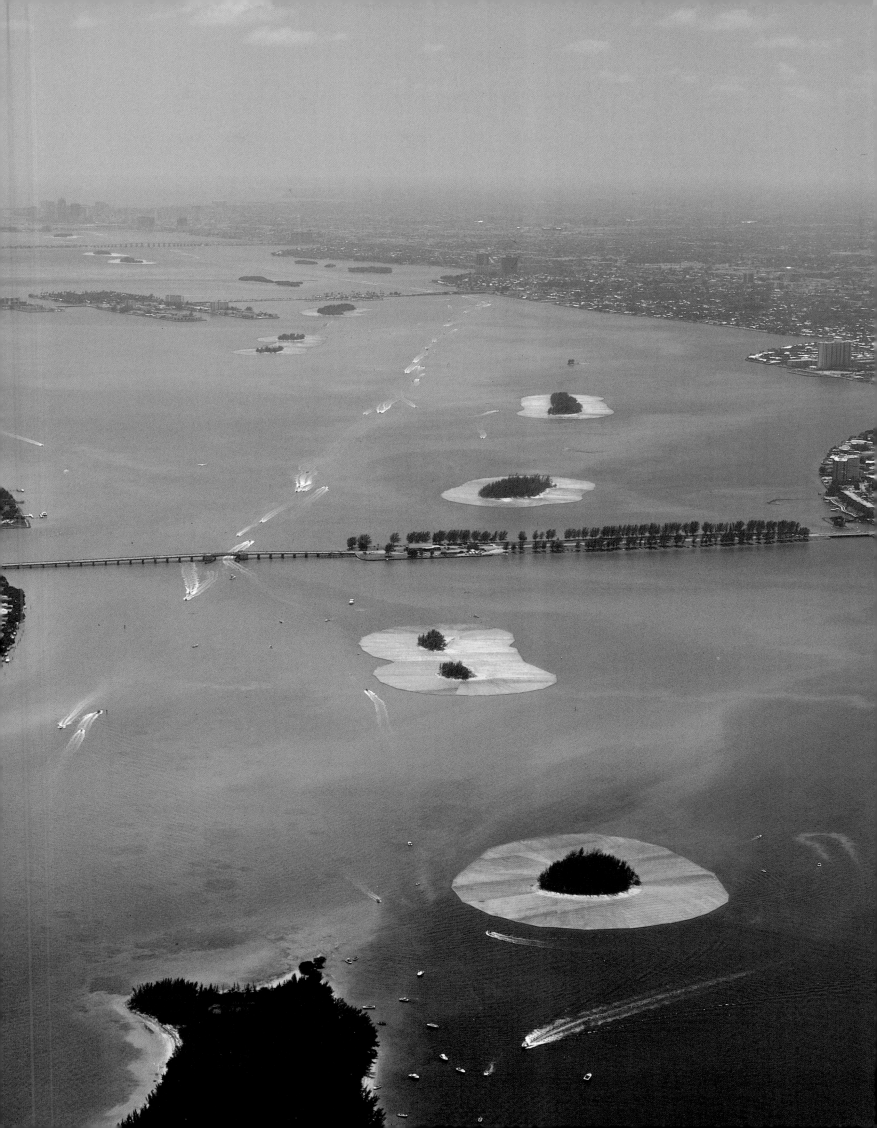

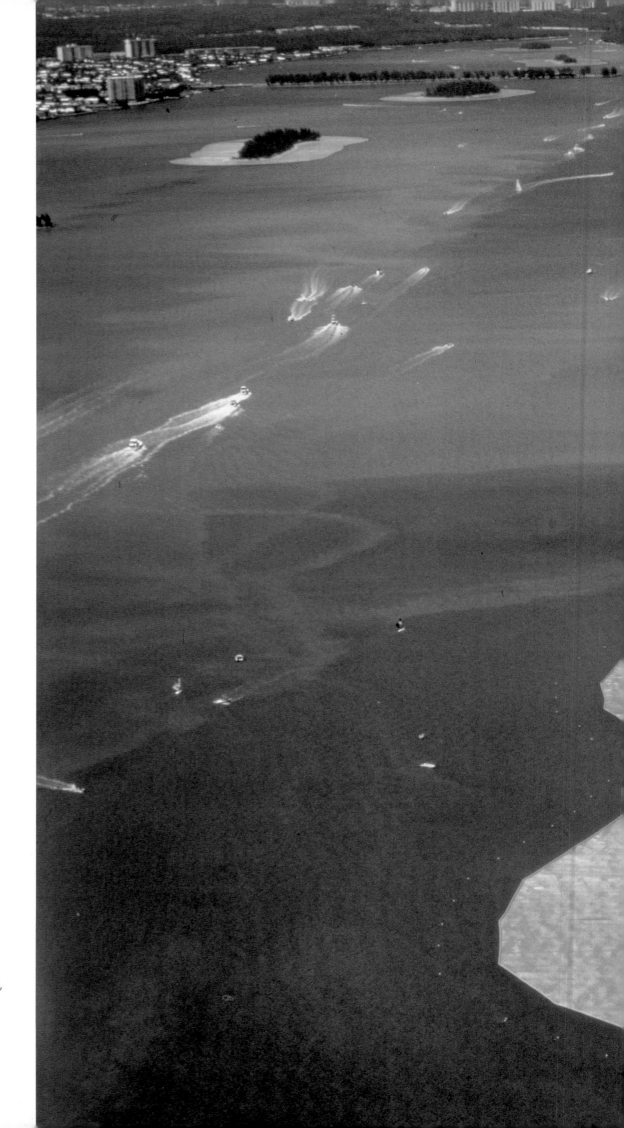

79

Surrounded Islands, Biscayne Bay, Greater Miami,
Florida, 1980 – 83

Photograph by Wolfgang Volz

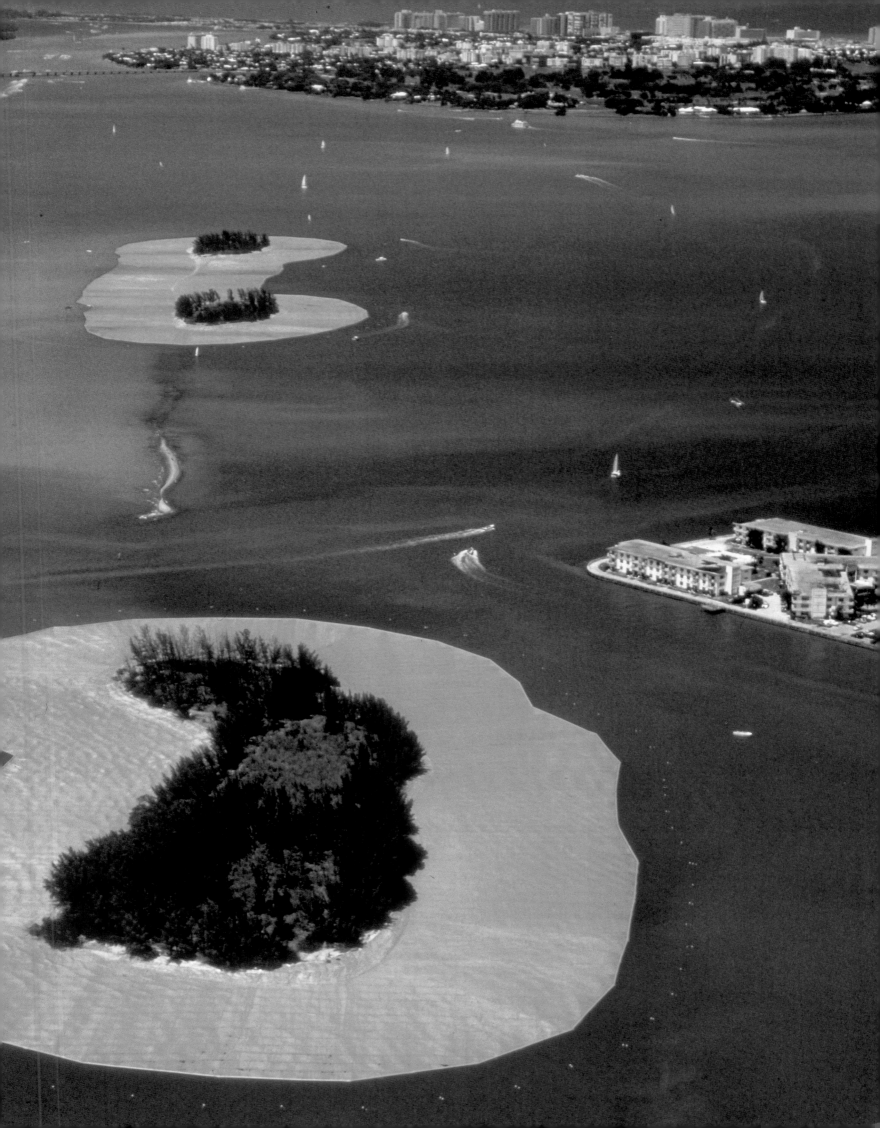

The Pont Neuf Wrapped, Paris, 1975–85

On September 22nd, 1985, a group of 300 professional workers completed Christo's temporary work of art, *The Pont Neuf Wrapped*. They had deployed 440,000 square feet of woven polyamide fabric, silky in appearance and golden sandstone in color, covering the following areas:
- the sides and vaults of the twelve arches, without hindering river traffic
- the parapets, down to the ground
- the sidewalks and curbs (pedestrians walked on the fabric)
- all the street lamps on both sides of the bridge
- the vertical part of the embankment of the western tip of the Ile de la Cité
- the esplanade of the "Vert-Galant"

The fabric was restrained by 42,900 feet of rope and secured by more than 12 tons of steel chains encircling the base of each tower, 3 feet underwater. The "Charpentiers de Paris," headed by Gerald Moulin, with French sub-contractors, were assisted by engineers from the USA who had worked on Christo's previous projects, under the direction of Theodore Dougherty: Vahé Aprahamian, James Fuller, John Thomson, and Dimiter Zagoroff. Johannes Schaub, the project's director, had submitted the work method and detailed plans and received approval for the project from the authorities of the City of Paris, the Department of the Seine, and the State Government. In crews of forty, 600 monitors worked around the clock to maintain the project and provide information, until it was removed on October 7th. All expenses related to *The Pont Neuf Wrapped* were borne by the artist, as with all his other projects, through the sale of his preparatory drawings and collages, as well as earlier works.

Begun under Henry III, the Pont-Neuf, which has connected the two banks of the Seine via the Ile de la Cité, the heart of Paris, for nearly 400 years, was completed in July 1606, during the reign of Henry IV. No other bridge in Paris offers such topographical and visual variety. From 1578 to 1890, the Pont-Neuf underwent continual changes and additions of the most extravagant sort, such as the construction of shops on the bridge under Soufflot, and the building, demolition, rebuilding, and renewed demolition of the massive rococo structure that housed the Samaritaine's water pump. Wrapping the Pont-Neuf continued this tradition of successive metamorphoses with a new, sculptural dimension and transformed it, for fourteen days, into a work of art. Ropes held down the fabric to the bridge's surface and maintained the principal shapes, accentuating relief while emphasizing the proportions of the Pont-Neuf.

80

The Pont Neuf Wrapped, Project for Paris

Drawing in two parts 1979

15 x 65 in. and 42 x 65 in.

Pencil, charcoal, crayon, pastel, technical data, and ballpoint pen

Photograph by Wolfgang Volz
Collection of Jeanne-Claude Christo, New York

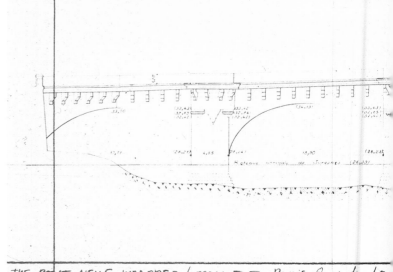

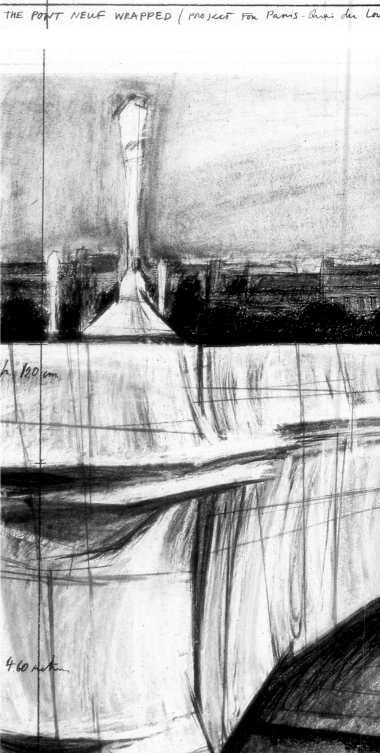

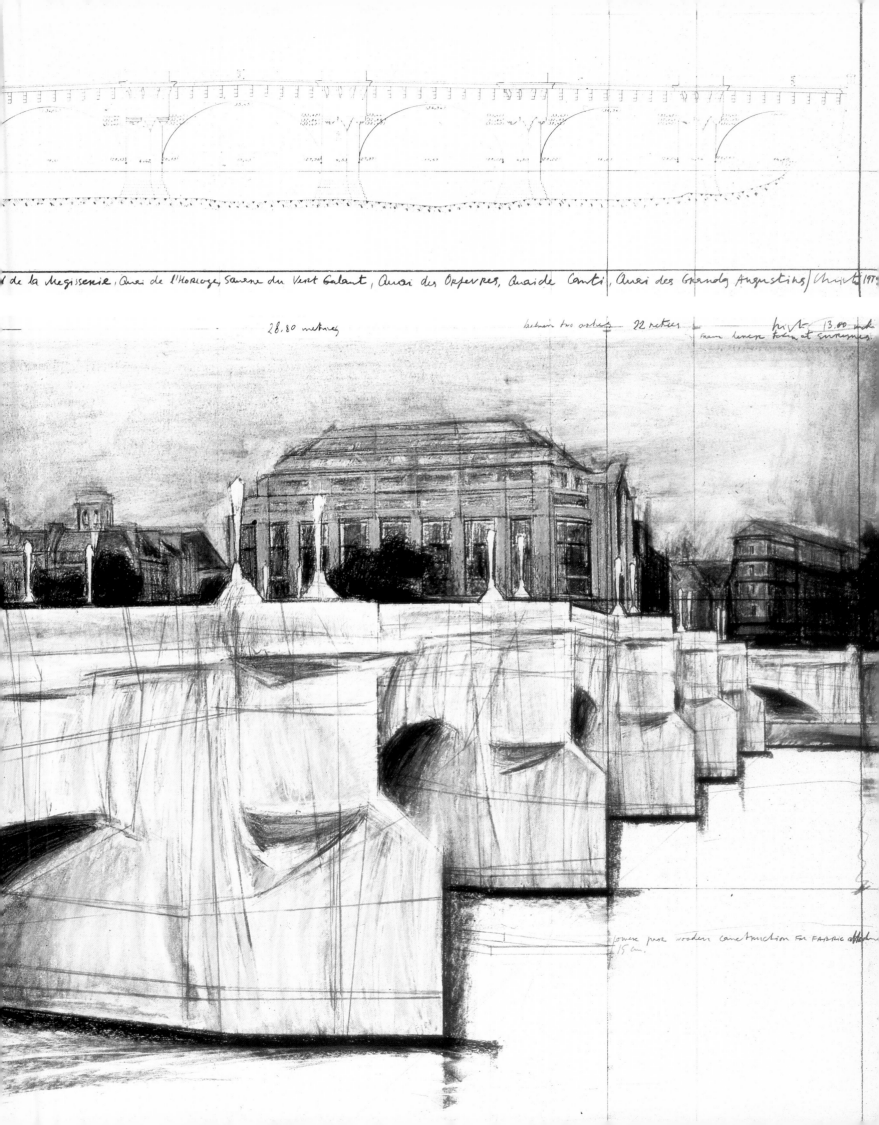

d de la Megisserie, Quai de l'Horloge, Square du Vert Galant, Quai des Orfevres, Quai de Conti, Quai des Grands Augustins / Christo 197

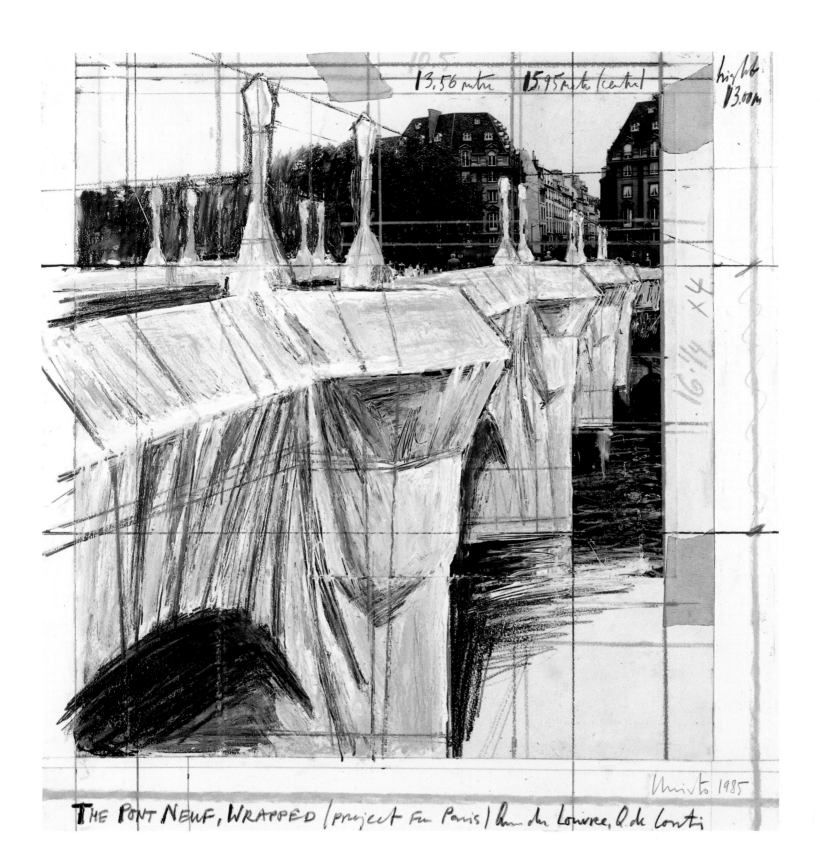

THE PONT NEUF, WRAPPED (project for Paris) *hm du Louvre, Q. de Conti*

81

The Pont Neuf Wrapped, Project for Paris

Collage 1985

15 ¼ x 14 in.

Pencil, crayon, photograph by Wolfgang Volz,
enamel paint, charcoal, and tape

Photograph by Wolfgang Volz
Collection of Jeanne-Claude Christo, New York

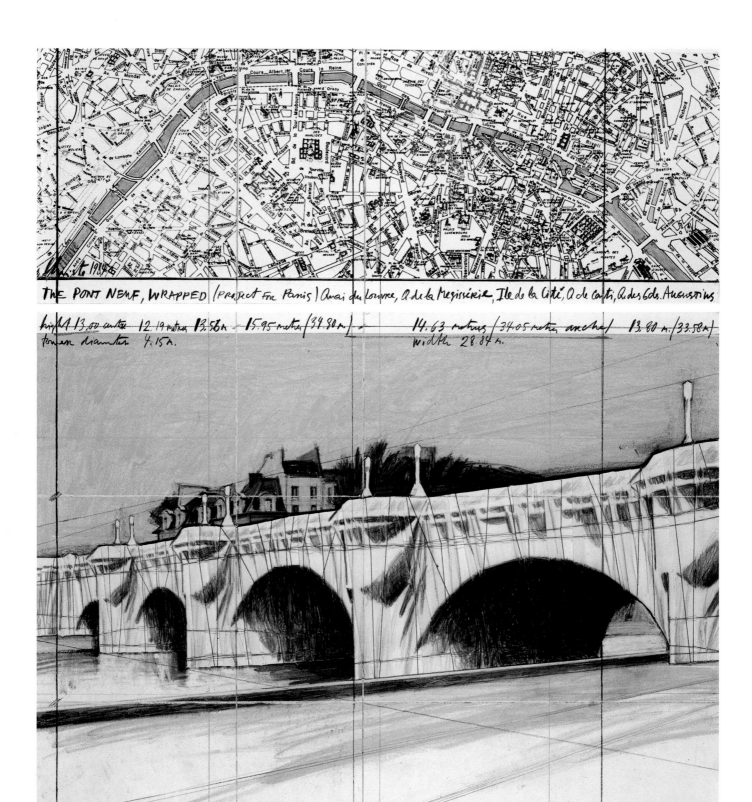

THE PONT NEUF, WRAPPED (Project for Paris) Quai du Louvre, Q. de la Megisserie, Ile de la Cité, Q. de Conti, Q. des Gds. Augustins

height 13.00 centre 12.19 metres 13.58 m. 15.95 metres (34.80 m) → 14.63 metres / 34.05 metres arches / 13.80 m. / 33.58 m.)
tower diameter 4.15 m. width 28.84 m.

the lower part - steel or wooden support for attachment Fabric panels

82

The Pont Neuf Wrapped, Project for Paris
Collage in two parts 1984
11 x 28 in. and 22 x 28 in.
Pencil, fabric, twine, pastel, charcoal, crayon,
and map

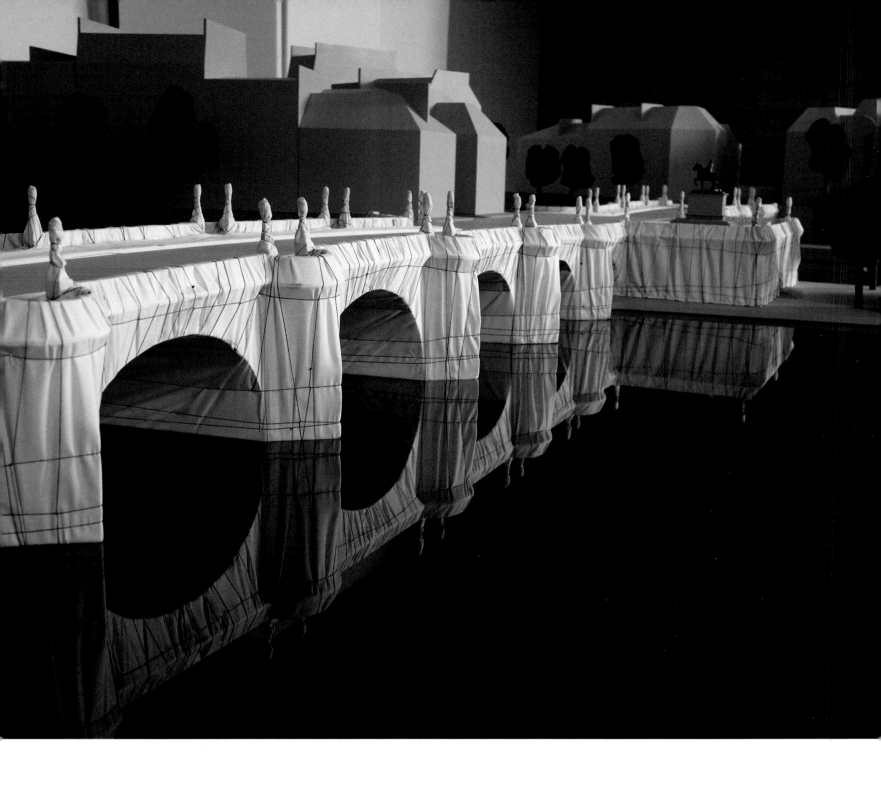

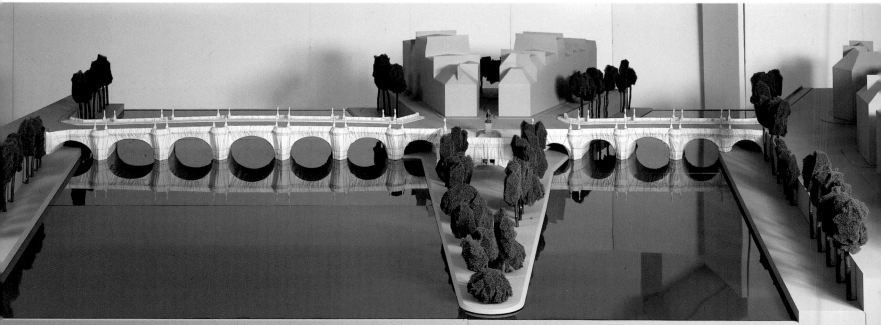

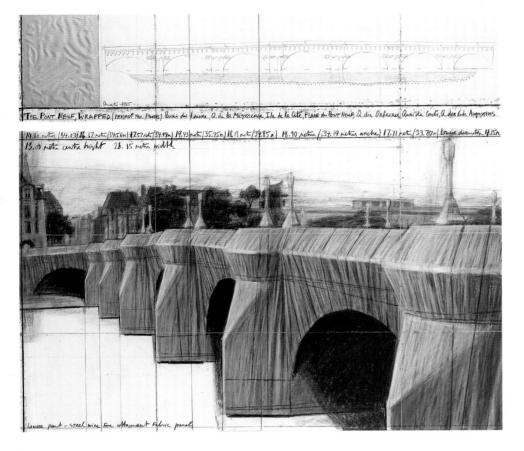

THE PONT NEUF, WRAPPED (Project for Paris) Quai du Louvre, Q. de la Mégisserie, Ile de la Cité, Place du Pont Neuf, Q. des Orfevres, Quai de Conti, Q. des Gds Augustins

14.80 metri / 34.03 / 16.57 metri / 34.56 m) 17.57 m / 34.94 m) 19.43 metri / 35.45 m) 18.13 m / 34.95 a) 19.90 metri / 34.19 metri arche) 17.71 metri / 33.77 m) tower diameter 4.15 m.
13.00 metri centre height 28.85 metri width

Lower part - steel wire for attachment fabric panels

84

The Pont Neuf Wrapped, Project for Paris

Drawing in two parts 1985

15 x 65 in. and 42 x 65 in.

Pencil, charcoal, pastel, crayon, technical data,
and fabric sample

Photograph by Wolfgang Volz
Collection of Jeanne-Claude Christo, New York

83

The Pont Neuf Wrapped, Project for Paris

Scale model 1981 (detail)

32 1/4 x 240 1/2 x 188 1/4 in.

Fabric, twine, wood, paint, foam rubber, and
Plexiglas
Top: detail
Below: overview

Photograph by Wolfgang Volz
Collection of Jeanne-Claude Christo, New York

85

The Pont Neuf Wrapped, Project for Paris

Collage in two parts 1985

11 x 28 in. and 22 x 28 in.

Pencil, fabric, twine, pastel, charcoal, crayon,
and map

Photograph by Wolfgang Volz
Collection of Jeanne-Claude Christo, New York

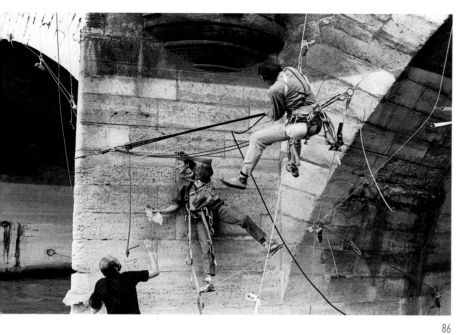

86

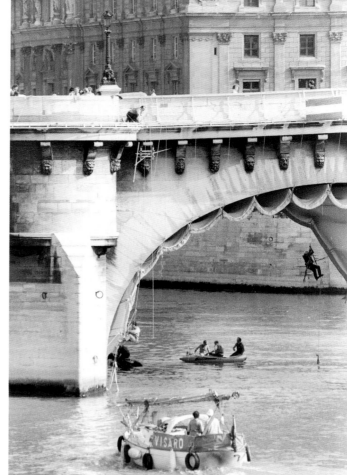

87

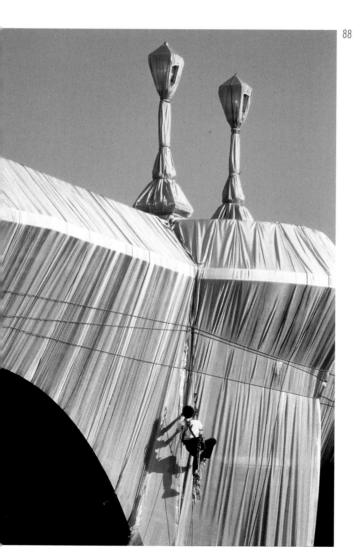

88

89

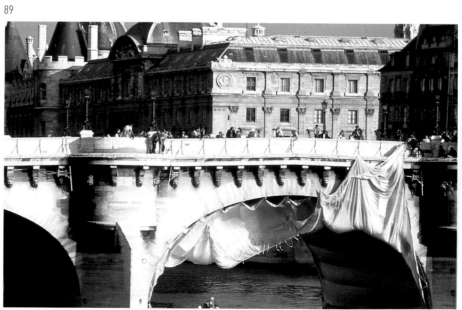

86 – 89

The Pont Neuf Wrapped, Paris, September 17th, 1985
During the installation

Photographs by Wolfgang Volz

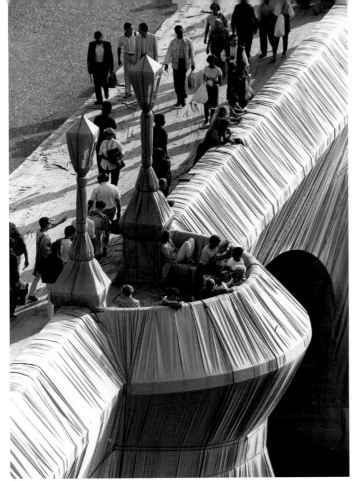

90

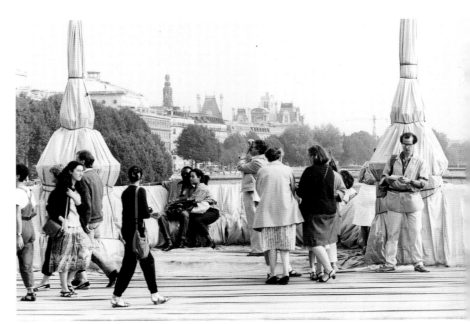

91

90 – 93

The Pont Neuf Wrapped, Paris, September 22nd, 1985

Photographs by Wolfgang Volz

92

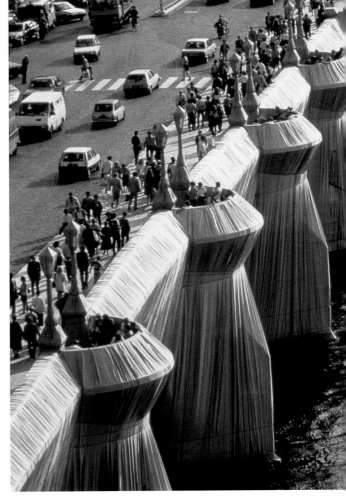

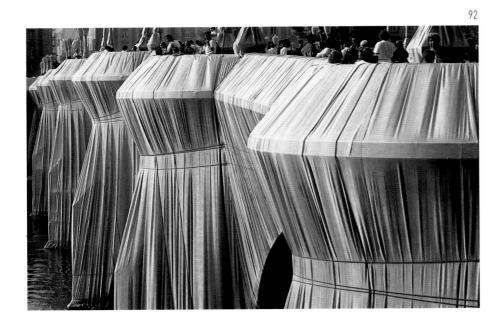

93

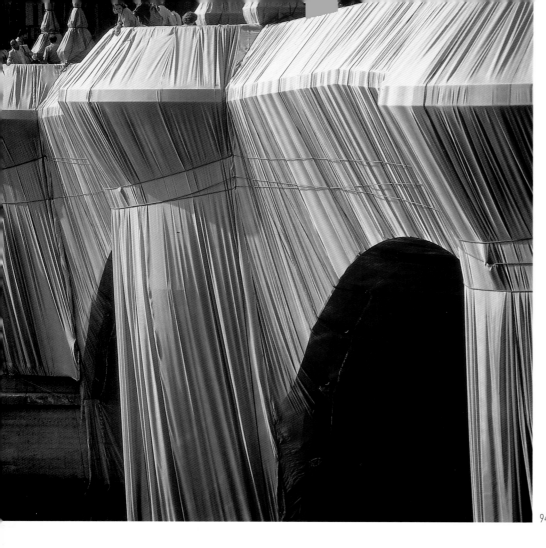

94–96
The Pont Neuf Wrapped, Paris, 1975–85
Photographs by Wolfgang Volz

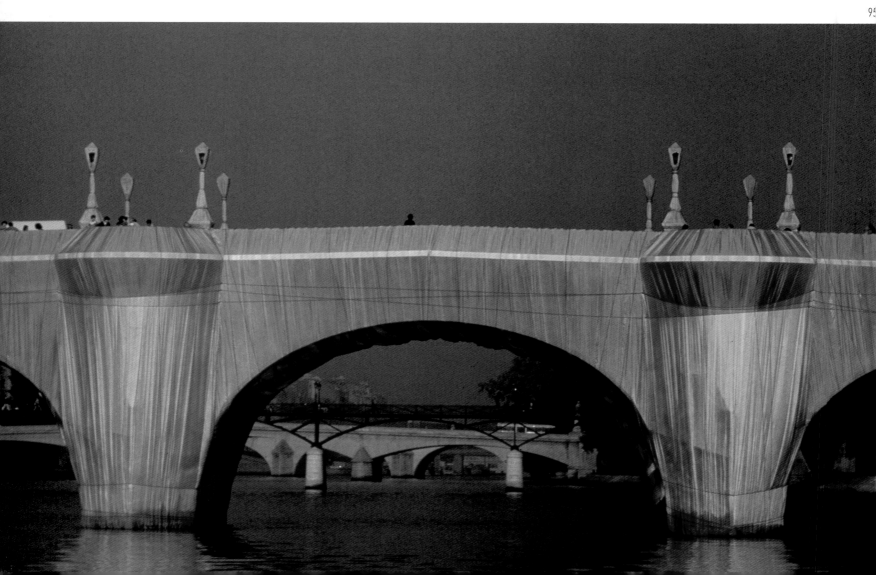

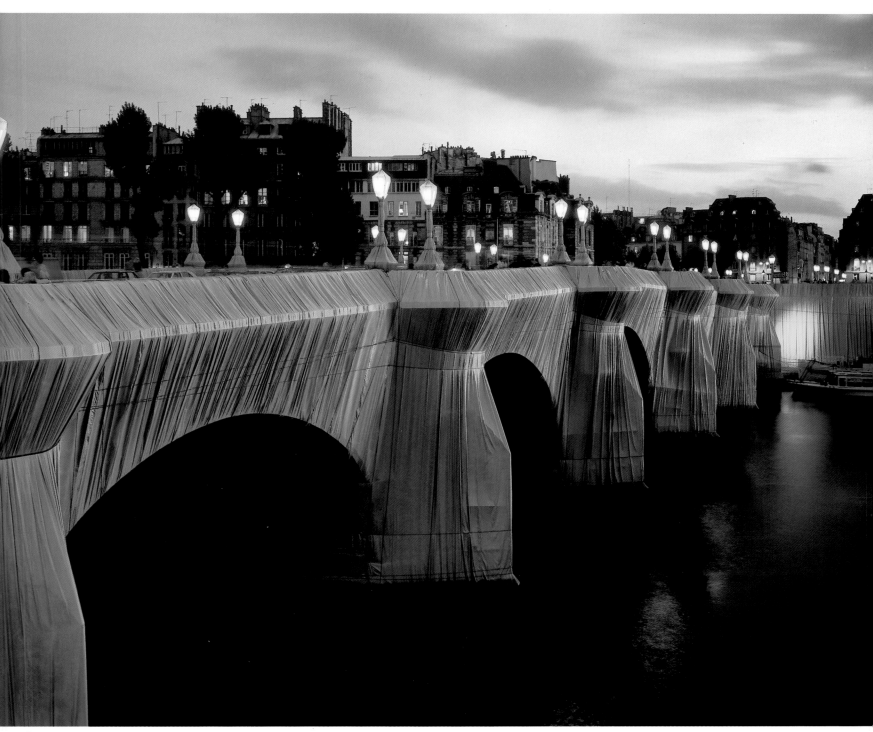

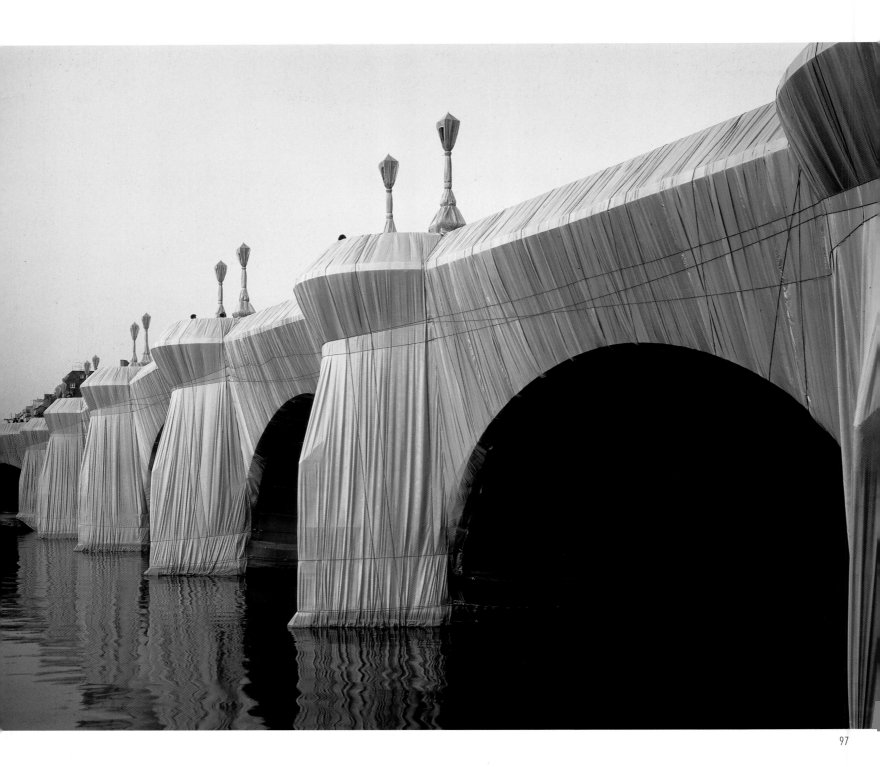

97, 98

The Pont Neuf Wrapped, Project for Paris 1975—85

Photographs by Wolfgang Volz

99

The Pont Neuf Wrapped, Project for Paris 1975—85

Photograph by Wolfgang Volz
(following two pages)

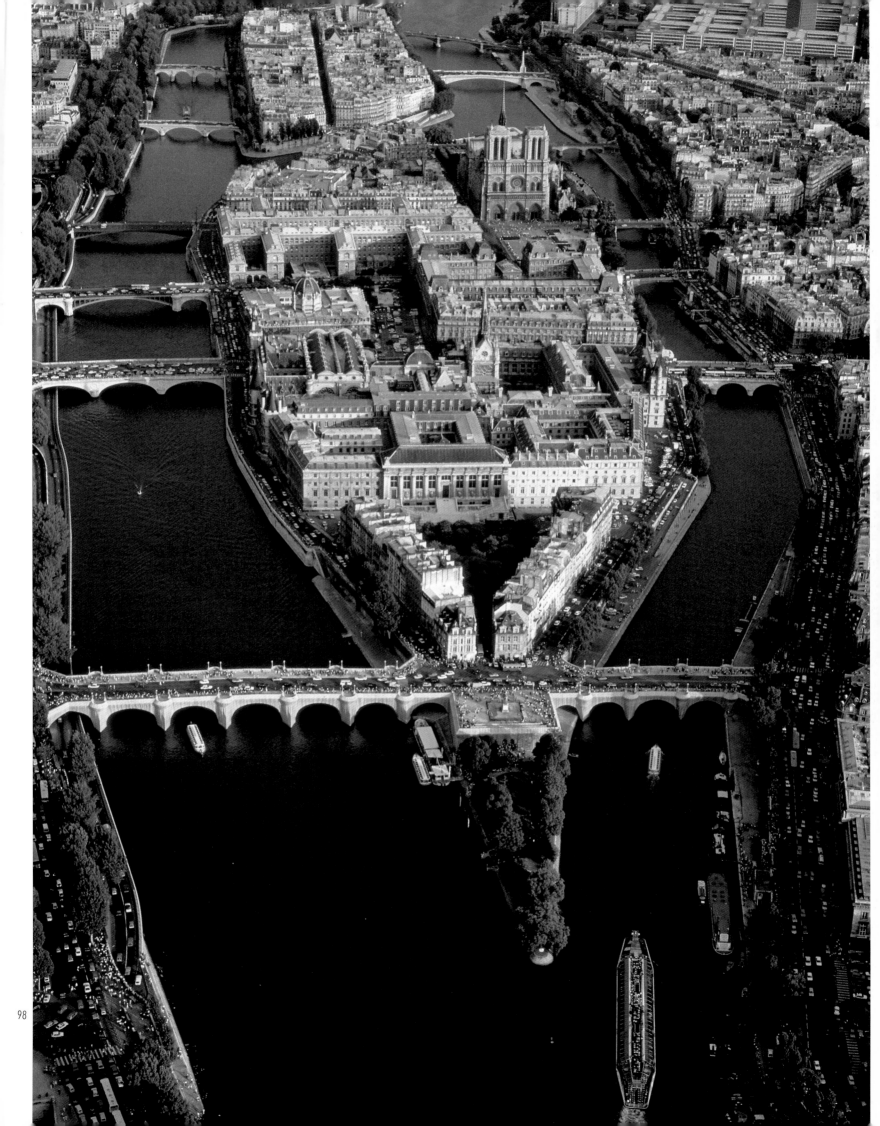

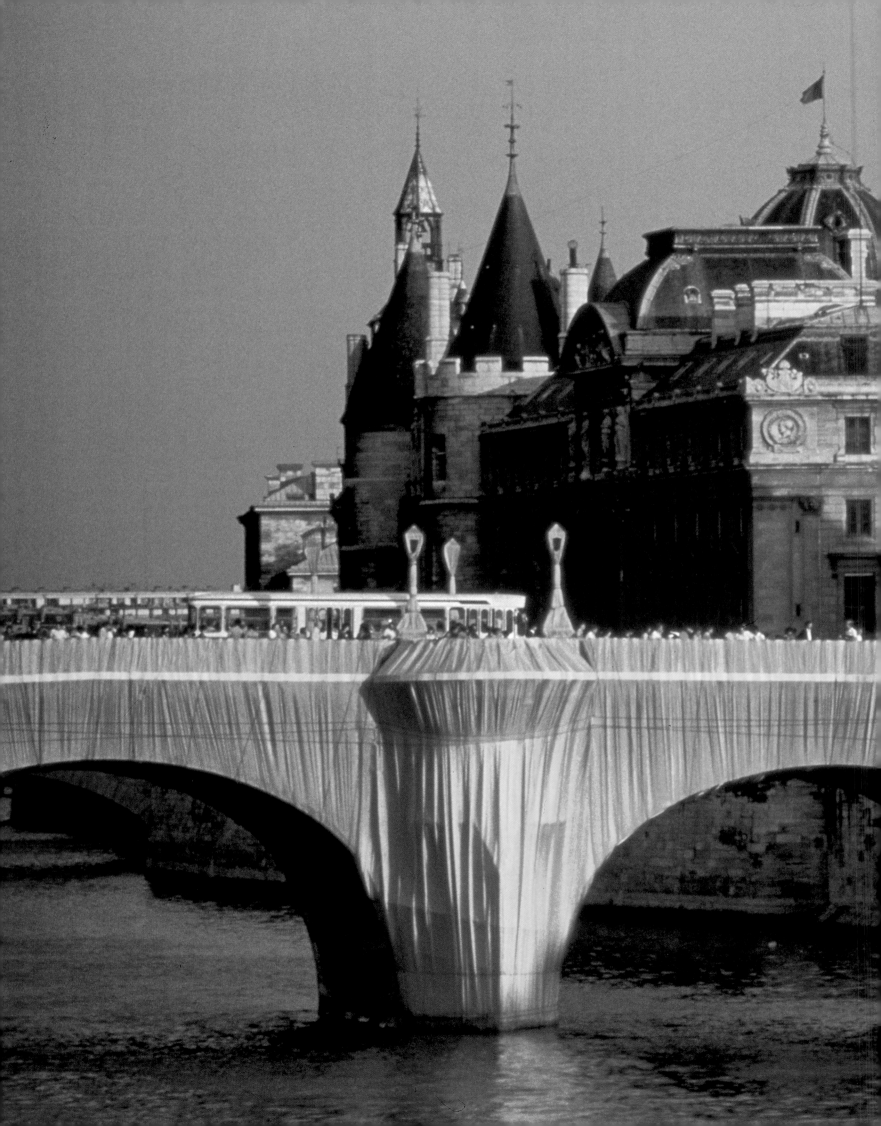

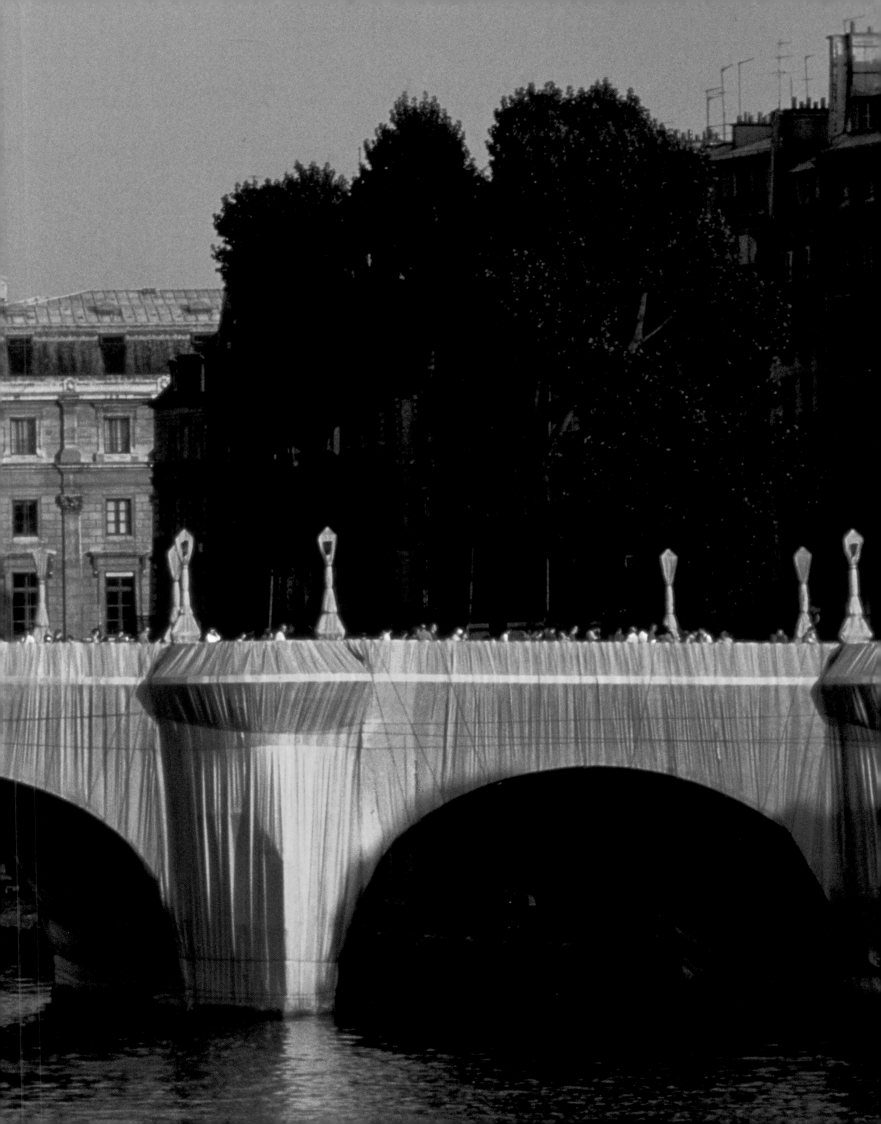

Biography
and Chronology of Selected Works

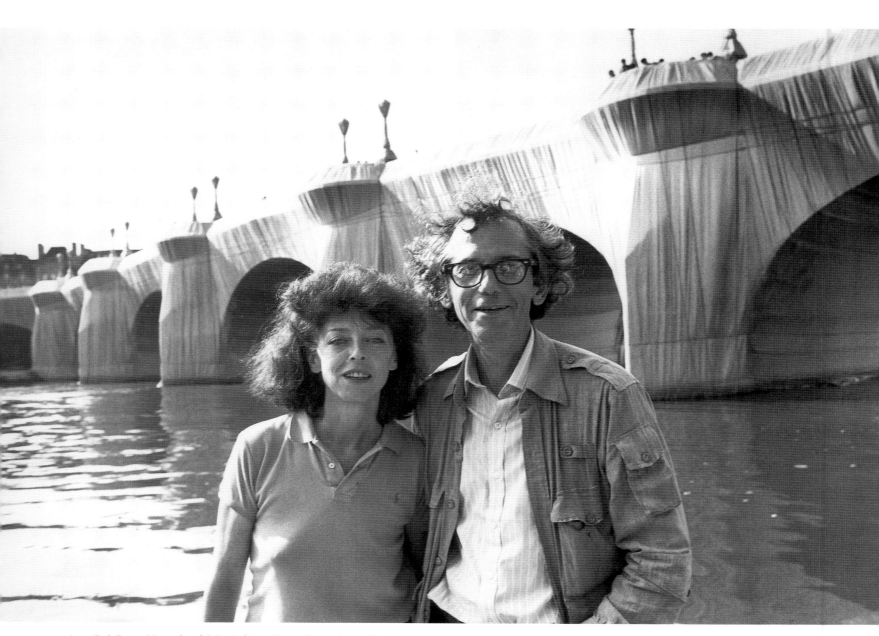

Jeanne-Claude Christo and Christo in front of *The Pont Neuf Wrapped,* Paris, October 1985. Photograph by Wolfgang Volz

1935	Christo is born – as Christo Javacheff – on June 13th in Gabrovo, Bulgaria; Jeanne-Claude de Guillebon is born on the same day in Casablanca, Morocco.
1952	Jeanne-Claude takes her baccalaureate in Latin and Philosophy at the University of Tunis.
1953–56	Christo studies at the Academy of Art in Sofia. In 1956 he moves to Prague.
1957	One semester's study at the Academy of Art in Vienna.
1958	Christo moves to Paris, where he meets Jeanne-Claude. *Wrapped Objects* and *Packages.*
1960	Their son Cyril is born on May 11th.
1961	*Wrapped Public Building. Stacked Oil Barrels* and *Dockside Packages* in Cologne Harbor.
1961–62	*Iron Curtain – Wall of Oil Barrels* blocking Rue Visconti in Paris. *Stacked Oil Barrels* in Gentilly, near Paris. *Wrapped Woman* in Paris, Düsseldorf, London, Minneapolis, and Philadelphia.
1963	*Showcases.*
1964	Christo takes up permanent residence in New York. *Store Fronts.*
1966	Personal exhibition in the Stedelijk Van Abbe Museum, Eindhoven, Netherlands: *Air Package and Wrapped Tree.* *42,390 Cubic Feet Package,* Walker Art Center, Minneapolis School of Art.
1968	*Wrapped Fountain* and *Wrapped Medieval Tower,* Spoleto, Italy. Packaging of a public building: *Wrapped Kunsthalle, Bern.* *5,600 Cubicmeter Package,* documenta 4, Kassel, and *Corridor Store Front,* with a total area of 1,500 square feet. *1,240 Oil Barrels Mastaba* and *Two Tons of Stacked Hay Wrapped,* Philadelphia Institute of Contemporary Art.
1969	*Wrapped Museum of Contemporary Art, Wrapped Floor,* and *Wrapped Stairway,* Chicago. *Wrapped Coast, One Million Square Feet, Little Bay,* Sydney, Australia. Project for a *Mastaba in Houston, Texas,* consisting of 1,249,000 oil barrels. Project for a *Closed Highway* all the way across the USA.
1970	Wrapping of two monuments in Milan. Initial plans for *Valley Curtain.*
1971	*Wrapped Floors,* Museum Haus Lange, Krefeld, Germany.
1971–72	Initial planning for the *Wrapped Reichstag, Project for Berlin (in progress).*
1972	*Valley Curtain,* Grand Hogback, Rifle, Colorado. Planning of *Running Fence.*
1974	*The Wall, Wrapped Roman Wall,* Rome. *Ocean Front,* Newport, Rhode Island.
1975	Initial plans for wrapping the Pont-Neuf in Paris.
1976	*Running Fence, Sonoma and Marin Counties, California.*
1977–78	*Wrapped Walk Ways, J. L. Loose Memorial Park, Kansas City, Missouri.*
1979	Initial planning for the *Mastaba of Abu Dhabi, Project for the United Arab Emirates (in progress).*
1980	Initial planning for *The Gates, Project for Central Park, New York (in progress).*
1980–83	*Surrounded Islands, Biscayne Bay, Greater Miami, Florida.*
1984	*Wrapped Floors and Stairways,* Architectural Museum, Basel.
1985	*The Pont Neuf Wrapped, Paris.*
1991	*The Umbrellas, Japan – USA.*
1992	Initial planning for *Over the River, Project for the Western USA (in progress).*

Wrapped Objects and Packages

The earliest *Wrapped Objects* were bottles, cans, oil barrels, and an automobile, which were covered with canvas secured with twine or rope and sometimes painted over. Occasionally objects were assembled as a set: for example, *Wrapped Cans and Bottles, 1958–59* included several packaged bottles and cans alongside a few unwrapped painted cans and bottles containing pigment. The kinds of objects Christo chose to wrap soon become more varied, and works such as *Wrapped Table, 1961, Wrapped Chair, 1961,* and *Wrapped Motorcycle, 1962,* were created. In some of these works, semitransparent materials were used instead of, or in addition to, fabric, and some of the objects were only partially covered. *Packages* were parcels entirely enveloped by fabric and twine or paper, so that their contents were neither visible nor recognizable.

Project for a Wrapped Public Building, 1961

The building should be situated in a vast and regular space. The edifice should be freestanding and have a rectangular base. It will be completely closed up, packed on every side. The entrances will be underground, placed about 50 to 65 feet from the building.

The packaging of this building will be done with rubberized tarpaulin and reinforced plastic, averaging 33 to 65 feet in width, steel cables, and ordinary rope. Using steel cables, it will be possible to secure the strong points needed for the packaging of the building.

To obtain the desired result will require about 90,000 square feet of tarpaulin, 6,000 feet of steel cable, and 25,000 feet of rope. The packaged public building can be used as:

- Stadium with swimming pools, football field, Olympic arena, or hockey and ice-skating rink
- Concert hall, conference hall, planetarium, or exhibition hall
- Historical museum of ancient and modern art
- Parliament or prison.

Christo, Paris, October 1961

Dockside Package and Stacked Oil Barrels, 1961

Created temporarily at the harbor docks in Cologne, Germany, during Christo's first personal exhibition, *Dockside Package* consisted of several heaps of cardboard barrels and industrial paper rolls covered with tarpaulins and secured with rope. The "stacked" work was made of several piles of oil barrels, lying sideways. In both cases, the art works were made by rearranging materials already existing at the harbor.

Wrapped Table, 1961
Table, fabric, and twine
49 x 24 ½ x 12 in.
Photograph by Eeva-Inkeri
Collection of Jeanne-Claude
Christo, New York

Wrapped Chair, 1961
Chair, fabric, and twine
35 ½ x 16 ¾ x 17 ¼ in.
Photograph by Eeva-Inkeri
Collection of Jeanne-Claude
Christo, New York

Wrapped Oil Barrels, 1958–59
Fabric, enamel paint, steel cable, and barrels (four of them wrapped, 14 unwrapped). Barrels between 19 ¼ x 13 and 35 x 23 ¼ in.
Photograph by Wolfgang Volz
Collection of Jeanne-Claude Christo, New York

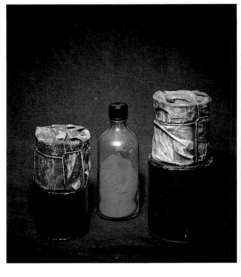

Wrapped Cans and Bottle, 1958–59
Painted canvas, twine, tin cans, and a glass bottle with pulverized color pigment. Wrapped cans: 3 x 3 ½ in. and 3 ¾ x 3 ¼ in. Bottle 6 ¼ x 2 ¼ in. Photograph by A. Grossmann
Collection of Jeanne-Claude Christo, New York

Wrapped Motorcycle, 1962
Motorcycle, polyethylene, and ropes
30 ¼ x 76 x 16 in.
Photograph by Eeva-Inkeri
Private collection, Paris

Package, 1960
Fabric, rope, and twine
29 ½ x 13 ½ x 8 in.
Photograph by Eeva-Inkeri
Collection of Jeanne-Claude
Christo, New York

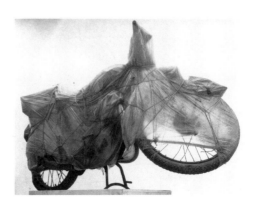
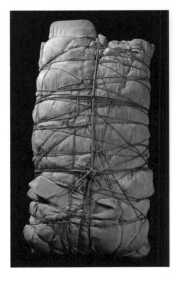

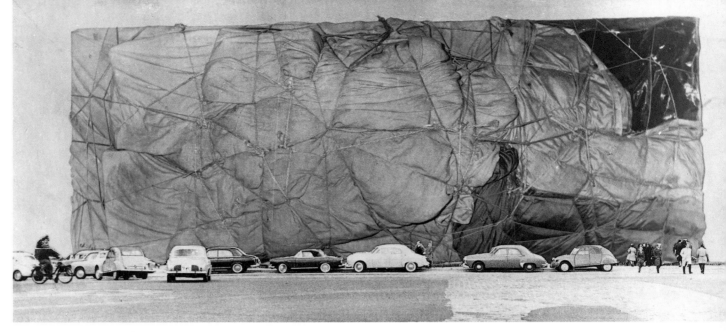

Project for a Wrapped Public Building, 1961
Photocollage. Photograph by Harry Shunk
Collection of Jeanne-Claude Christo, New York

Dockside Package (Cologne Harbor), 1961
Cardboard barrels, industrial paper rolls, tarpaulin, and rope
Photograph by S. Wewerka

Dockside Package (Cologne Harbor), detail, 1961
Cardboard barrels, industrial paper rolls, tarpaulin, and rope
Photograph by S. Wewerka. The photograph shows Christo
inspecting his work

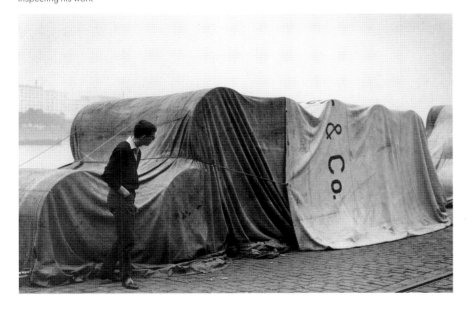

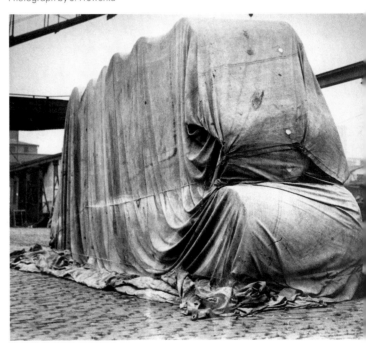

Wrapped Building in Lower
Manhattan, Project for
2 Broadway and
20 Exchange Place,
1964 – 66
Photomontage, col-
lage, detail, 1964.
20 ½ x 29 ½ in.
Photograph by
Raymond de Seynes
Collection of Horace
and Holly Solomon,
New York

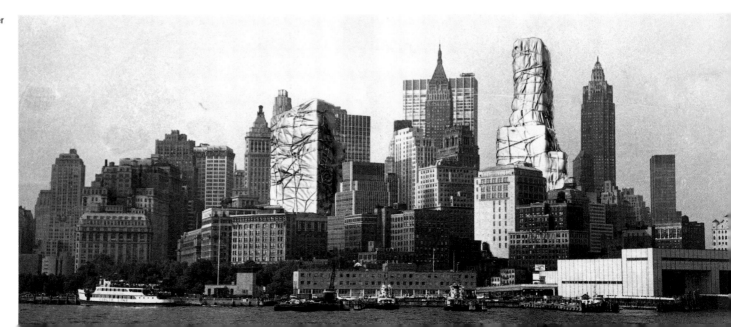

Store Fronts, 1964

A series of shop facades painted in various colors; fabric and/or wrapping paper covered the inside of the display windows and glass doors. There was an electric light inside and the glass surface was not entirely obscured, since some space was left at the top.

Wrapped Fountain, 1968, and Wrapped Medieval Tower, 1968

Two projects that took place during the "Festival of Two Worlds" in Spoleto, Italy. Christo originally intended to wrap the eighteenth-century "Teatro Novo," but could not obtain the required permit. Instead, a 46-foot high Baroque fountain and an 82-foot high medieval tower were wrapped for the three-week festival.

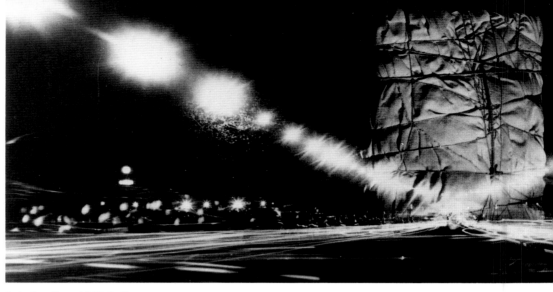

Project for a Wrapped Public Building, 1963
Photomontage, Photograph by Harry Shunk
Collection of Jeanne-Claude Christo, New York

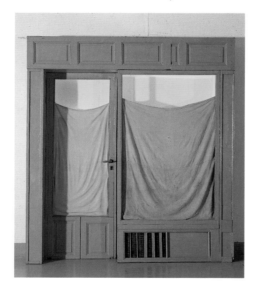

Purple Store Front, 1964
Wood, enamel paint, fabric, Plexiglas, paper, and electric light. 7 ¾ x 7 ¼ x 11 ½ feet
Photograph by Wolfgang Volz
Collection of Jeanne-Claude Christo, New York

Four Store Fronts, 1964–65
Galvanized metal, uncolored and colored Plexiglas, Masonite, canvas, and electric light (parts 1 and 2)
8 x 19 ¼ x 2 feet
Photograph by Ferdinand Boesch
Collection of Jeanne-Claude Christo, New York

Wrapped Coast, Little Bay, One Million Square Feet, Sydney, Australia, 1969

Little Bay, property of the Prince Henry Hospital, is located some nine miles south-east of the center of Sydney. The cliff-lined shore area that was wrapped is approximately 1 ½ miles long, 150–180 feet wide, 85 feet high at the northern cliffs, and was at sea level at the southern sandy beach. One million square feet of erosion control fabric (synthetic woven fiber usually manufac-

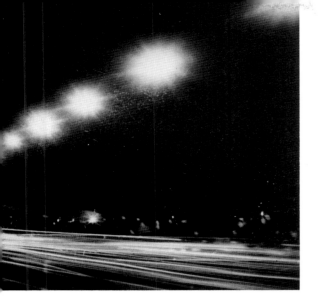

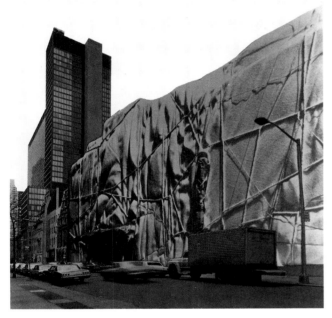

Wrapped Medieval Tower, Spoleto, Italy, 1968
Polypropylene fabric and rope. Photograph by Jeanne-Claude Christo

Wrapped Fountain, Spoleto, Italy, 1968
Polypropylene fabric and rope. Photograph by Jeanne-Claude Christo

Wrapped Museum of Modern Art, Project for New York
Photocollage, detail, 1968. 15 x 10 in. Photograph by Ferdinand Boesch
The Museum of Modern Art, New York, gift of Mrs. Dominique de Menil

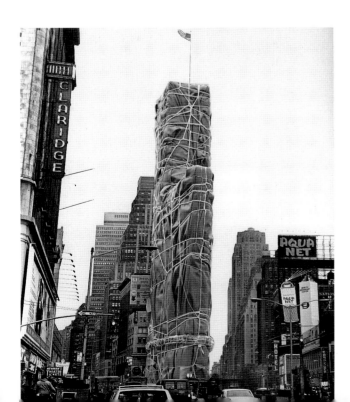

**Wrapped Building,
Project for the Allied
Chemical Tower,
1 Times Square,
New York**
Photocollage, detail,
1968. 18 x 10 in.
Photograph by
Harry Shunk
Collection of Jeanne-
Claude Christo,
New York

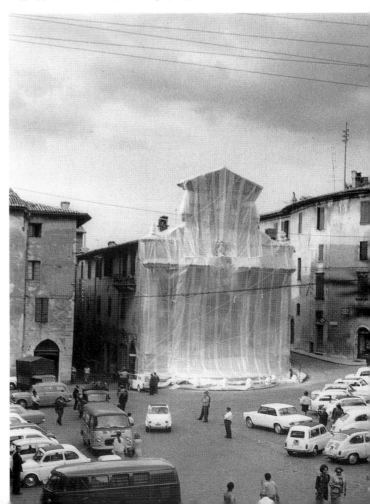

tured for agricultural purposes) were used for the wrapping. Thirty-five miles of polypropylene rope, 1 ½ inches in circumference, tied the fabric to the rocks. Ramset guns fired 25,000 charges of fasteners, threaded studs, and clips to secure the ropes to the rocks.

Mr. Ninian Melville, a retired major in the Army Corps of Engineers, was in charge of the workers at the site. Over a period of four weeks, 17,000 manpower hours were expended by 15 professional mountain climbers, 110 laborers, architecture and art students from the University of Sydney and East Sydney Technical College, as well as a number of Australian artists and teachers. The project was financed by Christo through the sale of his original preparatory drawings and collages.

The coast remained wrapped for ten weeks from October 28th, 1969 on. Then all materials were removed and recycled, and the site returned to its original condition.

Valley Curtain, Rifle, Colorado, 1970–72

On August 10th, 1972, at 11:00 A. M., a group of thirty-five construction workers and sixty-four temporary helpers – art school and college students, and itinerant art workers – tied down the last of twenty-seven ropes that secured the 142,000 square feet of orange-colored woven nylon fabric to its moorings at Rifle Gap. The valley lies seven miles north of Rifle, on Highway 325, between Grand Junction and Glenwood Springs in the Grand Hogback mountain range. *Valley Curtain* was designed by Dimiter Zagoroff and John Thomson of Unipolycon, Lynn, Massachusetts, and Dr. Ernest C. Harris of the Ken R. White Company, Denver, Colorado. It was built by A & H Builders, Inc. of Boulder, Colorado (President: Theodore Dougherty), under the site supervision of Henry B. Leininger.

The curtain was suspended at a width of 1,250 feet and a height curving from 365 feet at each end to 182 feet at the center, and it remained clear of the slopes and the valley bottom. A 10-foot wide skirt attached to the lower part of the curtain visually completed the area between the thimbles and the ground.

An outer cocoon enclosed the fully fitted curtain for protection during transit and while it was being raised into position and secured to the eleven cable clamp connections at the four main upper cables. The cables spanned 1,368 feet, weighed 110,000 pounds, and were anchored to 800 tons of concrete foundations.

An inner cocoon, integral to the curtain, provided added security. The bottom of the curtain was laced to a 3-inch diameter Dacron rope, from which the control and tie-down lines ran to the twenty-seven anchors.

The *Valley Curtain* project took twenty-eight months to complete. The temporary work of art was financed by Christo and all of the materials were recycled. On August 11th, 1972, twenty-eight hours after the completion of the *Valley Curtain*, a gale estimated to be in excess of 60 MPH made it necessary to start the removal procedure.

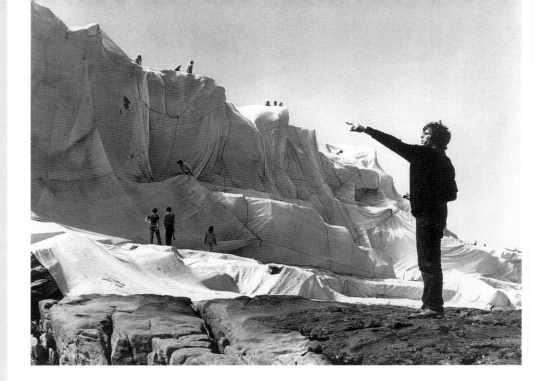

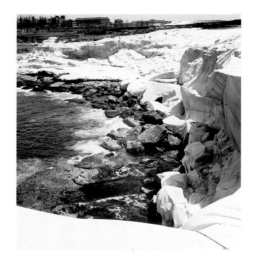

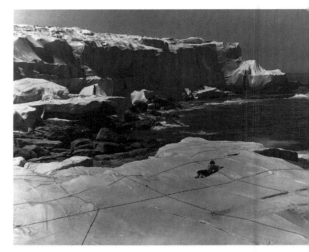

Wrapped Coast, One Million Square Feet, Little Bay, Sydney, Australia, 1968–69
One million square feet of erosion control fabric and 35 miles of rope. Photographs by Harry Shunk

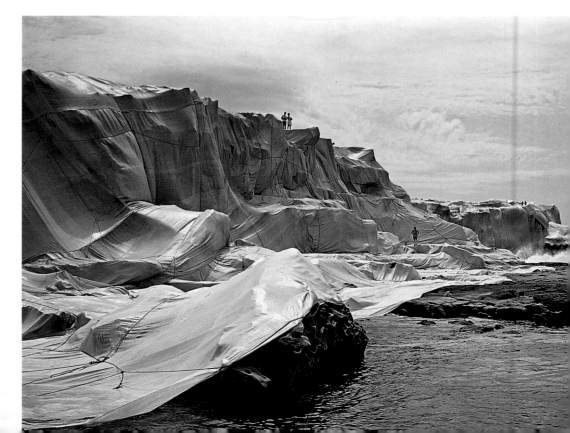

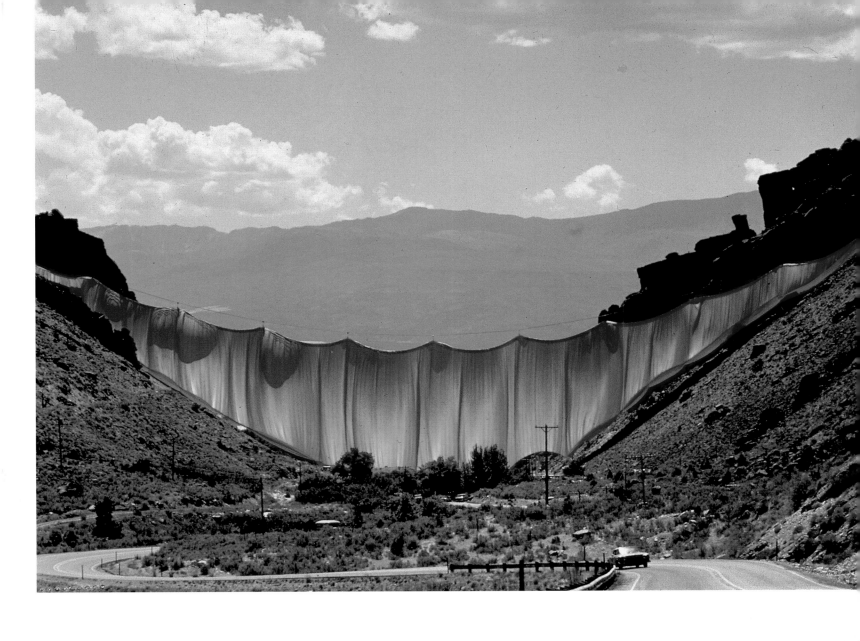

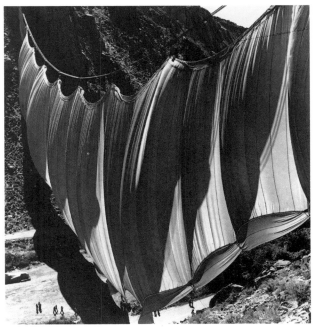

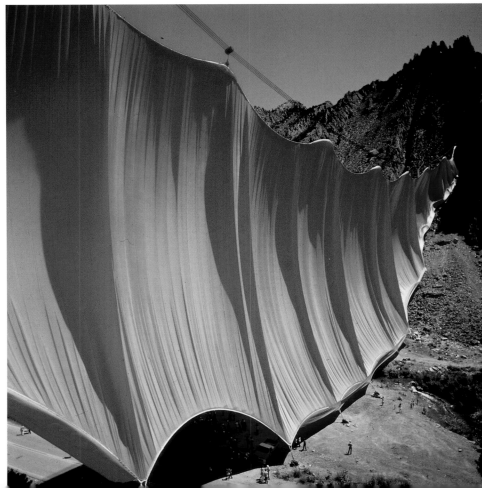

Valley Curtain, Rifle, Colorado, 1970–72
Breadth: 1,250 feet, height: 182–365 feet, 142,000 square feet of nylon
polyamide fabric, 110,000 pounds of steel cable. Photographs by Harry Shunk

The Mastaba of Abu Dhabi, Project for the United Arab Emirates (in progress)

The Mastaba of Abu Dhabi will represent:

– The symbol of the Emirate and the greatness of Sheikh Zayed. The Mastaba will be taller and more massive than the Cheops Pyramid near Cairo.

– The symbol of the civilization shaped by oil throughout the world.

– The Mastaba wil be made of 390,500 oil barrels. The project has the most unique character. Nothing comparable has ever existed in any other country. Hundreds of bright colors, as enchanting as the Islamic mosaics, will give a constantly changing visual experience according to the time of day and the quality of the light.

– The grandeur and vastness of the land will be reflected in the majesty of the Mastaba, which is to be 984 feet wide, 738 feet deep, and 492 feet high.

– The only purpose of this monument is to be itself [. . .].

The Mastaba will be constructed of materials that relate to the area: inside, natural aggregates and cement to form a concrete structure with a sand core; and outside, an overall surfacing of 55-gallon stainless steel oil barrels in various bright colors:

– All barrels, on the four sides and on the top, will be installed so that they lie horizontally on their sides.

– The two 984-foot wide sides will be vertical, showing the circular heads of the colored barrels.

– The two 738-foot ends will slope at the 60-degree natural angle of stacked barrels, showing the curved sides of the barrels.

– The top of the Mastaba will be a horizontal surface 416 feet wide and 738 feet deep, showing the rounded length of the barrels.

– The volume of the Mastaba will be such that many 48-story skyscrapers could easily fit into it.

It is suggested that the Mastaba be situated on a slightly rising plain to allow viewers the full impact of its grandeur as they approach by foot, by automobile, or by airplane. There will be no entrance to it except for a passageway to the elevators to take visitors to the top, 492 feet above the ground. From there, they will enjoy superb views, being able to see approximately thirty miles across the countryside. The area adjacent to the walkways approaching the Mastaba will be like an oasis to the visitor with flowers and grass [. . .].

Christo, New York, 1979

Running Fence, Sonoma and Marin Counties, California, 1972–76

Running Fence, 18 feet high, 24 ½ miles long, extending from east to west near Freeway 101, north of San Francisco, on the private properties of fifty-nine ranchers, following the rolling hills and dropping down to the Pacific Ocean at Bodega Bay, was completed on September 10th, 1976. The art project consisted of: forty-two months of collaborative efforts, ranchers' participation, eighteen public hearings, three sessions at the superior courts of California, and the drafting of an Environmental Impact Report.

Conceived and financed by Christo, *Running Fence* was made of 165,000 yards of heavy, woven white nylon fabric, hung from a steel cable strung between 2,050 steel poles. The poles were embedded in the ground, using no concrete, and were braced laterally with guy wires and earth anchors. All parts of the *Running Fence* were designed for complete removal, and no visible evidence of it remains on the hills. After fourteen days, the project was removed, and all the materials used were donated to the ranchers.

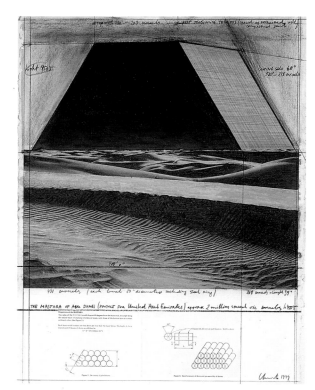

The Mastaba of Abu Dhabi, Project for the United Arab Emirates
Collage, 1979. Pencil, photograph, crayon, charcoal, pastel, and technical data. 31 ½ x 23 ¼ in.
Photograph by Wolfgang Volz
Collection of Jeanne-Claude Christo, New York

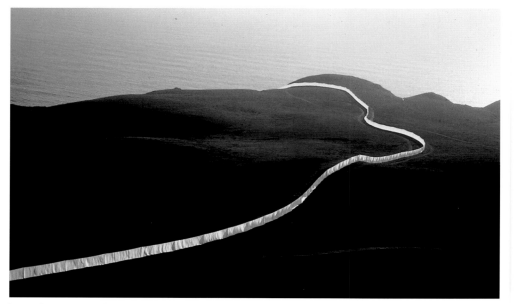

Running Fence, Sonoma and Marin Counties, California, 1972–76
Height: 18 feet, length: 24 ½ miles. Photograph by Wolfgang Volz

Running Fence, Sonoma and Marin Counties, California, 1972–76. Photograph by Wolfgang Volz

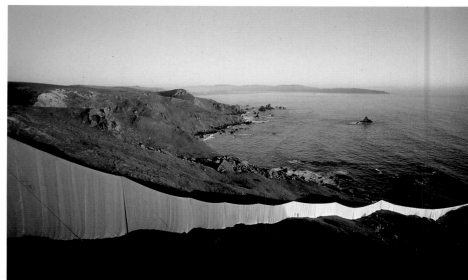

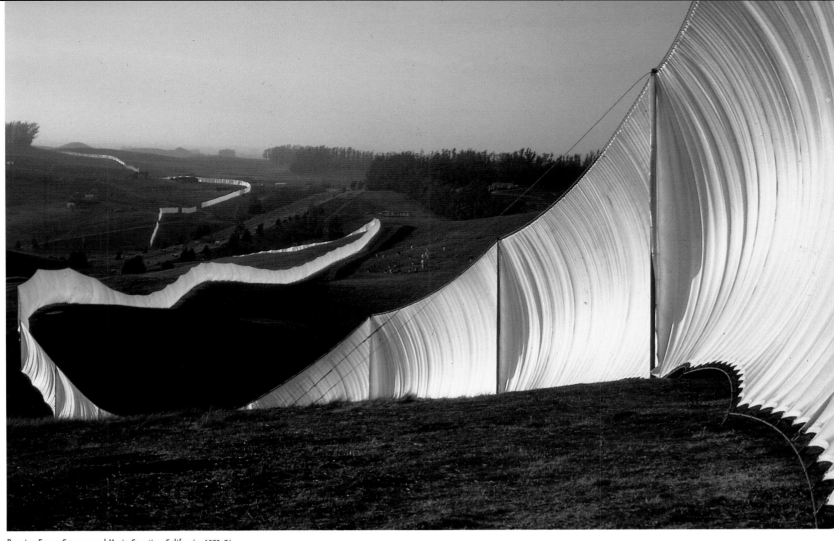

Running Fence, Sonoma and Marin Counties, California, 1972–76
Photograph by Jeanne-Claude Christo

Running Fence, Sonoma and Marin Counties, California, 1972–76
Photograph by Wolfgang Volz

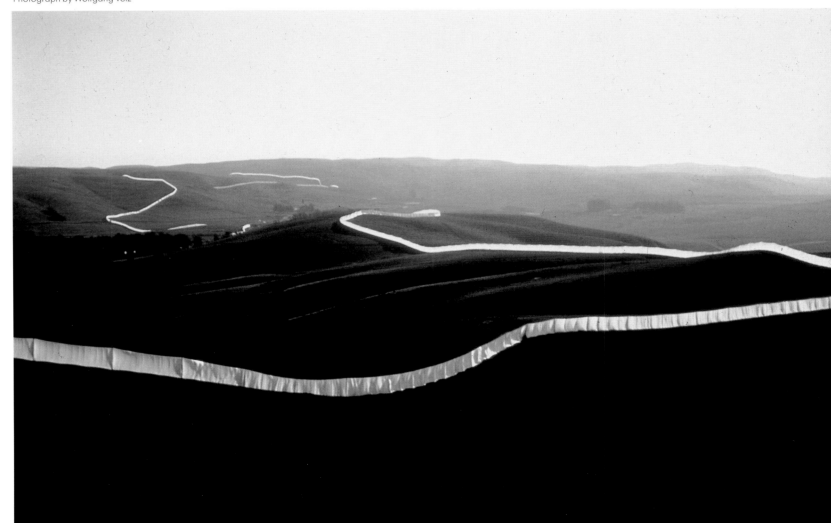

The Umbrellas, Japan and USA, 1984–91

At sunrise, on October 9th, 1991, Christo's 1,880 workers began to open 3,100 umbrellas in Ibaraki and California. This temporary work of art reflected the similarities and differences in the ways of life and the use of the land in two inland valleys, one twelve miles long in Japan, and the other eighteen miles long in the USA.

In Japan, the valley is located north of Hitachiota and south of Satomi, seventy-five miles north of Tokyo, around Route 349 and the Sato River, in the Prefecture of Ibaraki, on the properties of 459 private landowners and governmental agencies. In the USA, the valley is located sixty miles north of Los Angeles, along Interstate 5 and the Tejon Pass, between Gorman and Grapevine, on the properties of Tejon Ranch, 25 other private landowners, and governmental agencies.

Eleven manufacturers in Japan, USA, Germany, and Canada prepared the various elements of the umbrellas: fabric, aluminum superstructure, steel frame bases, anchors, wooden base supports, bags, and molded base covers. Starting in December 1990, with a total work force of five hundred, Muto Construction Co. Ltd. in Ibaraki and A. L. Huber & Son in California installed the earth anchors and steel bases. The sitting platform/base covers were placed during August and September 1991. From September 19th to October 7th, 1991, the umbrellas were transported to their assigned bases, bolted to the receiving sleeves, and elevated to an upright closed position. On October 4th, students, agricultural workers, and friends — 960 in the USA and 920 in Japan — joined the workforce to complete the installation.

Christo's twenty-six million dollar work of art was entirely financed by the artist through The Umbrellas, Joint Project for Japan and USA Corporation (Jeanne-Claude Christo-Javacheff, president). Previous projects by the artist have all been financed in a similar manner through the sale of his studies, preparatory drawings, collages, scale models, early works, and original lithographs. The artist does not accept any sponsorship. The removal started on October 27th, and the land was restored to its original condition. The umbrellas were taken apart and all elements recycled.

The umbrellas, free-standing dynamic modules, reflected the availability of the land in each valley, creating an inviting inner space, like houses without walls or temporary settlements, and related to the ephemeral character of the work of art. In the precious and limited space of Japan, the umbrellas were positioned close together and sometimes following the geometry of the rice fields. In this luxuriant vegetation, enriched by water year round, the umbrellas were blue. In the Californian vastness of uncultivated grazing land, the configuration of the umbrellas was whimsical, spreading in every direction. The brown hills were covered by dry grass, and in that landscape, the umbrellas were yellow. From October 9th, 1991, for a period of eighteen days, *The Umbrellas* were enjoyed by the public, as people walked in their luminous shadows.

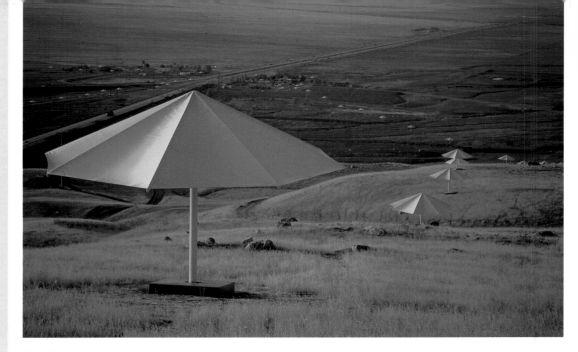

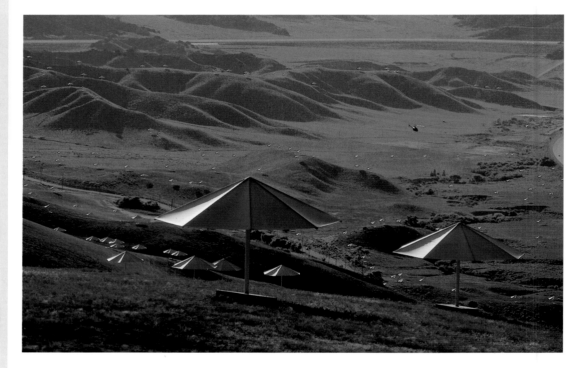

The Umbrellas, Japan–USA, 1984–91
California site. Photographs by Wolfgang Volz

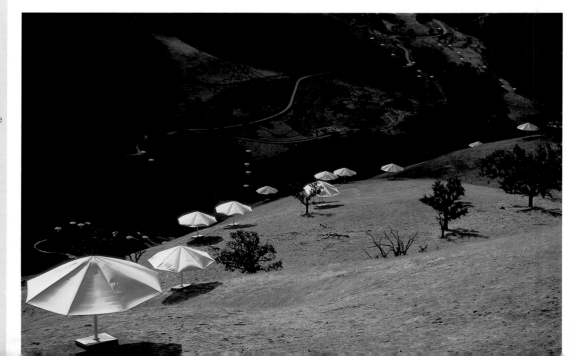

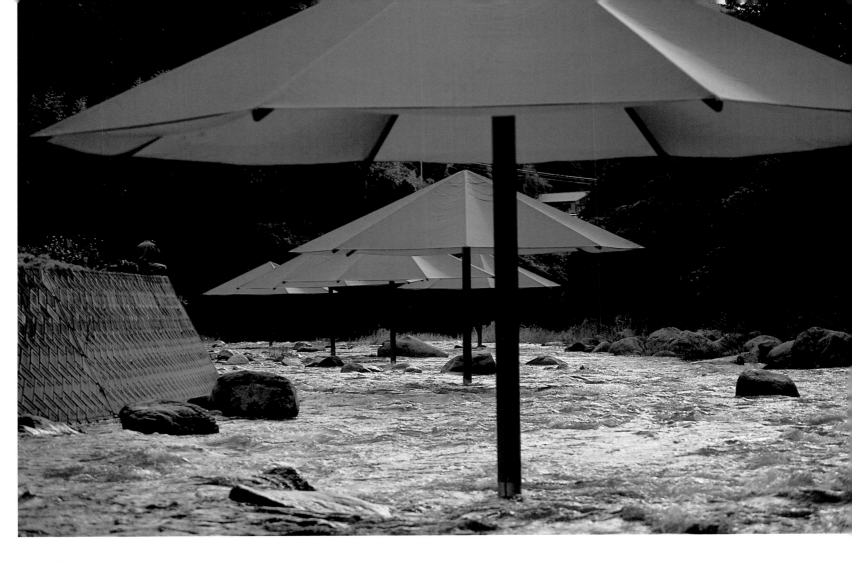

The Umbrellas, Japan–USA, 1984–91
Ibaraki site. Photographs by Wolfgang Volz

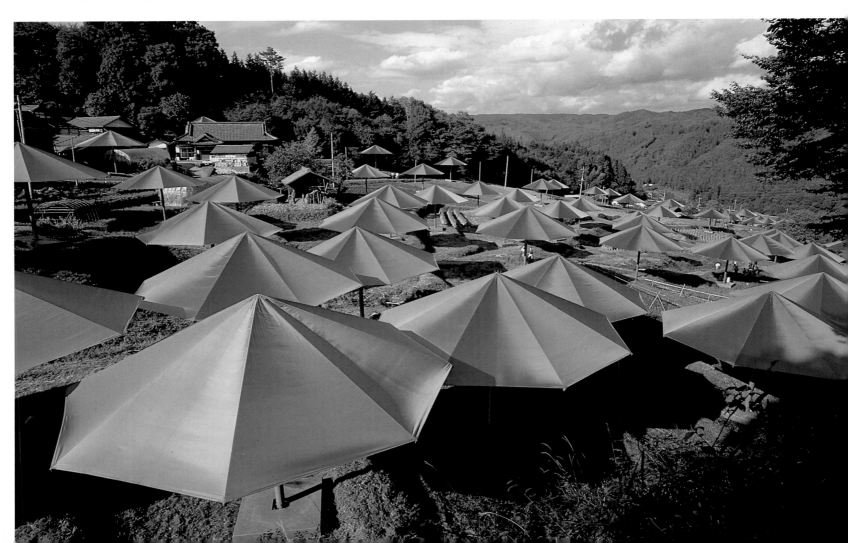

The Gates, Project for Central Park, New York

The Gates will be 15 feet high, with a width varying from 9 to 28 feet following the edges of the walkways, perpendicular to selected footpaths of Central Park. The fabric attached to the top of each steel gate will come down to 5 ½ feet from the ground, allowing the synthetic woven panels to wave horizontally towards the next gate.

The Gates are planned to remain in place for fourteen days in the last two weeks of October 1983 or 1984, after which the 27-mile long work of art will be removed, and the ground restored to its original condition. A written contract will be drafted between the New York City Department of Parks and our organization based upon the agreements made in California with all relevant governmental agencies at the time of the construction of the *Running Fence* project [. . .].

The contract will require us to provide:

– Personal and property liability insurance, protecting the Department of Parks from damages claims.
– An environmental impact statement, if requested by the Park.
– A removal bond, providing funds for complete restoration of the ground.
– Full cooperation with the Community Boards, the Department of Parks, the New York City Arts Commission, and the Landmarks Commission.
– Employment of local Manhattan residents.
– Clearance for the usual activities in the Park and access for rangers, maintenance, clean-up, police, and emergency service vehicles.
– The direct cost of the Park's supervision will be charged to us.
– The configuration of the path wil be selected together with the Department of Parks.
– No vegetation or rock formations will be disturbed.
– Only small vehicles will be used, and these will be confined to the perimeter of existing walkways during installation and removal.
– Precaution will be taken to ensure that the scheduling of *The Gates* does not interfere with any wildlife patterns.
– All holes will be professionally backfilled with natural material, leaving the ground in good condition, and it will be inspected by the Department of Parks, which will hold the bond until full satisfaction.
– Financial help will be given to the Department of Parks in order to cover any possible additional clean-up task, secretarial work, or any expenses that might occur in direct relation to *The Gates*.

Full-size prototype tests are being conducted by our engineers on the steel frames, their base supports, and the fabric panel connections.

By uplifting and framing the space above the walkways, the luminous fabric of *The Gates* will underline the organic design in contrast to the geometric grid pattern of Manhattan and will harmonize with the beauty of Central Park.

Christo, 1980

The Gates,
Project for
Central Park, New York
Collage in two parts,
1992
12 x 30 ½ in. and
26 ¼ x 30 ½ in.
Pencil, fabric, chalk,
charcoal, and
aerial photograph
Photograph by Wolfgang Volz

Over the River, Project for Western USA

Fabric panels suspended horizontally above the water will follow the configuration and width of the changing course of the river's tranquil and white waters. Steel wires, anchored on the upper part of the river banks, will cross the river and will serve as attachments for the fabric panels.

The woven nylon panels, sewn in advance, with rows of grommets at the edges perpendicular to the river, will allow loose folds of the fabric to gather in the middle of the curving cables, 6 to 25 feet above the river bed. The 4 to 6-mile stream of successive panels will be interrupted by bridges, rocks, trees, or bushes, creating abundant flows of light.

Wide clearance between the banks and the edges of the fabric panels will create a play of contrast, allowing sunlight to illuminate the river on both sides and through the luminous fabric.

As with my previous art projects, *Over the River* will be financed through the sale of my preparatory drawings, lithographs, collages, and early works by C.V.J. Corporation (Jeanne-Claude Christo-Javacheff, president).

The road and footpaths running along the river will allow the project to be appreciated from above by car and from below on foot. For a period of two weeks, the temporary work of art *Over the River* will enrich the recreational activities and the natural life of the river.

Christo, New York, 1992

Wrapped Globe, "Planet of the Year," 1988
Polyethylene, cord, and globe
Cover picture of *Time* magazine, January 2nd, 1989.
Diameter: 16 in. Photograph by Gianfranco Gorgoni
© Christo and *Time* Magazine
Collection of Time Inc. Corp., New York

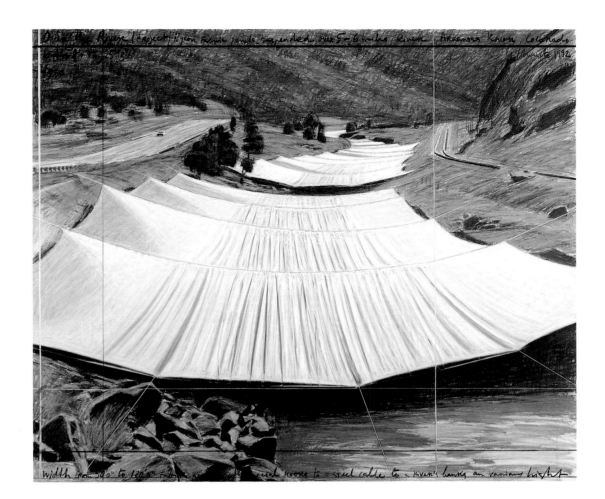

Over the River, Project for the Arkansas River, Colorado
Collage, 1992. Pencil, fabric, twine, pastel, charcoal, and crayon
26 1/4 x 30 1/2 in.
Photograph by Simon Chaput
Collection of Jeanne-Claude Christo, New York

Over the River, Project for the Arkansas River, Colorado
Collage, 1992. Pencil, fabric, pastel, charcoal, and crayon
26 1/4 x 30 1/2 in.
Photograph by Simon Chaput
Collection of Jeanne-Claude Christo, New York

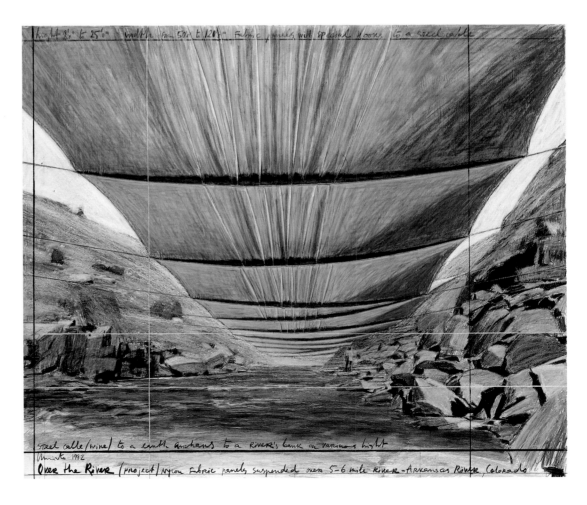

Appendix

Personal Exhibitions

1961
Galerie Haro Lauhus, Cologne

1962
Galerie J, Paris

1963
Galerie Schmela, Düsseldorf
Galleria Apollinaire, Milan
Galleria del Leone, Venice
Galleria La Salita, Rome
Galleria Apollinaire, Milan

1964
Galerie Ad Libitum, Antwerp, Belgium
Galleria G. E. Sperone, Turin, Italy
Galleria del Leone, Venice
Galerie Schmela, Düsseldorf

1966
Stedelijk Van Abbe Museum, Eindhoven, Netherlands
Leo Castelli Gallery, New York

1967
Wide White Space Gallery, Antwerp, Belgium
Galerie der Spiegel, Cologne

1968
John Gibson Gallery, New York
The Museum of Modern Art, New York
I.C.A., University of Pennsylvania, Philadelphia
Galleria del Leone, Venice

1969
Lo Giudice Gallery, Chicago
Museum of Contemporary Art, Chicago
Wide White Space Gallery, Antwerp, Belgium
Central Street Gallery, Sydney, Australia
National Gallery of Victoria, Melbourne, Australia
Jonn Gibson Gallery, New York
Galerie der Spiegel, Cologne

1970
The New Gallery, Cleveland, Ohio
Galerie Françoise Lambert, Milan
Galerie Renée Ziegler, Zurich
Kaiser Wilhelm Museum, Krefeld, Germany

1971
Annely Juda Fine Art, London
Galerie Yvon Lambert, Paris
Museum Haus Lange, Krefeld, Germany
The Museum of Fine Arts, Houston, Texas
Kunstsammlungen, Nuremberg, Germany
Galerie Victor Loeb, Bern, Switzerland
Kunsthaus Hamburg
Colophon Galleria, Milan
Centro La Capella, Trieste, Italy
Ars Studeo, Copenhagen

Galerie Mikro, Berlin
C.A.Y.C. Buenos Aires, Argentina

1972
The New Gallery, Cleveland, Ohio
The Contemporary Arts Center, Cincinnati, Ohio
Galerie W. Aronowitsch, Stockholm
Joslyn Art Museum, Omaha, Nebraska
La Jolla Museum of Contemporary Art, California
Santa Barbara Museum of Art, California
The Friends of Contemporary Art, Denver, Colorado
The Morgan Gallery, Kansas City, Kansas

1973
Stedelijk Museum of Modern Art, Amsterdam
Seria al Galerie, Amsterdam
Alan Frumkin Gallery, New York
Miami-Dade Community College Art Gallery, Florida
Ball State University Art Gallery, Muncie, Indiana
University Museum, Seattle, Washington
La Rotonda, Milan
Galerie Françoise Lambert, Milan
Galerie Charles Kriwin, Brussels
Neue Pinakothek, Munich
Max Protetch Gallery, Washington, D.C.
Museo de Arte Moderno "La Tertulia," Cali, Colombia
Kalamazoo Institute of Arts, Michigan
Kansas State University, Manhattan, Kansas
Rosa Esman Gallery, New York
Kunsthaus, Zurich
Kunsthalle Düsseldorf
Rijksmuseum Kröller-Müller, Otterlo, Netherlands
Galleria d'Arte Vinciana, Milan

1974
Louisiana Museum of Modern Art, Humlebaek, Denmark
Henie-Onstad Kunstsenter, Høvikodden, Norway
Galerie W. Aronowitsch, Stockholm
Millersville College, Pennsylvania
Annely Juda Fine Art, London
Hatton Gallery, University of Newcastle-upon-Tyne, England
Musée de Peinture et de Sculpture, Grenoble, France

1975
Musée Jenisch, Vevey, Switzerland
Musée Rath, Geneva
White Gallery, Lutry, Switzerland
Galleria Conkreight, Caracas, Venezuela
Museo de Bellas Artes de Caracas, Venezuala
Gallery Gimpel Hanover, Zurich

The Art Museum, Princeton University, New Jersey
Galleria D'Alessandro-Ferranti, Rome
Galerie J. Benador, Geneva
La Jolla Museum of Contemporary Art, California
The Oakland Museum, Oakland, California
Institute of Contemporary Art, Boston
M. H. de Young Memorial Museum, San Francisco
University of Calgary Art Gallery, Alberta
Memorial Union Art Gallery, U.C. Davis, California
Grinnell College, Grinnell, Iowa
Galeria Ciento, Barcelona
Fabian Fine Arts, Cape Town, Republic of South Africa
Harcus-Krako-Rosen-Sonnabend Gallery, Boston
Galerie der Spiegel, Cologne
Galleria Bounaparte, Milan

1976
Museum des 20. Jahrhunderts, Vienna
Museum of Modern Art, San Francisco
La Jolla Museum of Contemporary Art, California
Pasadena City College, Pasadena, California
Fine Arts Center, University of Massachusetts, Amherst
The Broxton Gallery, Los Angeles
The Art Association, Newport, Rhode Island

1977
Colorado Springs Fine Arts Center
Galeria Joan Prats, Barcelona
Galeria Trece, Barcelona
The Israel Museum, Jerusalem
Newcomb College Art Department, Tulane University, New Orleans
Metropolitan Museum, Miami
Museum Boymans-van Beuningen, Rotterdam, Netherlands
Rheinisches Landesmuseum, Bonn
Kestner-Gesellschaft, Hannover
Minami Gallery, Tokyo
Annely Juda Fine Art, London
American Center, Kyoto, Japan

1978
Louisiana Museum of Modern Art, Humlebaek, Denmark
Henie-Onstadt Kunstsenter, Høvikodden, Norway
The American Foundation for the Arts, Miami
Western Michigan University, Kalamazoo, Michigan
Murray State University, Kentucky
Galerie Art in Progress, Munich
Kunstgewerbemuseum, Zurich
Palais des Beaux-Arts, Brussels
Musée de Grenoble, France
Nelson-Atkins Museum of Art, Kansas City, Missouri

Wadsworth Atheneum, Hartford, Connecticut
Fine Art Galleries, University of Arkansas at Little Rock, Arkansas

1979 Vienna Secession
Greenville Museum of Art, South Carolina
Institute of Contemporary Art, London
Institute of Contemporary Art, Boston
Kunstverein, Freiburg, Germany
Annely Juda Fine Art, London
Fine Arts Gallery at Wright State University, Dayton, Ohio
Appalachian State University, Boone, North Carolina
Hunter Museum of Art, Chattanooga, Tennessee
The Laguna Gloria Art Museum, Austin, Texas
Corcoran Gallery of Art Washington, D.C.
Nash Gallery, University of Minnesota, Minneapolis
Galerie Catherine Issert, Saint-Paul-de-Vence, France

1980 Newport Harbor Art Museum, Newport Beach, California
The New Gallery, Cleveland, Ohio
Swen Parson Gallery, Northern Illinois University, De Kalb, Illinois
Midwest Museum of American Art, Elkhart, Indiana
Mississippi Museum of Art, Jackson, Mississippi
The Winnipeg Art Gallery, Winnipeg, Manitoba
Clara A. Hatton Gallery, Colorado State University, Fort Collins, Colorado
French Cultural Center, Alliance Française, Abu Dhabi, United Arab Emirates
Artspace, Peterborough, Ontario
Cabrillo College Gallery, Aptos, California
Sonoma County Arts Council, Santa Rosa, California

1981 American Graffiti Gallery, Amsterdam
Hokin Gallery, Miami
Metropolitan Museum, Miami
Tennessee Tech University, Cookeville, Tennessee
The Albuquerque Museum, Albuquerque, New Mexico
Musée d'Art Contemporain, Montreal
Santa Monica College Art Gallery, California
Community Gallery of Lancaster County, Pennsylvania
The University of Texas, El Paso, Texas
Museum Ludwig, Cologne
Juda-Rowan Gallery, London
Portland Center for the Visual Arts, Oregon

La Jolla Museum of Contemporary Art, California
Madison Art Center, Wisconsin
Conejo Valley Art Museum, Thousand Oaks, California

1982

Jan.–Feb. Carnegie Hall, University of Maine, Orono, Maine: "Wrapped Walk Ways, J. L. Loose Memorial Park, Kansas City, Missouri, 1977–78: Documentation Exhibition"

Jan.–Mar. The Nickle Arts Museum, The University of Calgary, Alberta: "Christo: Collection on Loan from the Rothschild Bank, Zurich"

Feb.–Mar. Colby College Museum of Art, Waterville, Maine: "Wrapped Coast, One Million Square Feet, Little Bay, Australia, 1969: Documentation Exhibition"

Feb.–Mar. Städel Museum, Frankfurt am Main: "Projects in the City, 1961–81"

May Künstlerhaus Bethanien, Berlin: "Projects in the City, 1961–81"

May Biuro Wystaw Artystycznych, Cracow, Poland

May–June Art Gallery of Hamilton, Ontario: "Christo: Collection on Loan from the Rothschild Bank, Zurich"

June Miami-Dade Public Library, Florida: "Surrounded Islands, Project for Biscayne Bay, Greater Miami, Florida: Documentation Exhibition"

July–Aug. Galerie Catherine Issert, Saint-Paul-de-Vence, France: "Surrounded Islands, Project for Biscayne Bay, Greater Miami, Florida: Documentation Exhibition"

Oct. Dumont-Landis Gallery, New Brunswick, New Jersey: "Five Works in Progress"

Oct.–Nov. Elvehjem Museum of Art, University of Wisconsin, Madison: "Christo: Collection on Loan from the Rothschild Bank, Zurich"

Oct.–Nov. The Hara Museum of Contemporary Art, Tokyo: "Wrapped Walk Ways, J. L. Loose Memorial Park, Kansas City, Missouri, 1977–78: Documentation Exhibition"

1983

Jan.–Mar. Snite Museum of Art, O'Shaughnessy Galleries, University of Notre Dame, Indiana: "Christo: Collection on Loan from the Rothschild Bank, Zurich"

Mar.–Apr. Art Mobile, sponsored by the Miami-Dade Public Library, Florida: "Editions by Christo"

May–June Fukuoka Art Museum, Japan: "Wrapped Walk Ways, J. L. Loose Memorial Park, Kansas City, Missouri, 1977–78: Documentation Exhibition"

July–Aug. National Museum of Art, Osaka, Japan: "Wrapped Walk Ways, J. L. Loose Memorial Park, Kansas City, Missouri, 1977–78: Documentation Exhibition"

Sept.–Oct. Contemporary Arts Center, Cincinnati, Ohio: "Christo: Collection on Loan from the Rothschild Bank, Zurich"

Oct. The Art Museum of Santa Cruz County, Soquel, California: "Wrapped Coast, One Million Square Feet, Little Bay, Australia, 1969: Documentation Exhibition"

Nov.–Dec. Delahunty Gallery, Dalls, Texas: "Surrounded Islands, Biscayne Bay, Florida, 1980–83; and Four Works in Progress"
Galeria Pero, Madrid: "Drawings and Collages"

1984

Jan.–Feb. Hartnell College Gallery, Salinas, California: "Wrapped Coast, One Million Square Feet, Little Bay, Australia, 1969: Documentation Exhibition"

Mar.–Apr. Luther Burbank Center for the Arts, Santa Rosa, California: "Wrapped Coast, One Million Square Feet, Little Bay, Australia, 1969: Documentation Exhibition"

Apr. Satani Gallery, Tokyo: "The Pont Neuf Wrapped, Project for Paris, Work in Progress"

May–June Herron Gallery, Indianapolis Center for Contemporary Art, Indiana University: "Wrapped Coast, One Million Square Feet, Little Bay, Australia, 1969: Documentation Exhibition"

July–Sept. Nationalgalerie, Berlin: "Surrounded Islands, Biscayne Bay, Greater Miami, Florida, 1980–83: Documentation Exhibition"

July–Sept. Annely Juda Fine Art, London: "Objects, Collages and Drawings 1958–83"
Sun Valley Center for the Arts and Humanities, Idaho: "Works on Paper"

Aug.–Sept. Westport-Weston Arts Council, Westport, Connecticut: "Wrapped Coast, One Million Square Feet, Little Bay, Australia, 1969: Documentation Exhibition"

Sept.–Oct. Henie-Onstad Kunstsenter, Høvikodden, Norway: "Surrounded Islands, Biscayne Bay, Greater Miami, Florida, 1980–83: Documentation Exhibition"
Boston Athenaeum: "Works on Paper"

1985

Jan.–Mar. Art Gallery, University of West Florida, Pensacola: "Wrapped Coast, One Million Square Feet, Little Bay, Australia, 1969: Documentation Exhibition"

Feb.–Apr. Kunsthalle Hamburg: "Surrounded Islands, Biscayne Bay, Greater Miami, Florida, 1980–83: Documentation Exhibition"

Mar.–Apr. New Britain Museum of American Art, New Britain, Connecticut: "Wrapped Walk Ways, J. L. Loose Memorial Park, Kansas City, Missouri, 1977–78: Documentation Exhibition"

May–June Fondation Maeght, Saint-Paul-de-Vence, France: "Surrounded Islands, Biscayne Bay, Greater Miami, Florida, 1980–83: Documentation Exhibition"

Aug.–Sept. Rijksmuseum Kröller-Müller, Otterlo, Netherlands: "Surrounded Islands, Biscayne Bay, Greater Miami, Florida, 1980–83: Documentation Exhibition"

1985–86

Nov.–Jan. Carpenter & Hochman, Dallas, Texas: "Christo: Drawings and Collages"

1986

Jan.–Feb. Labirynt 2 Gallery, Lublin, Poland: "Christo: The Pont Neuf Wrapped, Paris, 1985"
Florida State University, Art Gallery, Tallahassee, Florida: "Prints and Lithographs"

Feb.–Apr. Fundación Caja de Pensiones, Madrid: "Surrounded Islands, Biscayne Bay, Greater Miami, Florida, 1980–83: Documentation Exhibition"
Galeria Joan Prats, Barcelona: "Christo: Drawings and Collages"
University Museum, Southern Illinois University at Carbondale, Illinois: "Prints and Lithographs"

Boss Museum, Miami Beach, Florida: "Wrapped Coast, One Million Square Feet, Little Bay, Australia, 1969: Documentation Exhibition"; "Wrapped Walk Ways, J. L. Loose Memorial Park, Kansas City, Missouri, 1977–78: Documentation Exhibition"; "Ocean Front, Newport, Rhode Island, 1974: Documentation Exhibition"

Apr.–May Alternative Work Site, Omaha, Nebraska: "Prints and Lithographs"

Aug.–Oct. Barrett Art Gallery, Utica College, Utica, New York: "Prints and Lithographs"

Oct.–Nov. Satani Gallery, Tokyo: "Wrapped Reichstag, Project for Berlin: Documentation Exhibition"
Art Gallery, College of Saint Rose, Albany, New York: "Prints and Lithographs"

Nov. Real Art Ways, Connecticut: "Prints and Lithographs"

1987

Feb.–Mar. Musée Cantonal des Beaux-Arts, Lausanne, Switzerland: "Surrounded Islands, Biscayne Bay, Greater Miami, Florida, 1980–83: Documentation Exhibition"

Feb.–Apr. Lehmann College Art Gallery, Bronx, New York: "Wrapped Walk Ways, J. L. Loose Memorial Park, Kansas City, Missouri, 1977–78: Documentation Exhibition"

Mar.–May Aldrich Museum of Contemporary Art, Ridgefield, Connecticut: "Christo: Drawings and Collages"

Apr.–May Elizabeth Galasso Fine Art Leasing, Ossining, New York: "Christo: Painted Photographs and Collages"

May–June Halsey Gallery, College of Charleston, South Carolina: "Wrapped Walk Ways, J. L. Loose Memorial Park, Kansas City, Missouri, 1977–78: Documentation Exhibition"
Museum van Hedendaagse Kunst, Gent, Belgium: "Surrounded Islands, Biscayne Bay, Greater Miami, Florida, 1980–83: Documentation Exhibition"
The Museum of Modern Art, Seibu Takanawa, Karuizawa, Japan: "Christo: Collection on Loan from the Rothschild Bank, Zurich"

Nov. Le Centre D'Art Nicolas de Staël, Braine-l'Alleuv, Belgium: "Christo: Dessins, Collages, Photos"

Dec.–Jan. Salena Gallery, Long Island University, Brooklyn, New York: "Prints and Lithographs"

1988

Jan. The Seibu Museum of Art, Tokyo: "Christo: Collection on Loan from the Rothschild Bank, Zurich"
Satani Gallery, Tokyo: "Christo: The Umbrellas, Joint Project for Japan and the USA: Documentation Exhibition"

Mar. The Schneider Museum of Art, Southern Oregon State College, Ashland: "Christo: Prints and Lithographs"

May Annely Juda Fine Art, London: "Christo: The Umbrellas, Joint Project for Japan and the USA: Documentation Exhibition"

June Toa Road Gallery, Kobe, Japan: "Christo: Collages, Drawings and Lithographs"
Hyogo Prefectural Museum of Modern Art, Kobe, Japan: "Christo: Collection on Loan from the Rothschild Bank, Zurich"

Dec. Taipei Fine Arts Museum, Taiwan: "Christo: Collection on Loan from the Rothschild Bank, Zurich"
Szentendre Mühely Galeria, Szentendre, Hungary: "Christo: Prints"

1989

Jan. Labirynt 2 Gallery, Lublin, Poland: "Christo: Art Documentation"

Deutsches Theater, East Berlin: "Christo"

Feb. Art Gallery at Kendall College of Art and Design, Grand Rapids, Michigan: "Christo: Prints and Lithographs"

May Laage-Salomon Gallery, Paris: "Christo: The Umbrellas, Joint Project for Japan and the USA: Documentation Exhibition"

June Guy Pieters Gallery, Knokke-Zoute, Belgium: "Christo: The Umbrellas, Joint Project for Japan and the USA: Documentation Exhibition"
Stanford University Museum of Art, California: "Christo: Four Works in Progress: Documentation Exhibition"
Art Gallery, Skidmore College, Saratoga Springs, New York: "Christo: Prints and Lithographs"
Galerie des Kulturbundes [Gallery of the Cultural League], Schwarzenberg, East Germany: "Christo"

July Galerie Catherine Issert, Saint-Paul-de-Vence, France: "Christo: Projects 1965–88"

Aug.	Musée d'Art Moderne et d'Art Contemporain de la Ville de Nice: "Christo: A Selection of Works from the Lilja Collection"
Sept.	Museu de Arte Contemporânea da Universidade de São Paolo, Brazil: "Christo: Prints and Lithographs"
Nov.	Cleveland Center for Contemporary Art, Ohio: "Christo: Four Works in Progress"

1990

Jan.	De Saisset Museum, Santa Clara University, California: "Christo: Prints and Lithographs"
Feb.	Henie-Onstad Kunstsenter, Høvikodden, Norway: "Christo: From the Lilja Collection"
Apr.	Hiroshima City Museum of Contemporary Art: "Christo: Surrounded Islands, Biscayne Bay, Greater Miami, Florida, 1980–83: Documentation Exhibition"
Sept.	Art Gallery of New South Wales, Sydney, Australia: "Christo: Works from 1958 to 1990"
	The Hara Museum of Contemporary Art, Tokyo: "Christo: Surrounded Islands, Biscayne Bay, Greater Miami, Florida, 1980–83: Documentation Exhibition"
	Bogerd Fine Arts, Amsterdam: "Christo"
	Akron Art Museum, Ohio: "Christo: Works from Area Collections"
Oct.	Magidson Fine Art, New York: "Christo: Drawings – Multiples"
	Gallery Seomi, Seoul, Korea: "Printmaking Exhibition by Christo"
Nov.	Satani Gallery, Tokyo: "The Umbrellas, Joint Project for Japan and the USA, Works in Progress"

1991

Mar.	Annely Juda Fine Art, London: "Christo: Projects Not Realized and Works in Progress"
	Galerie Eric van de Weghe, Brussels: "Christo"
May	Southwestern Community College Art Gallery, Chula Vista, California: "Christo: Prints and Lithographs"
June	Galeria Joan Prats, Barcelona: "Christo: Obra 1958–91"
	The Reykjavik Municipal Museum, Iceland: "Christo: From the Lilja Collection"
	Cunningham Memorial Art Gallery,

	Bakersfield, California: "Christo: Prints and Lithographs"
	Sapporo Art Park, Sapporo, Japan: "Christo: Surrounded Islands, Biscayne Bay, Greater Miami, Florida, 1980–83: Documentation Exhibition"
Sept.	Art Tower Mito, Contemporary Art Gallery, Ibaraki, Japan: "Valley Curtain, Rifle, Colorado, 1970–72: Documentation Exhibition"; "The Umbrellas, Joint Project for Japan and the USA, Works in Progress"
	Bakersfield College Art Gallery, Bakersfield, California: "Wrapped Coast, One Million Square Feet, Little Bay, Australia, 1969: Documentation Exhibition"
	Todd Madigan Gallery, Bakersfield, California: "Wrapped Walk Ways, J. L. Loose Memorial Park, Kansas City, Missouri, 1977–78: Documentation Exhibition"
	Seomi Gallery, Seoul, Korea: "Christo: Four Works in Progress"
Oct.	Satani Gallery, Toyko: "Christo: Early Works, 1958–64"
Nov.	Alternatives Gallery, San Luis Obispo, California: "Christo: Prints and Lithographs"
	Kunsthallen Brandts Klaedefabrik, Odense, Denmark: "Christo: From the Lilja Collection"

1992

Jan.	Shiga Museum of Modern Art, Otsu, Japan: "Christo: Surrounded Islands, Biscayne Bay, Greater Miami, Florida, 1980–83: Documentation Exhibition"
	Reynolds Gallery, Westmont College, Santa Barbara, California: "Christo: Prints and Lithographs"
Feb.	Center for the Arts, Pepperdine University, Malibu, California: "Christo: Prints and Lithographs"
	Galerie 63, Klosters, Switzerland: "Christo: Originals and Lithographs"
Mar.	Gallery Seomi, Seoul, Korea: "The Umbrellas, Japan–USA, 1984–91"
	Gallery Hyundai, Seoul, Korea: "Surrounded Islands, 1980–83"; "The Pont Neuf Wrapped, 1975–85"; "Wrapped Reichstag, 1972 – In Progress"; "The Gates, 1980 – In Progress"
Apr.	Marugame Genichiro Inokuma Museum of Contemporary Art, Kanaga, Japan: "Valley Curtain, Rifle, Colorado, 1970–72: Documentation Exhibition"; "The Umbrellas, Joint Project for Japan and the USA, Works in Progress"

June	Hanson Art Galleries, Beverly Hills, California: "Christo"
	Hanson Art Galleries, San Francisco: "Christo"
July	The Exhibition Hall of Toyota City Hall, Nagoya, Japan: "Valley Curtain, Rifle, Colorado, 1970–72: Documentation Exhibition"
Nov.	Visual Arts Gallery, The University of Alabama at Birmingham: "Christo: Prints and Lithographs"

1993

Jan.	Akademiegalerie im Marstall, Berlin: "Christo in Berlin"
May	Art Front Gallery, Hillside Terrace, Tokyo: "Christo: Works from the Eighties and Nineties"
June–July	KunstHausWien, Vienna: "Christo: The Reichstag and Urban Projects"

1993–94

Oct.–Jan.	Kunstmuseum, Bonn: "Christo: The Pont Neuf Wrapped, Paris, 1975–85: Documentation Exhibition"

Public Collections Holding Works by Christo

Aachen, Germany, Neue Galerie der Stadt

Akron Art Museum, Ohio

Albuquerque Museum of Art, New Mexico

Amsterdam, Stedelijk Museum of Modern Art

Ann Arbor, Museum of Art, The University of Michigan

Armidale, Australia, New England Regional Art Museum

Basel, Switzerland, Kunstmuseum

Berlin Museum

Berlin, Nationalgalerie

Bern, Switzerland, Kunstmuseum

Boise Art Museum, Idaho

Bonn, Haus der Geschichte der Bundesrepublik Deutschland

Bonn, Rheinisches Landesmuseum

Bridgeport, Connecticut, Housatonic Museum of Art

Brunswick, Maine, Museum of Art, Bowdoin College

Brussels, Belgium, Musées Royaux des Beaux-Arts de Belgique

Buffalo, New York, Albright-Knox Art Gallery

Cambridge, Massachusetts, Fogg Art Museum, Harvard University

Canberra, Australian National Gallery

Cardiff, National Museum of Wales

Chattanooga, Tennessee, Hunter Museum of Art

Chicago, The Art Institute of Chicago

Chicago, Museum of Contemporary Art

The Cleveland Institute of Art, Ohio

The Cleveland Museum of Art, Ohio

Cologne, Museum Ludwig

Dallas Museum of Art, Texas

Des Moines Art Center, Iowa

The Detroit Institute of Arts, Michigan

Dublin, The Hugh Lane Municipal Gallery of Modern Art

Dublin, National Gallery of Ireland

Duisburg, Germany, Wilhelm Lehmbruck Museum

Eindhoven, Netherlands, Stedelijk Van Abbe Museum

Frankfurt am Main, Deutsches Architektur-museum

Fukuoka Art Museum, Japan

Geneva, Switzerland, Musée d'Art et d'Histoire

Gent, Belgium, Museum van Hedendaagse Kunst

Goslar, Germany, Mönchehaus, Museum für Moderne Kunst

Greensboro, Weatherspoon Art Gallery, University of North Carolina

Greenville, South Carolina, Greenville Museum of Art

Grenoble, France, Musée de Grenoble

Hamburg, Kunsthalle

Hannover, Kestner-Gesellschaft

Hannover, Kunstmuseum

Hannover, Sprengel Museum

Hanover, New Hampshire, Hood Museum of Art, Dartmouth College

Hiroshima City Museum of Contemporary Art

Houston, Texas, The Menil Collection

Houston, Texas, The Museum of Fine Arts

Høvikodden, Norway, Henie-Onstad-Kunst-senter

Humlebaek, Denmark, Louisiana Museum of Modern Art

Iowa City, Dorothy Schramm Collection, University of Iowa Museum of Art

Iwaki Art Museum, Japan

Jackson, Mississippi Museum of Art

Jerusalem, The Israel Museum

Kansas City, Missouri, Nelson-Atkins Museum of Art

Karuizawa, Japan, Takanawa Museum

Kitakyushu City, Japan, Kitakyushu Municipal Museum of Art

Kofu, Japan, Yamanashi Prefectural Museum of Art

Krefeld, Germany, Kaiser Wilhelm Museum

Kurashiki, Japan, The Ohara Museum of Art

La Jolla, California, Museum of Contemporary Art

Linz, Austria, Neue Galerie der Stadt Linz, Wolfgang-Gurlitt-Museum

London, The Tate Gallery

London, Victoria and Albert Museum

Los Angeles County Museum of Art

Lund, Sweden, University Museum

Madison Art Center, Wisconsin

Marseilles, France, Musée Cantini

Miami, Florida, Lowe Art Museum, University of Miami

Milwaukee Art Museum, Wisconsin

Minneapolis, Minnesota, Walker Art Center

Mito, Japan, Art Tower Mito, Contemporary Art Gallery

Mönchengladbach, Germany, Städtisches Museum Abteiberg Mönchengladbach

Montreal, Musée d'Art Contemporain

Muncie, Indiana, Ball State University Art Gallery

Munich, Bayerische Staatsgemälde-sammlungen, Neue Pinakothek

New Britain, Connecticut, New Britain Museum of American Art

New Haven, Connecticut, Yale University Art Gallery

New York, The Museum of Modern Art

New York, The Whitney Museum of American Art

Nice, France, Musée d'Art Moderne et d'Art Contemporain de la Ville de Nice

Nîmes, France, Musée d'Art Contemporain

Norfolk, Virginia, The Chrysler Museum

Northampton, Massachusetts, Smith College Museum of Art

Oberlin, Ohio, The Allen Memorial Art Museum

Osaka, Japan, National Museum of Art

Otsu, Japan, Shiga Museum of Modern Art

Otterlo, Netherlands, Rijksmuseum Kröller-Müller

Paris, Centre National d'Art Contemporain

Paris, Centre National d'Art et de Culture Georges Pompidou

Paris, Musée d'Art Moderne de la Ville de Paris

Philadelphia, CIGNA Museum and Art Collection

Philadelphia Museum of Art

Philadelphia, The Pennsylvania Museum of Fine Arts

Providence, Rhode Island, David Winton Bell Gallery, Brown University

Purchase, New York, Neuberger Museum, State University of New York

Richmond, Virginia Museum of Fine Arts

Rotterdam, Netherlands, Museum Boymans-van Beuningen

St. Louis Art Museum, Missouri

St. Louis City Museum, Missouri

St. Paul, Minnesota, Museum of Art

San Francisco Museum of Modern Art

Santa Barbara Museum of Art, California

Sarasota, Florida, John and Mable Ringling Museum of Art

Skopje, Macedonia, Museum of Contemporary Art

Soquel, California, The Art Museum of Santa Cruz County

Stockholm, Moderna Museet

Stuttgart, Kunstverein

Stuttgart, Staatsgalerie

Syndey, Australia, Art Gallery of New South Wales

Sydney, Australian Museum

Sydney, Australia, The Power Institute of Fine Arts

Takamatsu Municipal Museum of Art, Japan

Tampere, Finland, Sara Hildenin Taidemuseo

Teheran Museum of Contemporary Art, Iran

Tokyo, The Hara Museum of Contemporary Art

The Tokyo Metropolitan Art Museum

Tokyo, The Sezon Museum of Art

Tokyo, The Sogetsu Art Museum

Toronto, Art Gallery of Ontario / Musée des Beaux-Arts de l'Ontario

Toulon, France, Musée de Toulon

Toyama, Japan, The Museum of Modern Art

Vancouver Art Gallery, British Columbia

Vienna, Museum des 20. Jahrhunderts

Washington, D.C., Corcoran Gallery of Art

Worcester Art Museum, Massachusetts

Yongin-Gun, Kyunggi-Do, Korea, Ho-am Museum

Zurich, Kunstgewerbemuseum

Zurich, Kunsthaus

Bibliography

Books

1965
Christo. Texts: David Bourdon, Otto Hahn, and Pierre Restany, design: Christo. Milan: Edizioni Apollinaire

1968
Christo: 5,600 Cubicmeter Package. Photos: Klaus Baum, design: Christo. Baierbrunn: Verlag Wort und Bild

1969
Christo. Text: Lawrence Alloway, design: Christo. New York: Harry N. Abrams, Inc.

Christo: Wrapped Coast, One Million Square Feet. Photos: Shunk-Kender, design: Christo. Minneapolis: Contemporary Art Lithographers

1970
Christo. Text: David Bourdon, design: Christo. New York: Harry N. Abrams, Inc.

1971
Christo: Projekt Monschau. Text: Willi Bongard. Cologne: Verlag Art Actuell

1973
Christo: Valley Curtain. Photos: Harry Shunk, design: Christo. Stuttgart: Verlag Gert Hatje (published in English, French, and Italian)

1975
Christo: Ocean Front. Texts: Sally Yard and Sam Hunter, photos: Gianfranco Gorgoni, editor: Christo. Princeton: Princeton University Press

Environmental Impact Report: Running Fence. Prepared by Environmental Science Associates, Inc. Santa Clara, California: Delta Printing

1977
Christo: The Running Fence. Text: Werner Spies, photos: Wolfgang Volz. Stuttgart: Verlag Gerd Hatje; New York: Harry N. Abrams, Inc.; Paris: Edition du Chène

1978
Christo: Running Fence. Chronology: Calvin Tomkins, text: David Bourdon, photos: Gianfranco Gorgoni, design: Christo. New York: Harry N. Abrams, Inc.

Christo: Wrapped Walk Ways, Text: Ellen Goheen, photos: Wolfgang Volz, design: Christo. New York: Harry N. Abrams, Inc.

1982
Christo – Complete Editions 1964 – 82. Catalogue raisonné, introduction: Per Hovdenakk. Munich: Verlag Schellmann und Kluser; New York: New York University Press

1984
Christo: Works 1958 – 83. Text: Yusuke Nakahara. Tokyo: Sogetsu Shuppan, Inc.

Christo: Surrounded Islands, Biscayne Bay, Greater Miami, Florida, 1980 – 83. Text: Werner Spies, photos: Wolfgang Volz. Cologne: DuMont; New York: Harry N. Abrams, Inc., 1985; Saint-Paul-de-Vence, France: Fondation Maeght; Barcelona: Editiones Poligrafa

Christo – Der Reichstag. Editors: Michael S. Cullen and Wolfgang Volz. Frankfurt am Main: Suhrkamp Verlag

1985
Christo. Text: Dominique Laporte. Paris: Art Press/Flammarion; New York: Pantheon Books, 1986

Christo: Surrounded Islands, Biscayne Bay, Greater Miami, Florida, 1980 – 83. Introduction and commentaries: David Bourdon, texts: Jonathan Fineberg and Janet Mulholland, photos: Wolfgang Volz, design: Christo. New York: Harry N. Abrams, Inc.

1987
Le Pont Neuf de Christo, Ouvrage d'Art, Œuvre d'Art ou Comment se faire une opinien. Text: Nathalie Heinrich, photos: Wolfgang Volz. Paris: A.D.R.E.S.S.E.

Helt Fel I Paris. Texts: Pelle Hunger and Joakim Stromholm, photos: J. Stromholm. Frome, England: Butler and Tanner Ltd., The Selwood Printing Works

1988
Christo: Prints and Objects, 1963 – 1987. Catalogue raisonné, introduction: Werner Spies, editors: Jörg Schellmann and Josephine Benecke. Munich: Editions Schellmann; New York: Abbeville Press

1990
Christo: The Pont Neuf Wrapped, Paris, 1975 – 85. Texts: David Bourdon and Bernard de Montgolfier, photos: Wolfgang Volz. New York: Harry N. Abrams, Inc.; Paris: Adam Biro; Cologne: DuMont; Amsterdam: Andreas Landshoff

Christo. Text: Yusuke Nakahara. Tokyo: Shinchosha Co. Ltd.

Christo. Text: Marina Vaizey. Barcelona: Editiones Poligrafa; Recklinghausen: Verlag Aurel Bongers; New York: Rizzoli; Paris: Albin Michel; Amsterdam: Meulenhoff/Landshoff; Tokyo: Bijutsu Shupan-Sha

1991

The Accordion-Fold Book for The Umbrellas, Joint Project for Japan and USA/Christo. Preface and interview: Masahiko Yanagi, photos: Wolfgang Volz. San Francisco: Chronicle Books

Selected Exhibition Catalogues

1961

Galerie Haro Lauhus, Cologne. Text: Pierre Restany

1966

Stedelijk Van Abbe Museum, Eindhoven, Netherlands. Text: Lawrence Alloway

1968

The Museum of Modern Art, New York. Text: William Rubin

I.C.A. University of Pennsylvania, Philadelphia. Text: Stephen Prokopoff

1969

National Gallery of Victoria, Melbourne, Australia. Text: Jan van der Marck

1971

Museum Haus Lange, Krefeld, Germany. Text: Paul Wember

1973

Kunsthalle, Düsseldorf. Text: John Matheson

1974

Musée de Peinture et de Sculpture, Grenoble, France. Text: Maurice Besset

1975

Galerie Ciento, Barcelona. Text: Alexandre Cirici

Museo de Bellas Artes de Caracas, Venezuela. *Christo, Exposición Documental Sobre El Valley Curtain.* Photos: Harry Shunk. Caracas: Impresión Editorial Arte

1977

Annely Juda Fine Art, London. Texts: Wieland Schmied and Tilmann Buddensieg, photos: Wolfgang Volz

1978

Galerie Art in Progress, Munich: Galerien Maximilianstrasse. Text: Albrecht Haenlein

Rijksmuseum Kröller-Müller, Otterlo, Netherlands. Introduction: R. Oxenaar, text: Ellen Joosten

1979

Vienna Secession. Introduction: H. J. Painitz, text: Werner Spies, photos: Wolfgang Volz

I.C.A., Boston, Laguna Gloria Art Museum, Austin, Texas, and Corcoran Gallery of Art, Washington, D.C. Introduction: Stephen Prokopoff, texts: Pamela Allara and Stephen Prokopoff

1981

Museum Ludwig, Cologne. Introduction: Karl Ruhrberg and Klaus Gallwitz, texts: Evelyn Weiss and Gerhard Kolberg

Juda-Rowan Gallery, London. Texts: Christo and Anitra Thorhaug

La Jolla Museum of Contemporary Art, California. *Christo: Collection on Loan from the Rothschild Bank AG, Zurich.* Introduction: Robert McDonald, text: Jan van der Marck

1982

The Hara Museum of Contemporary Art, Tokyo. *Christo, Wrapped Walk Ways.* Texts: Toshio Hara, Ellen R. Goheen, and Toshiaki Minemura, photos: Wolfgang Volz. Tokyo: Fondation Arc-en-ciel

U.A.E. University, Al-Ain, United Arab Emirates. *Christo, Environmental Art Works.* Preface: Ezzidin Ibrahim

1984

Satani Gallery, Tokyo. *Christo – The Pont Neuf Wrapped, Project for Paris.* Text: Yusuke Nakahara, interview: Masahiko Yanagi, photos: Wolfgang Volz

Annely Juda Fine Art, London. *Christo: Objects, Collages and Drawings, 1958–83*

Architekturmuseum, Basel. *Wrapped Floors, im Architekturmuseum in Basel.* Texts: Ulrike and Werner Jehle-Schulte, photos: Wolfgang Volz

1986

Satani Gallery, Tokyo. *Christo – Wrapped Reichstag, Project for Berlin.* Interview: Masahiko Yanagi, photos: Wolfgang Volz

Galeria Joan Prats, Barcelona. *Christo, Dibuixos i Collages*

1987

Museum van Hedendaagse Kunst, Gent, Belgium. *Surrounded Islands, Biscayne Bay, Greater Miami, Florida, 1980–83.* Texts: Werner Spies, photos: Wolfgang Volz

The Seibu Museum of Art, Tokyo. *Christo: A Collection on Loan from the Rothschild Bank, Zurich.* Texts: Torsten Lilja, Yusuke Nakahara, Tokuhiro Nakajima, and Akira Moriguchi, interview: Masahiko Yanagi, photos: Wolfgang Volz

Centre d'Art Nicolas de Staël, Braine-L'Alleud, Belgium. *Christo: Dessins, Collages, Photos.* Text: A. M. Hammacher, interviews: Marcel Daloze and Dominique Verhaegen, photos: Wolfgang Volz

Edition Mönchehaus Museum, Verein zur Förderung Moderner Kunst, Goslar, Germany. *Christo, Laudatio zur Verleihung des Kaiserrings, Goslar, 26. September 1987.* Speech held by Werner Spies

1988

Satani Gallery, Tokyo. *The Umbrellas, Joint Project for Japan and USA.* Introduction: Ben Yama, text: Masahiko Yanagi, photos: Wolfgang Volz

Annely Juda Fine Art, London. *The Umbrellas, Joint Project for Japan and USA.* Interview and text: Masahiko Yanagi, photos: Wolfgang Volz

Taipei Fine Arts Museum, Taipei, Taiwan. *Christo: Collection on Loan From the Rothschild Bank AG, Zurich.* Preface: Kuang-Nan Huang, text: Werner Spies and Joseph Wang, photos: Wolfgang Volz

1989

Guy Pieters Gallery, Knokke-Zoute, Belgium. *The Umbrellas, Joint Project for Japan and USA.* Photos: Wolfgang Volz, text: Masahiko Yanagi, commentaries: Susan Astwood

Musée d'Art Moderne et d'Art Contemporain de la Ville de Nice, France. *Christo: Selection from the Lilja Collection.* Text: Torsten Lilja, Claude Fournet, Pierre Restany, Werner Spies, and Masahiko Yanagi, photos: Wolfgang Volz

Galerie Catherine Issert, Saint-Paul-de-Vence, France. *Christo: Projects 1965–1988.* Text: Raphael Sorin

1990

Henie-Onstad Kunstsenter, Høvikodden, Norway. *Christo: Works 1958–89, from the Lilja Collection.* Introduction: Torsten Lilja, text: Per Hovdenakk, interview: Jan Åman, photos: Wolfgang Volz

Hiroshima City Museum of Contemporary Art and The Hara Museum of Contemporary Art, ARC, Gunma, Japan. *Christo: Surrounded Islands, Florida, 1980–83.* Text: Jonathan Fineberg, photos: Wolfgang Volz

Art Gallery of New South Wales, Sydney, Australia. *Christo: Works from 1958–1990.* Preface: John Kaldor, texts: Albert Elsen, Toni Bond, Daniel Thomas, and Nicholas Baume

Bogerd Fine Art, Amsterdam. *Christo: Drawings – Multiples*

Satani Gallery, Tokyo. *Christo, The Umbrellas, Joint Project for Japan and USA.* Text: Masahiko Yanagi, photos: Wolfgang Volz

1991

Annely Juda Fine Art, London. *Christo: Projects Not Realised and Works in Progress.* Preface: Annely and David Juda

Galeria Joan Prats, Barcelona. *Christo: Obra 1958–1991*. Text: Marina Vaizey

Art Tower Mito, Contemporary Art Gallery, Ibaraki, Japan. *Christo: Valley Curtain, Rifle, Colorado, 1970–72, Documentation Exhibition, and The Umbrellas, Joint Project for Japan and USA, Work in Progress*. Text: Jan van der Marck, interview: Masahiko Yanagi

Satani Gallery, Tokyo. *Christo: Early Works 1958–64*. Texts: Masahiko Yanagi and Harriet Irgang

1992
Seomi Gallery and Hyundai Gallery, Seoul, Korea. *Christo: Works from the Eighties and Nineties*. Photos: Wolfgang Volz

Marugame Genichiro Inokuma Museum of Contemporary Art, Kagana Japan. *Christo: Valley Curtain, Rifle, Colorado, 1970–72, Documentation Exhibition, and The Umbrellas, Joint Project for Japan and USA*. Text: Jan van der Marck, interview: Masahiko Yanagi

1993
Art Front Gallery, Hillside Terrace, Tokyo. *Christo: Works from the Eighties and Nineties*. Text: Masahiko Yanagi, photos: Wolfgang Volz

Films about Christo

1969
Wrapped Coast. Blackwood Productions

1972
Christo's Valley Curtain. Maysles Brothers/Ellen Giffard

1977
Running Fence. Maysles Brothers/Charlotte Zwerin

1978
Wrapped Walk Ways. Blackwood Productions

1985
Islands. Maysles Brothers/Charlotte Zwerin

1990
Christo in Paris. David and Albert Maysles, Deborah Dickson, and Susan Froemke

1993
Christo, The Umbrella, Japan – USA. Maysles Brothers (in preparation)